hoefner / sachs
piccolo mondo

gestalten

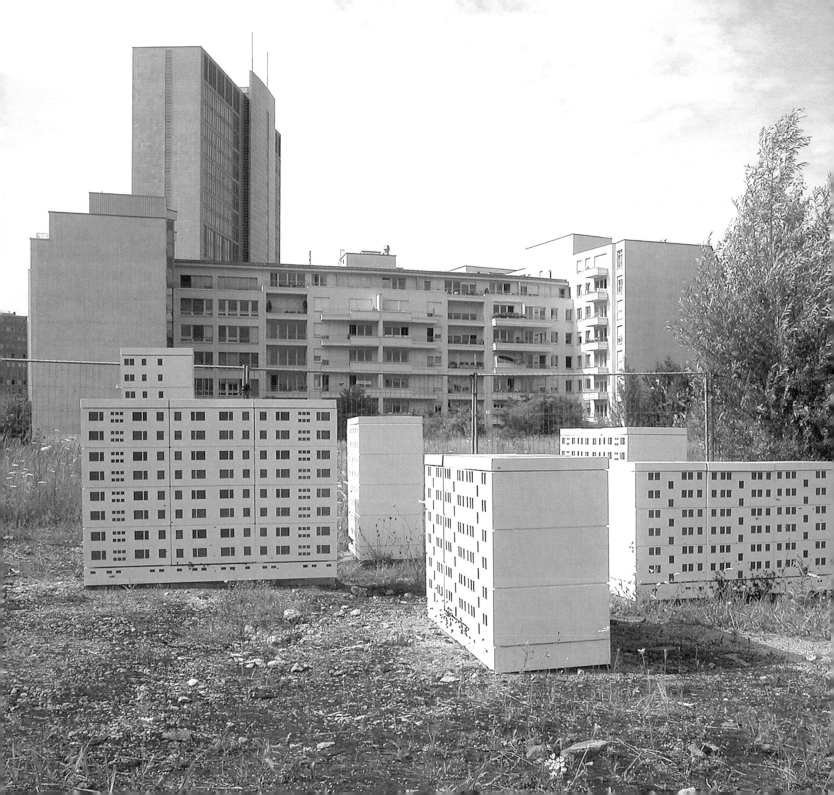

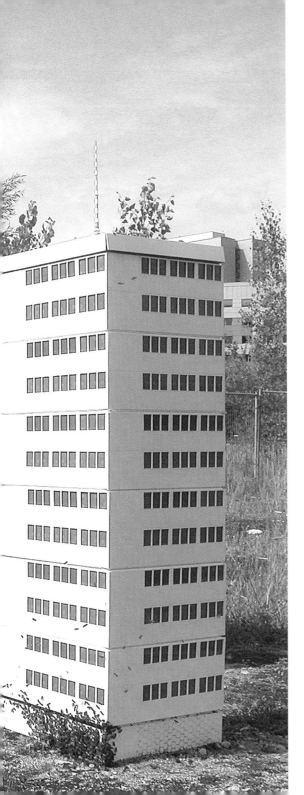

Honey Neustadt

GDR ‹Plattenbau› tower-block development for honey bees, corner of Kommandan-tenstrasse and Beuthstrasse (now Skulpturenpark Berlin_Zentrum), Berlin
June–October 2006
60 Styrofoam beehive frames, 50 x 50 x 20 cm each, stacked to form 8 beehives in 1:20-scale based on the GDR tower block models WBS70, PHH 12, PHH 16, IW 64 P, P2 IW 76

One million honeybees (*Apis mellifera*) find a home in the bee colony *Honey Neustadt*. Every morning the bees swarm throughout Berlin to its parks and to plants on private balconies, before returning in the evening to prefabricated Styrofoam housing. By the end of summer, they will have produced more than 250 kilograms of honey. The colony is maintained by a local beekeeper. Packaged and labelled as *Berliner Blüte (Berlin Blossom)*, the honey finds its way into Berlin's households and also onto the art market.

Honey Neustadt is modelled on prefabricated housing developments constructed for workers in ‹dormitory towns›. One such district, Halle-Neustadt, was constructed from the mid-1960s onwards as a satellite town for the East German city of Halle. In fulfilment of their ultra-functionalised working existences, its residents commuted daily to and from work in chemical plants located in the nearby towns of Buna and Leuna.

In *Honey Neustadt*, the work of its residents – honey production – also involves a chemical process. The architectural layout of both communities share further parallels: the bee dwellings consist of industrially prefabricated bee frames that are stacked one on top of the other and outfitted, floor-by-floor, with standardised honeycomb panels. This approach reflects the old urban planning philosophy of creating a sense of community by imposing high densities.

The floral pictograms on the buildings did not have merely a decorative function. They also served to visually orient the residents within the housing blocks and acted as identifiers for their home environment. In *Honey Neustadt*, the geometric forms that adorn the beehives help the bees recognise their own dwellings. In similar fashion, a coat of arms designed for *Honey Neustadt* is cut into the ground at the project site. It is visible to observers both near and far – including the satellites that feed Google Earth.

This beehive-city is designed as a miniature memorial for the residents of the dormitory towns and could, for example, be built on the areas of greenery that result when these dormitory towns become shrinking cities and are partially torn down, as is often the fate of these developments today.

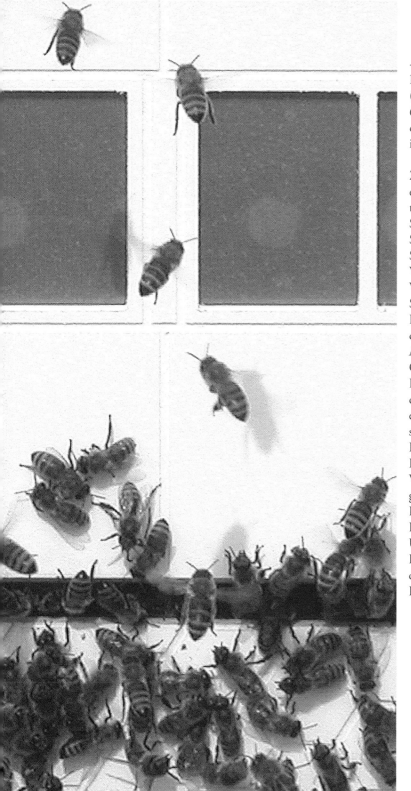

Plattenbausiedlung für Honigbienen, Kommandantenstrasse Ecke Beuthstrasse
(heute Skulpturenpark Berlin_Zentrum), Berlin, Juni–Oktober 2006
60 Bienenbeuten, Styropor, jeweils 50 x 50 x 20 cm, gestapelt zu acht Bienenhäusern
der Plattenbautypen WBS 70, PHH 12, PHH 16, IW 64 P und P2 IW 76,
im Maßstab 1:20

Zwischen Juni und Oktober 2006 finden in der Bienensiedlung *Honey Neustadt*
eine Million Honigbienen (*Apis mellifera*) ein Zuhause. Die Bienen schwärmen
täglich zu den öffentlichen Grünanlagen und den privaten Balkonpflanzen der
Stadt aus und kehren abends in ihre Styropor-Plattenbauten zurück. Am Ende des
Sommers haben sie über 250 Kilogramm Honig produziert. Betreut wird die
Siedlung von einem lokalen Imker. Als *Berliner Blüte* findet der Honig sowohl den
Weg in Berliner Haushalte als auch Absatz auf dem Kunstmarkt.
Vorbild der Plattenbausiedlung *Honey Neustadt* sind sogenannte Schlafstädte. Im
Sinne eines vollkommen funktionalisierten Arbeitslebens pendelten z. B. die in
Halle-Neustadt angesiedelten Menschen täglich zwischen ihrer Wohneinheit und
den Chemischen Werken Buna und Leuna.
Auch die Honigproduktion der Bienen von *Honey Neustadt* ist dem Bereich der
Chemie zugehörig. Übereinstimmungen gibt es zudem in der architektonischen
Konstruktion beider Siedlungstypen: Die Bienenbehausungen bestehen aus in-
dustriell vorgefertigten Bienenkästen, die aufeinander gestapelt werden und
etagenweise mit normierten Wabenplatten bestückt sind – dem einstmaligen
städteplanerischen Credo von ‹Gesellschaft durch Dichte› vergleichbar.
Florale Piktogramme auf den Plattenbauten haben nicht nur eine dekorative
Funktion, sondern dienen den Anwohnern zur Orientierung innerhalb der
Wohnblöcke und zur Identifikation mit ihrer Anlage. Sie korrespondieren mit den
geometrischen Formen, die an den Bienenhäusern angebracht sind und den
Bienen helfen, ihre Behausungen wiederzufinden. In diesem Sinn ist das in den
Boden gefräste Stadtwappen von *Honey Neustadt* weithin sichtbar, für die nähere
Umgebung bis hin zu den Satelliten von Google Earth.
Der Bienenhaus-Städtebau ist als Miniaturdenkmal für die ehemaligen Bewohner
der Schlafstädte konzipiert und könnte z. B. auf den durch Schrumpfung und
Rückbau entstandenen Grünflächen stehen.

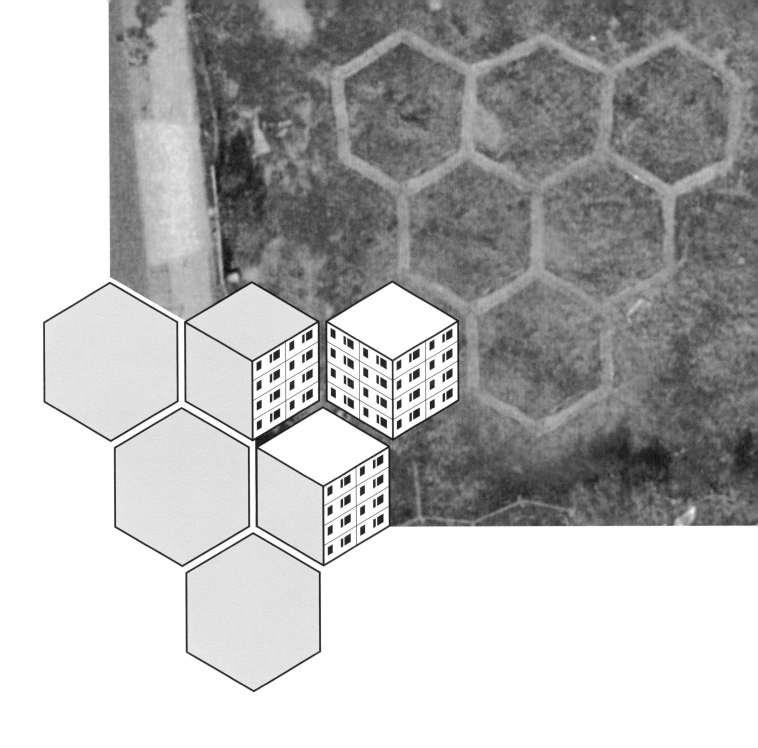

Coat of arms for *Honey Neustadt*, cut into the ground over an area of 30 x 30 m
Stadtwappen *Honey Neustadt*, auf einer Fläche von 30 x 30 m in den Boden gefräst

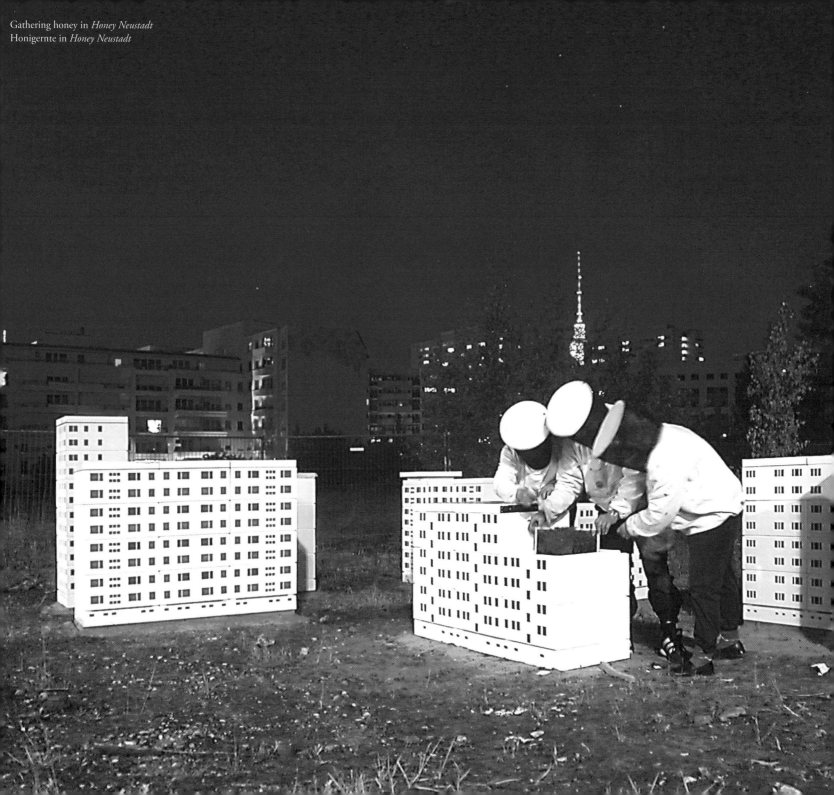

Gathering honey in *Honey Neustadt*
Honigernte in *Honey Neustadt*

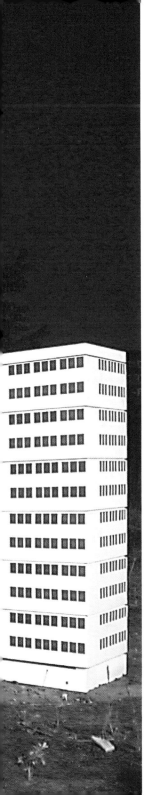

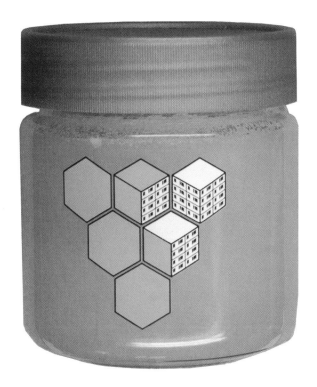

250g of *Berliner Blüte* honey
250g Honig *Berliner Blüte*

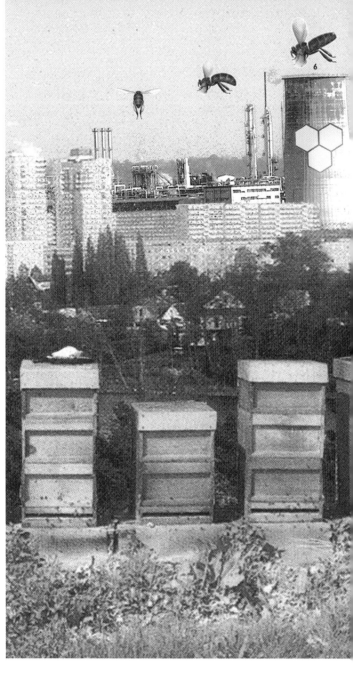

Preliminary sketch: conventional beehouses in Halle-Neustadt
Konzeptskizze: herkömmliche Bienenbeuten in Halle-Neustadt

Neuhaus Wohnerlebniswelt

Franz Hoefner / Markus Lohmann / Natascha Rossi / Harry Sachs

Compressed home environment, Kultur/Block, Halle-Neustadt 2003
Home furnishings, built-in kitchens, doors, carpet, wallpaper, lamps
18 rooms, 150 sq.m.

In an unoccupied East German ‹Plattenbau› high-rise with 200 apartments, existing furnishings are removed and relocated to a block of four neighbouring apartments, two on one floor and two above these on the next floor, to create *Neuhaus Wohnerlebniswelt (Neuhaus home-experience world)*.
By breaking holes through the walls and ceilings and using the furnishings left behind by previous tenants, an organic home adventure park is built, which subverts the standardised structure of the larger building itself.
Every cubic inch of space is utilised to create a succession of levels and rooms of varying sizes, all within the confines of the four apartments. Amidst the monotonous, repeating patterns that characterise the tower block, a compact apartment is built that consists of a labyrinth-like system of small rooms. Visitors can view the apartment by undertaking a 20-minute tour.

Verdichtete Wohnlandschaft, Kultur/Block, Halle-Neustadt 2003
Wohnungseinbauten, Einbauküchen, Türen, Teppiche, Tapeten, Lampen
18 Räume, 150 qm

Aus 200 Wohnungen eines leerstehenden Plattenbaukomplexes werden die zurückgelassenen Einbauten demontiert und in einem Segment von vier an- und übereinander liegenden Wohnungen konzentriert.
Mit Hilfe einiger Wand- und Deckendurchbrüche wird der einheitlichen Struktur des modernen Plattenbaus eine organische Wohnerlebniswelt entgegengesetzt, gebaut aus den vorgefundenen individuellen Wohnoberflächen der ehemaligen Mieter.
Der Rauminhalt wird maximal genutzt, wodurch auf mehreren Ebenen unterschiedlich dimensionierte Räumlichkeiten entstehen. Innerhalb des streng normierten Rasters des Plattenbaus entsteht eine Kleinraumwohnung, die sich aus einem labyrinthischen Raumgefüge zusammensetzt und im Rahmen einer Wohnungsbesichtigung in circa zwanzig Minuten durchquert werden kann.

Preliminary sketch | Konzeptskizze

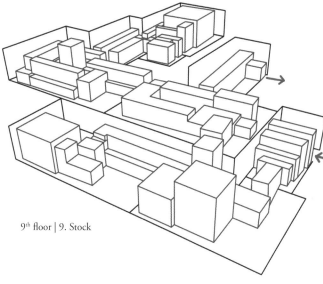

10th floor | 10. Stock

9th floor | 9. Stock

Floor plan | Raumplan

Teenager's room | Jugendzimmer

Entrance to the hall of mirrors | Eingang zum Spiegelsaal

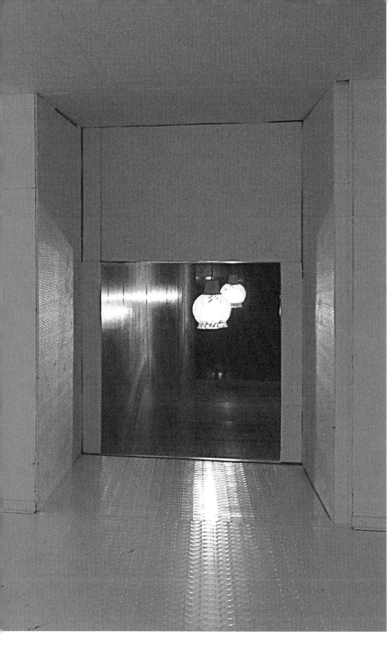

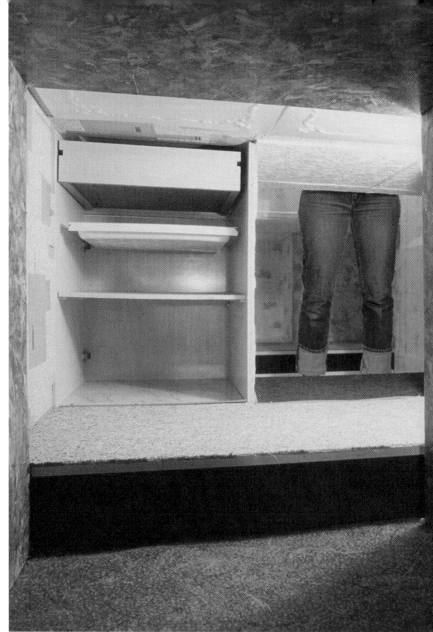

Green parlour | Grüner Salon

Living room | Wohnzimmer

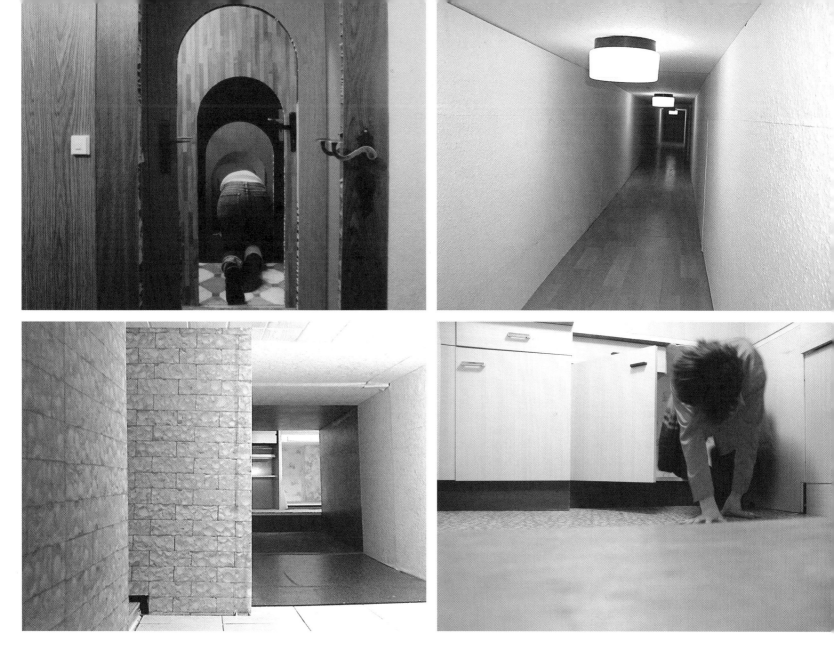

Entrance | Eingangstüren Corridor | Korridor

Hobby room | Hobbykeller Kitchen | Küche

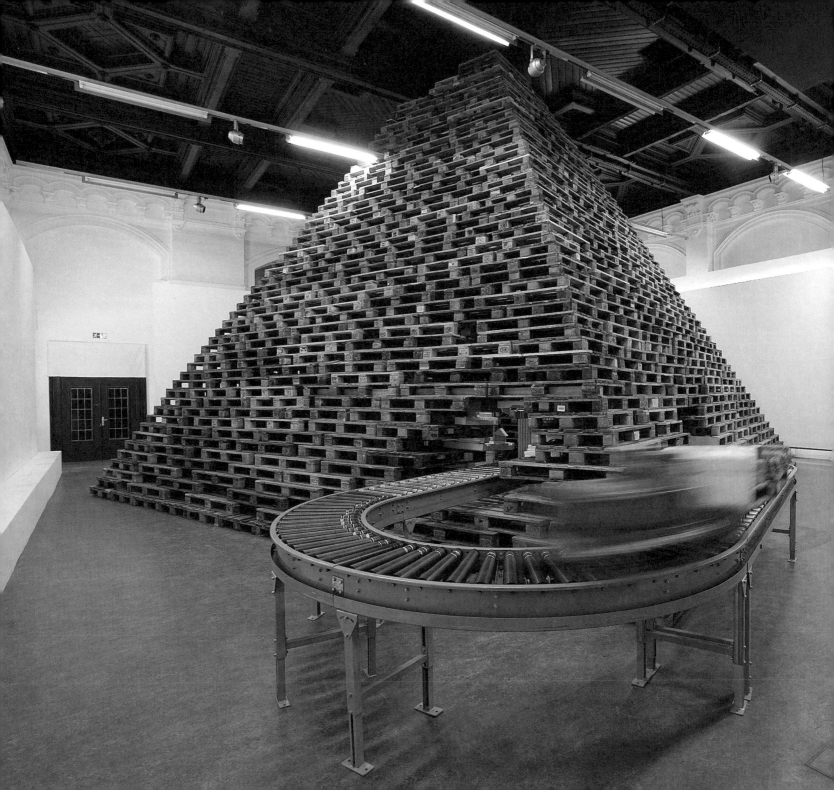

Das Beschäft

Michael Boehler / Franz Hoefner / Markus Lohmann / Harry Sachs

Workers' monument, Kunstverein Harburger Bahnhof, Hamburg 2007
Around 1000 reusable wooden pallets, conveyor belt, forklift,
various packaging materials
12 x 12 x 8 m

With the takeover of the Phoenix AG in Hamburg-Harburg by
Continental AG, the 19th and 20th century culture of factory work
takes another step towards extinction. Next door in the Kunstverein
Harburg, the *Beschäft* monument concerns itself with future of
labour. The title, *Beschäft*, is a combination of the German words for
‹activity› (Beschäftigung) and ‹business› (Geschäft).
The *Beschäft* takes warehouse and logistics materials (remnants of
industrial labour) and uses them to construct a monumental archi-
tecture that houses and shapes activities that could fill the newfound
leisure time created by the passing of work.
In the *Beschäft*, the ex-worker finds new diversions within an altered
but familiar working environment. Wooden pallets are stacked on
top of each other to form an impressive pyramid, which houses a
private, three-storey activity centre. Like a Phoenix rising from the
ashes, industrial production processes are reborn as a series of new
activities.
Prompted by the EURO logo that is branded into the wooden
pallets, the image of the Phoenix has been seared into the pallets in
multiple variations. A model train made of boxes travels along the
conveyor belt from a former production line, passing in and out of
an environment built from packaging materials. A forklift supports
a balcony midway between the floor and ceiling of the exhibition
space; hanging next to it on the roof deck is a hammock made of
packing straps that are tied together. Wood embroidery, drill-hole
drawings, and the milled calendar and pin-up designs on the pallets
all provide evidence that the cast-off factory worker is back at work
again.

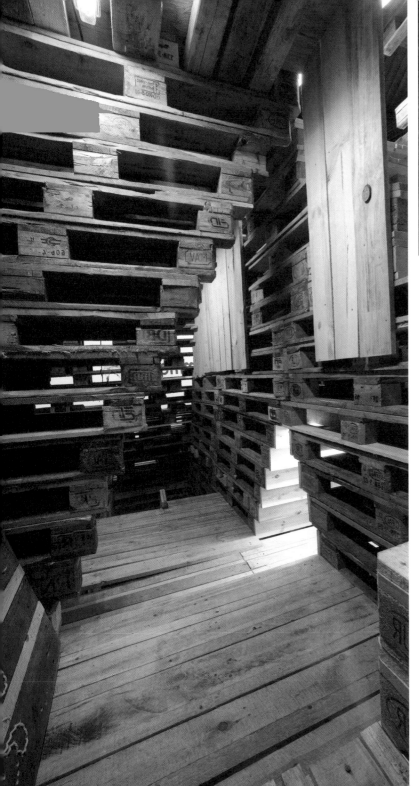

Arbeitermonument, Kunstverein Harburger Bahnhof, Hamburg 2007
ca. 1000 Mehrweg-Europaletten, Rollband, Elektrohubwagen,
Verpackungsmaterialien
12 x 12 x 8 m

Während in der benachbarten Phoenix AG im Rahmen der Fusion
mit der Continental AG das traditionelle Format moderner Fabrik-
arbeit einen weiteren Schritt seinem Ende entgegen geht, widmet
sich das Monument *Das Beschäft* im Kunstverein der Frage nach der
Zukunft der Arbeit.

Aus Materialien der Lagerlogistik formuliert *Das Beschäft* Beschäfti-
gungen, die jenseits fremdbestimmter Arbeit aus den recycelten
Überbleibseln industrieller Arbeitskultur entstehen, wenn scheinbarer
Zeitvertreib zum geschäftigen Zeitvertrieb wird. Im *Beschäft* geht
der ehemalige Arbeiter einer neuen Tätigkeit nach. Er beginnt, seine
Arbeitswelt zu verwandeln. Ungenutzte Europaletten werden zu
einer kunstvollen Pyramide aufgetürmt, die im Inneren auf drei Etagen
ein privates Beschäftigungsrefugium beherbergt. Wie ein Phoenix aus
der Asche lebt der rationale Produktionsablauf in einer Vielfalt neuer
Beschäftigungskreisläufe neu auf. Inspiriert von den EURO-
Kodierungen, die in die Mehrwegpaletten eingebrannt sind, werden
Varianten des Phoenixvogel-Symbols in Brandmaltechnik in die
Paletten gezeichnet. Auf dem Rollband der einstigen Produktions-
straße fährt nun eine Modelleisenbahn aus Transportkisten durch
die neu arrangierte Verpackungswelt. Ein Elektrohubwagen stützt auf
halber Raumhöhe einen Palettenbalkon, daneben hängt auf der
Dachterrasse eine Hängematte, geknüpft aus Verpackungsbändern.
In Paletten gefräste Kalenderbilder und Pin-up-Motive, Paletten-
stickereien und Lochzeichnungen zeugen davon, dass der ehemals
Beschäftigte wieder beschäftigt ist.

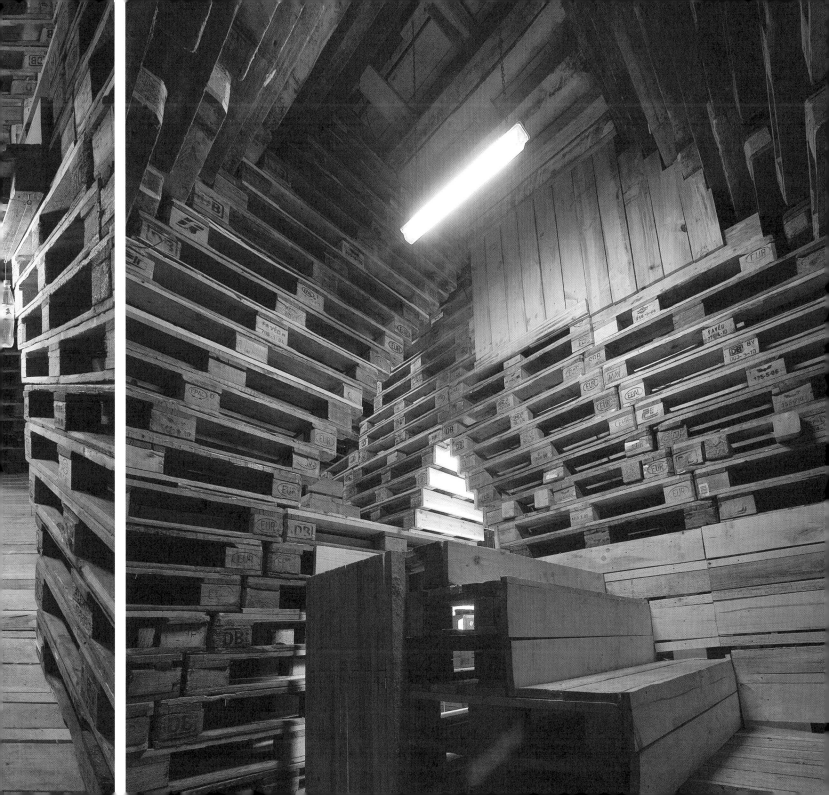

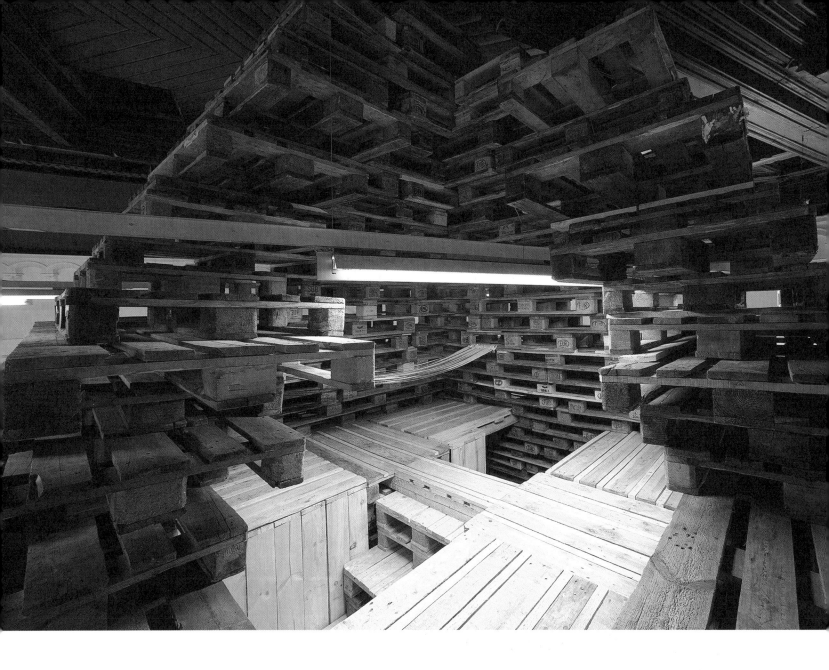

Roof terrace with hammock | Dachterrasse mit Hängematte

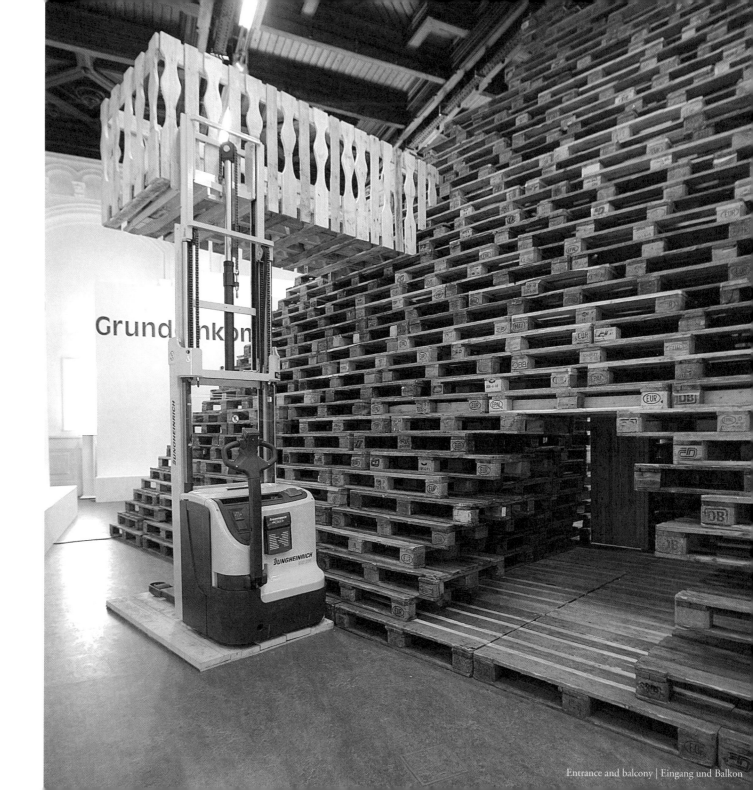

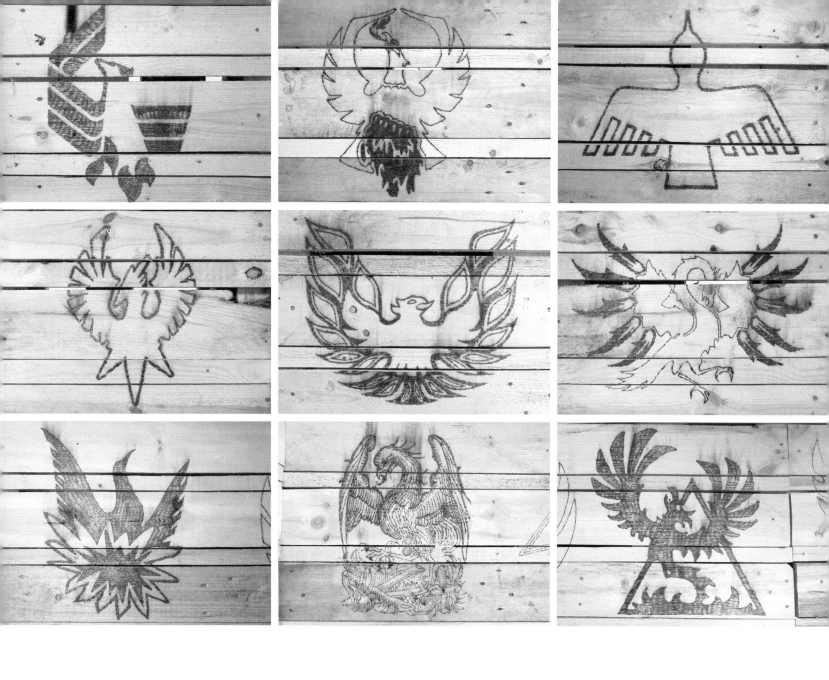

Collection of pyrography Phoenix logos | Sammlung von Phoenix-Logos in Holzbrandmalerei

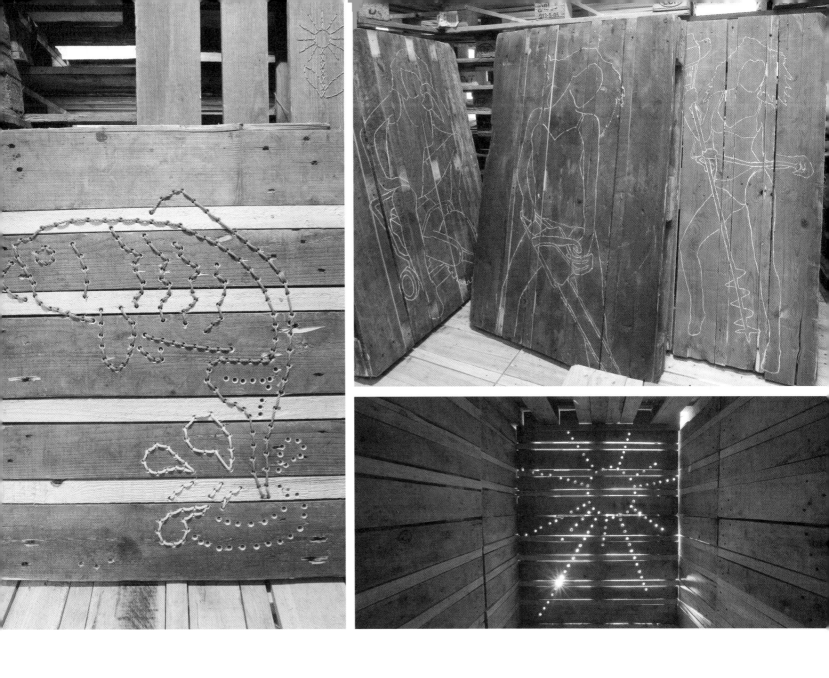

Milled pin-up motifs | gefräste Pin-up Motive

Pallet embroidery | Palettenstickerei

Drill-hole drawing: solarium | Lochzeichnung: Solarium

Douaneville

--

Michael Boehler / Franz Hoefner / Markus Lohmann / Harry Sachs

Settlement, in the context of ‹Zoll-Douane›, Hamburg
September–October 2004
Trailers, tents, portable toilet, lighting, satellite dishes, garden
furniture, radios and televisions, timer, etc.
17 x 8 x 8 m

In the *Douaneville* temporary settlement, tents and caravans are set
on the roof of a disused customs checkpoint, thus occupying
the urban no man's land at the former border dividing the city and
its freeport. The appearance and social connotations evoked by
Douaneville contrast with its setting amidst historical red-brick trade
buildings. It acts as a parasitic outpost of the ‹HafenCity› urban
renewal project. The improvised layout of this settlement blurs the
dividing lines between holiday campsites, permanent campsites,
alternative living models, nomadic tent settlements and refugee
camps.

--

Ansiedlung, im Rahmen von ‹Zoll-Douane›, Hamburg
September–Oktober 2004
Wohnwagen, Zelte, mobile Toilettenkabine, Beleuchtung, Satelliten-
schüsseln, Gartenmöbel, Radio- und TV-Geräte, Zeitschaltuhr, etc.
17 x 8 x 8 m

Douaneville schlägt als temporäre Siedlung seine Zelte auf dem Dach
der ehemaligen Personenabfertigungsanlage des Zolls auf und besetzt
den urbanen Zwischenraum auf der ehemaligen Grenzlinie zwischen
Stadt und Freihafen. Formal wie sozial kontrastiert *Douaneville* mit
der historischen Backsteinkulisse und den umgebenen Handels-
zentren und verweist als parasitärer Vorposten auf die begonnene
Stadterweiterung der angrenzenden HafenCity. Anordnung und
Improvisation der Anlage lassen die Grenzen zwischen Urlaub, Dauer-
camping, alternativen Wohnformen, nomadenhaften Zeltstädten
und Flüchtlingslagern verschwimmen.

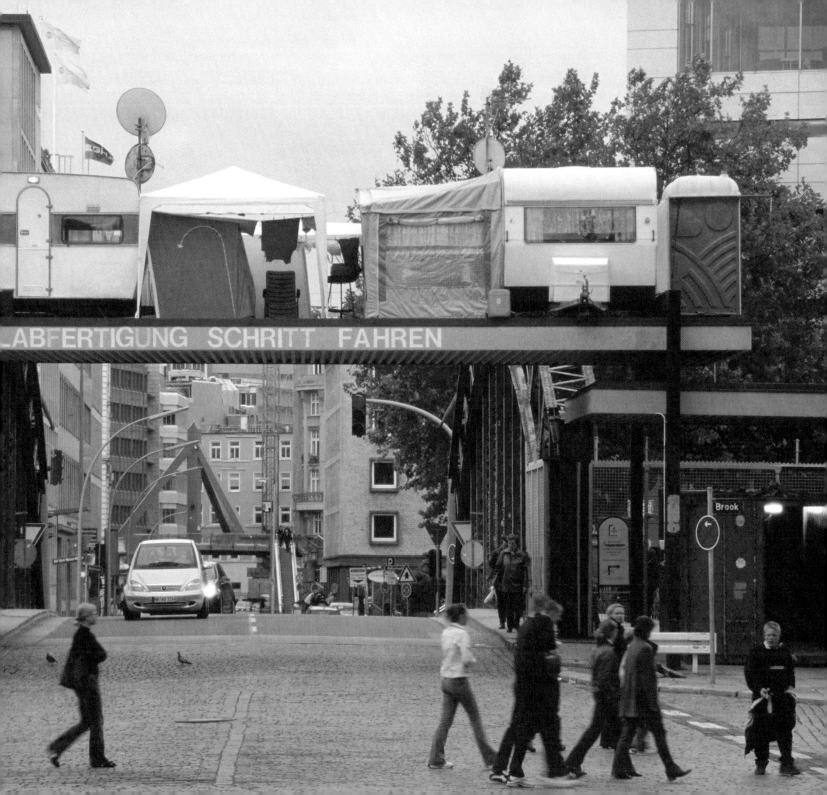

Mehrzweckhalle HafenCity

Michael Boehler / Markus Lohmann / Harry Sachs

Construction site, HafenCity, Hamburg, May–September 2002
21 greenhouse modules, shipping containers, visitor platform, conveyor belt, excavator, construction vehicle, crane, construction sign, office trailer, fencing etc.

The process-oriented construction *Mehrzweckhalle HafenCity (Multi-purpose hall, HafenCity)* is an intervention alongside the new ‹HafenCity› (Harbour City) redevelopment project in Hamburg. In stark contrast to the high-class, luxury buildings planned for the district, a modular multi-purpose hall is constructed, which can be converted and used for various purposes by the local residents. Used greenhouses formerly owned by the city are disassembled, recycled, painted, and, using a crane, stacked like building blocks on top of one another.

The *Mehrzweckhalle* maintains the appearance of a major construction site, but is directly adjacent to where construction on the actual HafenCity is underway. The *Mehrzweckhalle* is available to all interested groups. Patrons include brass and marching bands, dancing and capoeira groups, karate clubs, gun clubs, wedding and anniversary parties, and anglers. The hall hosts innumerable activities ranging from emergency drills, fireworks displays and hot-air balloon competitions, to disco parties, concerts and a fashion show with a dazzling catwalk. The many functions of *Mehrzweckhalle HafenCity* are evidence of its capacity to perpetually transform itself in order to meet the public's real needs.

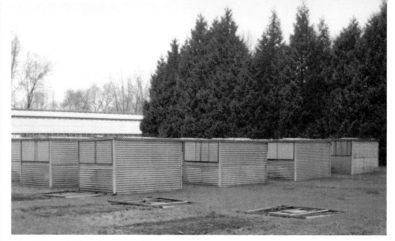

Greenhouses before they were taken apart
Gewächshäuser vor der Demontage

Großbaustelle, HafenCity, Hamburg, Mai–September 2002
21 Gewächshausmodule, Material- und Bürocontainer, Besucherplattform, Bagger, Förderband, Baufahrzeug, Baukran, Bauschild, Bauwagen, Bauzaun, etc.

Die *Mehrzweckhalle HafenCity* ist als prozessorientierte Baumaßnahme eine Intervention im Bebauungsplan von Hamburgs neuem Stadtteil HafenCity. Im Kontrast zu den luxuriösen Visionen des städtischen Masterplans wird eine modulare Mehrzweckhalle errichtet, die mit lokaler Bürgerbeteiligung für unterschiedliche Zwecke umgebaut und genutzt werden kann. Ehemals staatliche Gewächshäuser werden im Recyclingverfahren demontiert, lackiert und als Bausteine mit dem Kran aufeinander gestapelt.
In direkter Nachbarschaft zu den beginnenden Bauarbeiten der HafenCity als Großbaustelle inszeniert, steht die *Mehrzweckhalle HafenCity* interessierten Gruppen und Vereinen mietfrei zur Verfügung. Posaunenchöre, Showtanz- und Capoeira-Gruppen, Karateclubs, Schützenvereine und Musikkorps gehören neben Hochzeitsgesellschaften, Jubiläumsveranstaltern und Anglern zu den Nutzergruppen.
Zwischen Katastrophenschutzübung, Feuerwerk, Luftballonwettbewerb und einem Tag der offenen Tür, ob als Großraumdisco, Konzertbühne oder Laufsteg für Modenschauen, den gesellschaftlichen Bedürfnissen entsprechend wird die *Mehrzweckhalle HafenCity* stetig umgebaut.

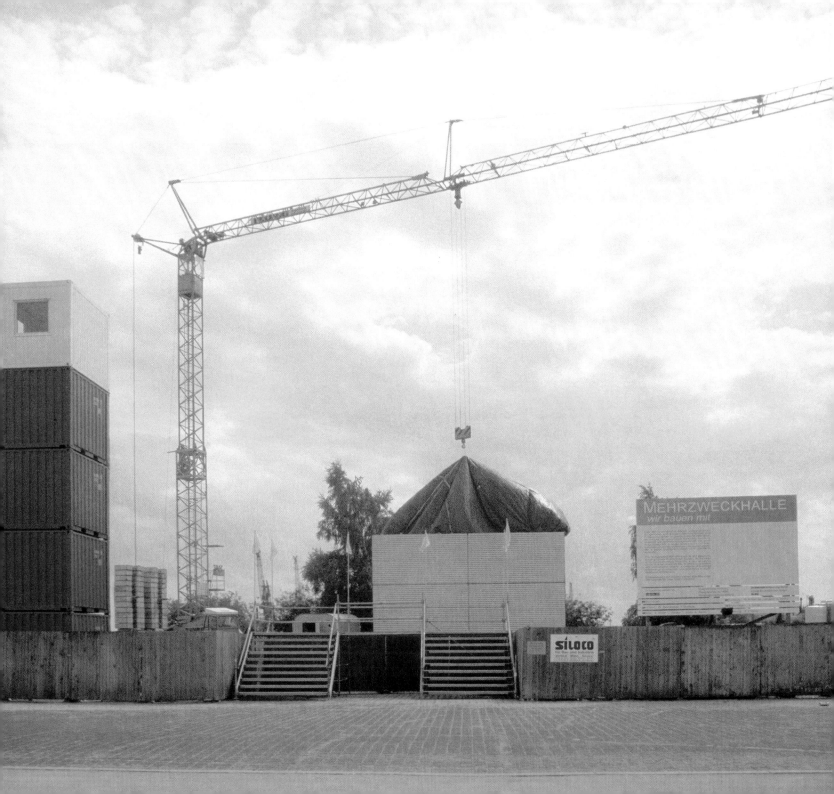

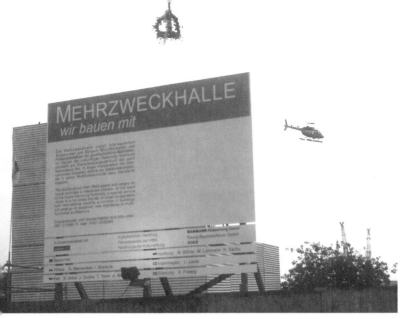

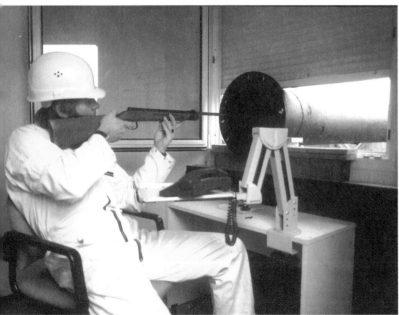

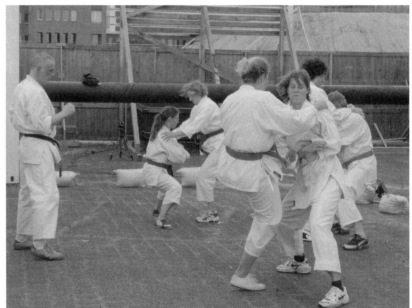

Roofing ceremony | Richtfest

Competition anglers | Sportangler

Local rifle club | Sportschützenverein Hamburg

Local karate club | Karateverein des Hamburger Turnerbunds

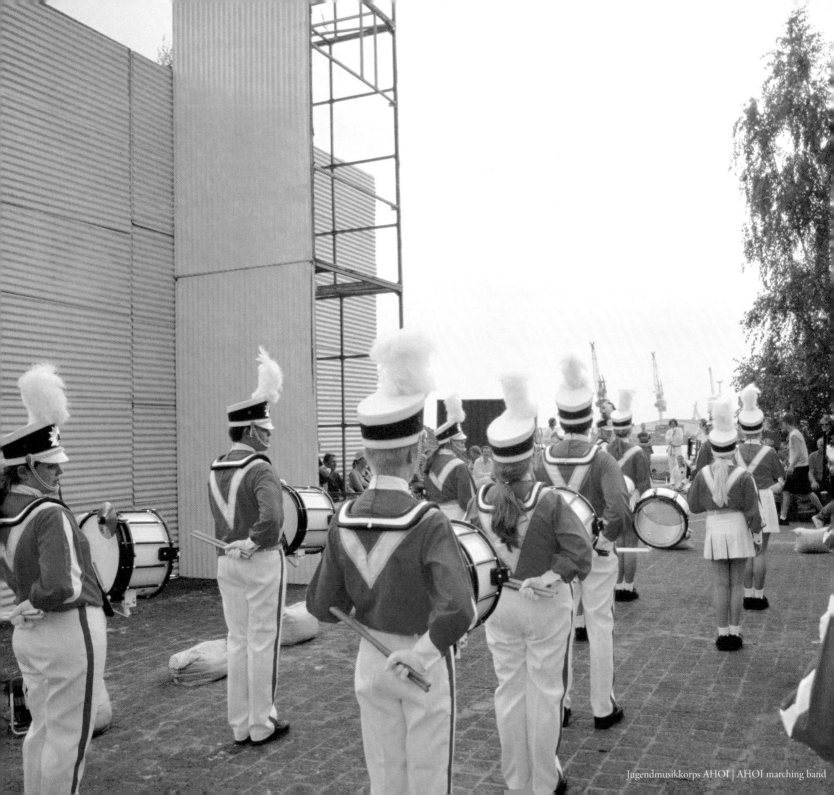

Jugendmusikkorps AHOI | AHOI marching band

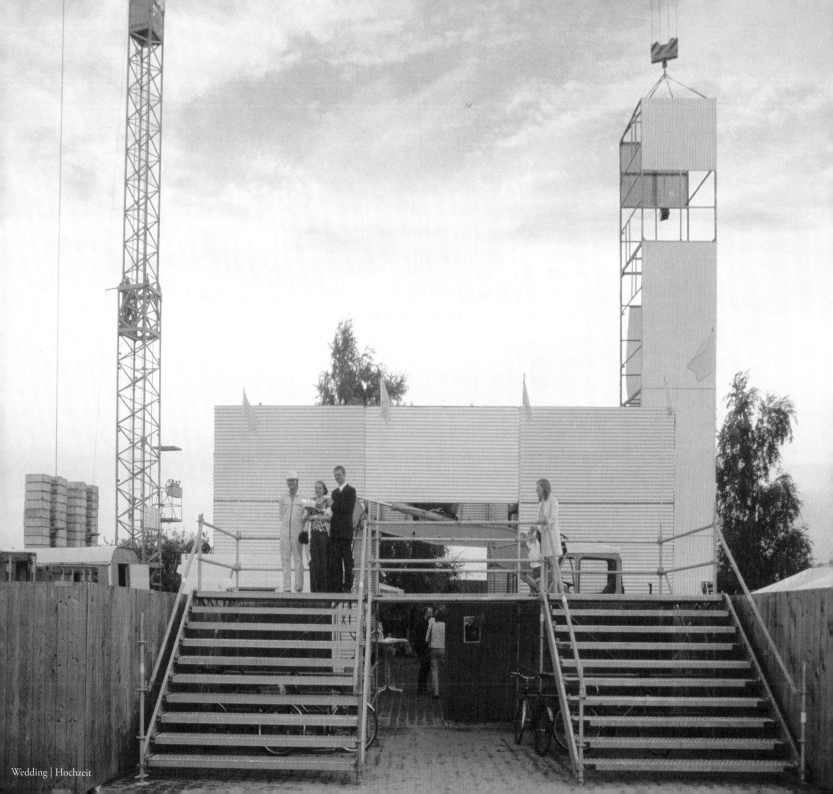

Wedding | Hochzeit

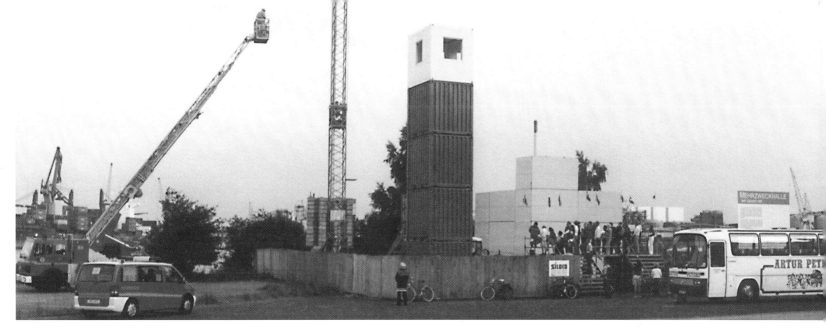

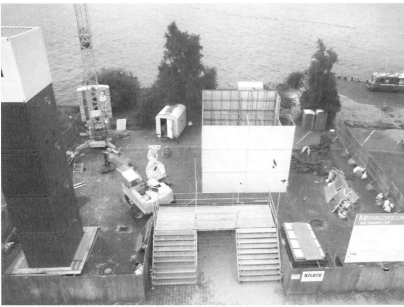

Aerial view | Luftaufnahme

Emergency drill | Katastrophenschutzübung

Bulldozer parade | Planierraupen Parade

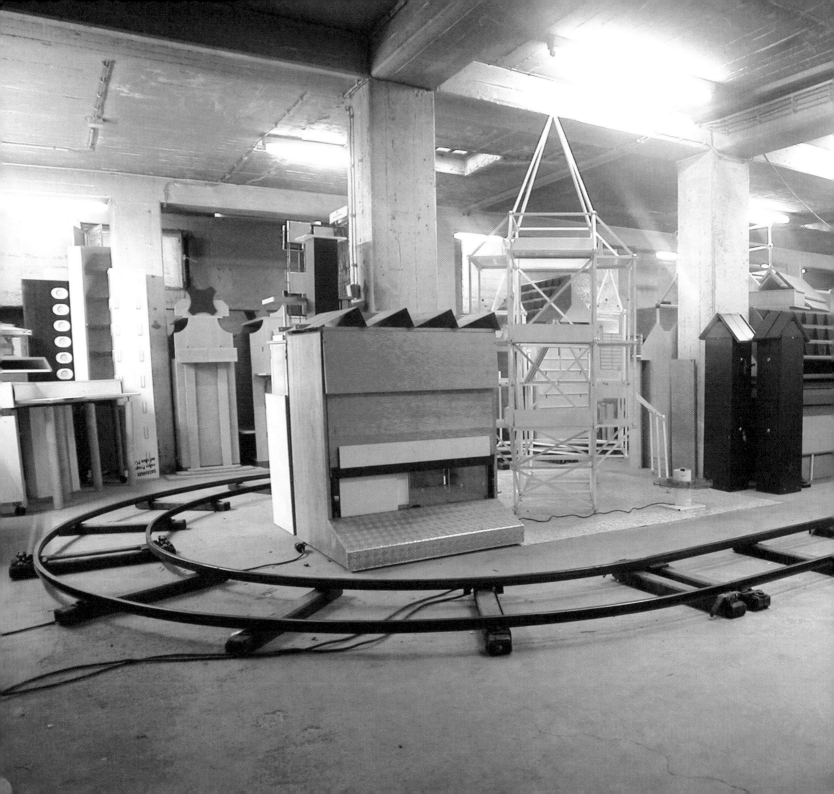

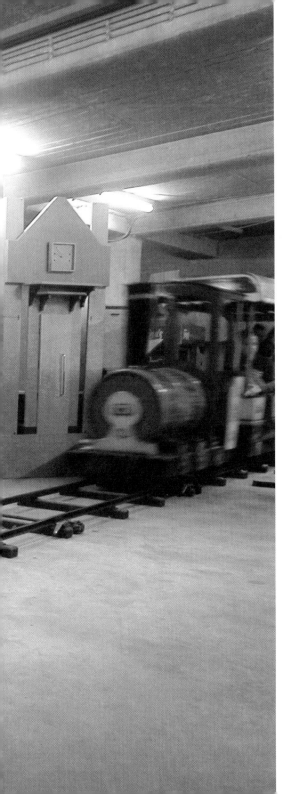

Rosapark

Fairground ride in Rosastrasse, Kunstverein Freiburg, 2005
Stock room equipment, shelf systems, electric train
150 sq.m.

In the former stock room of a bookshop, *Rosapark* offers the residents of Freiburg a 150-square-metre space where they can be visitors to their own city.
Shelves, displays and racks from the bookshop are transformed into a miniature model of downtown Freiburg. On a railway tour through this miniature cityscape, visitors have the opportunity to get an outsider's perspective of their own familiar environment. In this way, residents are able to view their own city through the lens of a tourist's camera.
Rosapark is based on the successful concept of the nearby ‹Europa-Park›, Germany's most visited tourist attraction after Cologne Cathedral.
Taking a cue from event-based city marketing campaigns, the residents' hometown is turned into a theme park and a destination that cannot be ruined by bad weather.

Fahrgeschäft in der Rosastrasse, Kunstverein Freiburg, 2005
Lagerutensilien, Regalsysteme, Elektrozug
150 qm

In dem ehemaligen Lagerraum einer Buchhandlung bietet *Rosapark* den Bürgern Freiburgs auf 150 Quadratmetern die Möglichkeit, zu Gast in ihrer eigenen Stadt zu sein.
Regale, Displays und Aufsteller der Buchhandlung werden zu einem Miniaturmodell der Freiburger Innenstadt transformiert. Bei einer Eisenbahn-Rundfahrt durch diese komprimierte Stadtmöbellandschaft erhalten die Besucher die Möglichkeit, einen Blick von außen auf ihre gewohnte Umgebung zu werfen. Der eigene Wohnort gerät in den touristischen Autofokus. *Rosapark* orientiert sich an dem Erfolgskonzept des benachbarten ‹Europa-Park›, Deutschlands meist besuchter Sehenswürdigkeit nach dem Kölner Dom.
Im Sinne eines erlebnisorientierten Städtemarketings wird die Heimatstadt zum Themenpark und zum wetterunabhängigen Kurzreiseziel.

Freiburg carnival ride
Fahrgeschäft Freiburg

Preliminary sketch
Konzeptskizze

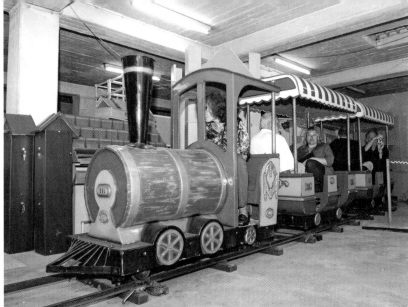

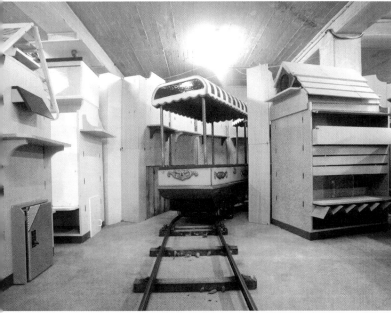

Aerial lift in Freiburg | Schloßbergseilbahn

Train tour through the city model | Eisenbahn-Rundfahrt durch das Stadtmodell

Area around the main station in Freiburg | Bahnhofsviertel Freiburg

Freiburg's historical city centre | Altstadt Freiburg

Freiburg cathedral | Freiburger Münster

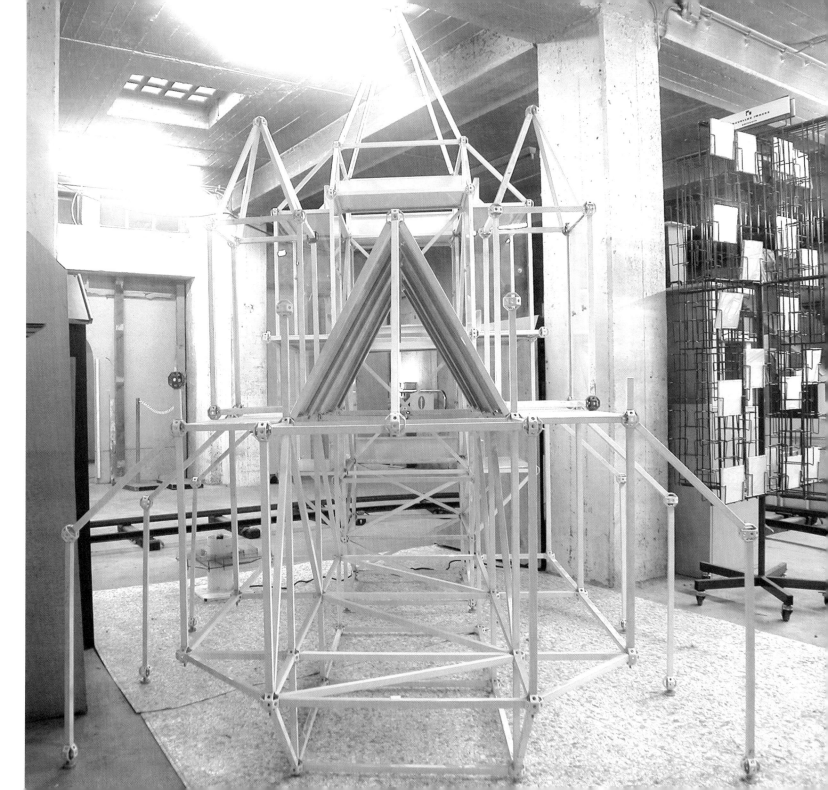

erikaLand

Michael Boehler / Franz Hoefner / Harry Sachs

Façade landscape, Werkleitz-Festival, Halle / Saale 2008
Pavilion tent, oilcloth tablecloths, birdhouses, insulation panels, jeans, camouflage netting, cellar doors, brick-patterned wallpaper, roof battens, balloons, mattresses

This large-scale sculpture which cloaks the buildings of the *Werkleitz Festival* is dedicated to America. It is composed of recycled and raw materials, timber, laminated wood, DIY materials, jeans and East German imitation jeans. It is a façade that recalls a Western film set. Following the principle of the game ‹Chinese whispers›, this juxtaposition piece shows what remnants of America exist in West and East Germany in the form of a distilled version of the New World: *erikaLand*.

Employing a down-home pioneering spirit and mixing white trash with allotment garden aesthetics and East German ‹Plattenbau› high-rise blocks with cowboy romance, an interpretation is built of the traces, influences and images that the United States of America has created and left behind in the reunified Germany. An independent national utopia takes shape behind the latticed jeans fence and camouflage hedge.

A mixture of ‹Take it easy, altes Haus› by the West German country-rock band Truck Stop and of the imagined Americana in the stories of German writer Karl May, who came from the area around Dresden that later on was one of the areas in the GDR where western TV could not be received.

Fassadenlandschaft, Werkleitz-Festival, Halle / Saale 2008
Pavillonzelt, Wachstischdecken, Vogelhaus, Dämmplatten, Jeanshosen, Tarnnetze, Kellertüren, Ziegeldekortapete, Dachlatten, Luftballons, Matratzen

Die Amerika gewidmete Großskulptur, deren Vokabular sich aus Recyclingmaterialien bzw. Sekundärrohstoffen, ‹timber wood› bzw. Sprelacart, Jeans bzw. ‹Doppelkappnahthosen› und DIY bzw. Heimwerkermaterialien zusammensetzt, verkleidet das Gebäudekonglomerat des Festivals.
Es entsteht eine Fassadenlandschaft ähnlich einer Westernfilmkulisse. Nach dem ‹Stille Post Prinzip› zeigt dieses Versatzstück auf, was von Amerika in West- bzw. Ostdeutschland als Kondensat der Neuen Welt übrig bleibt: das *erikaLand*
In White-Trash-Schrebergartenästhetik und Plattenbau-Westernromantik wird mit gemütlichem Pioniergeist eine Interpretation dessen gebaut, was die Vereinigten Staaten von Amerika im vereinigten Staat von Deutschland an Spuren, Einflüssen und Visionen geschaffen und hinterlassen haben. Hinter Jeansjägerzaun und Camouflagehecke entwickelt sich eine eigene Staatsutopie.
‹Take it easy altes Haus›, frei nach Karl May: ‹Das Tal der Ahnungslosen›.

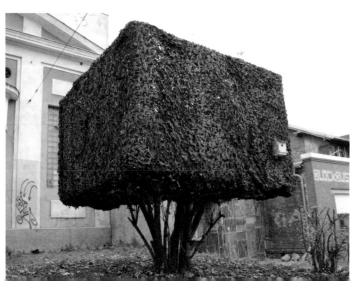

White birdhouse on camouflaged bush
Weißes Vogelhaus an getarntem Busch

Jeans lattice fence in front of façade with stars-and-stripes insulation
Jeans-Jägerzaun vor Fassade mit Flaggendämmung

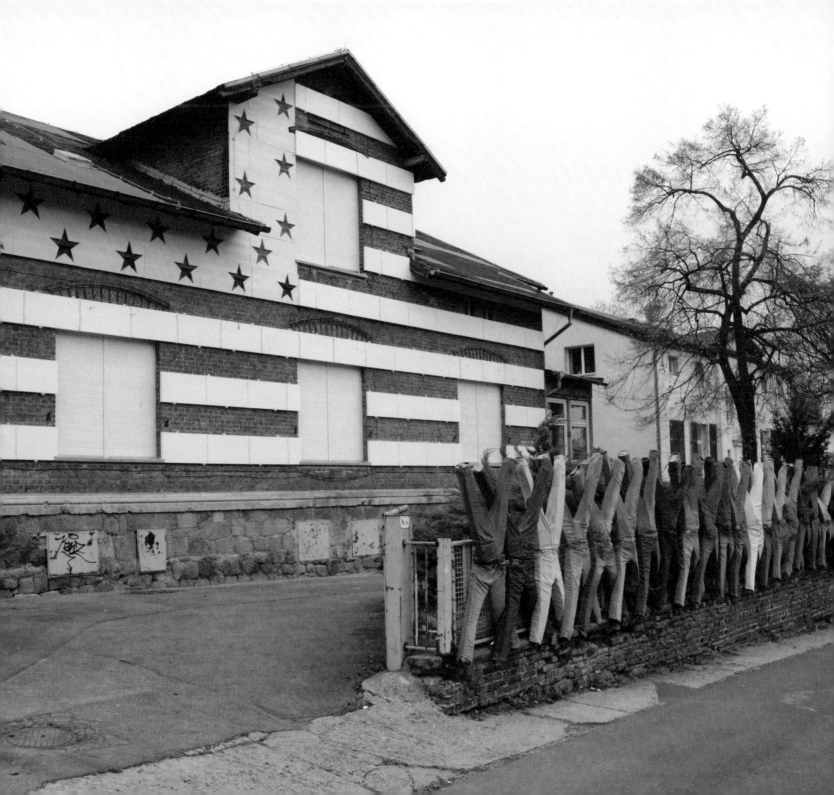

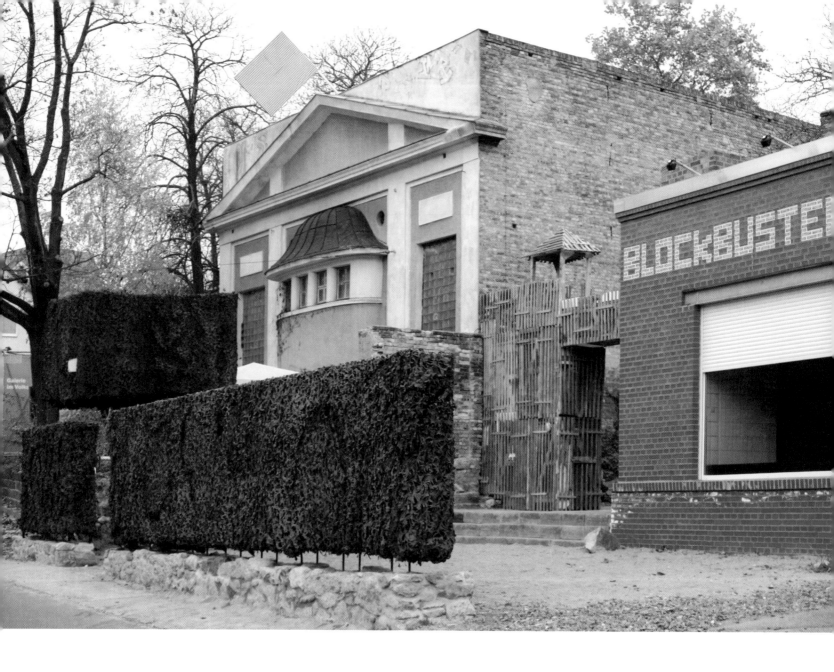

White House with tablecloth flag, Camouflaged hedge, Blockbuster with brick-pattern wallpaper
Das Weiße Haus mit Tischdeckenfahne, Camouflagehecke aus Tarnnetzen, Blockbuster aus Ziegeltapete

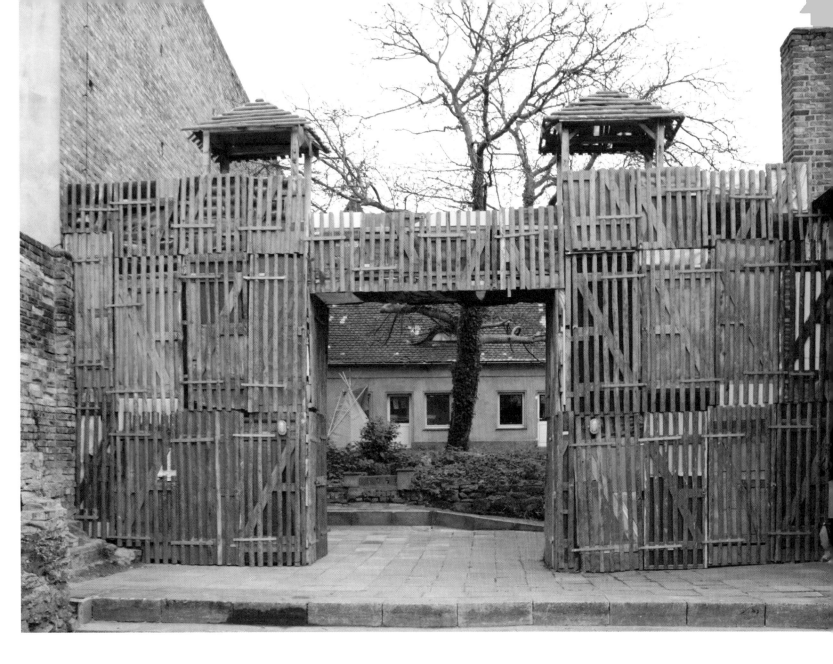

Fort made from basement doors
Fort aus Kellertüren

Forum Arcaden

Sample floor of a new shopping mall, Kunstverein Gera, 2008
Cardboard, watercolour, window mannequins, plaster, marble PVC flooring
120 sq.m.

Many commercial and retail buildings lie empty in the main square of Gera, a city in central Germany, ever since shopping malls robbed the square of its raison d'être. Now the two existing shopping centres, ‹Gera Arcaden› and ‹Elsterforum›, are about to get some competition from a third mall, *Forum Arcaden*, which is to be built next door, directly on the baroque market square.

A mock floor of *Forum Arcaden* is installed in the local Kunstverein (Art Association), which is located next to the proposed construction site. The office of the art space is transformed into the mall's management and information centre. Sections of the mall's layout are constructed with cardboard and displayed throughout the historical exhibition space. ‹Mall art›, in the form of watercolours of chain store logos and other pictogram signs from the competing shopping centres, adorns the walls. Sounds recorded at the other malls are played to provide an appropriate ambiance with realistic background noise.

The biblical figure of Samson, who can be seen battling a lion in the fountain on Gera's market square, now appears as ‹Samson in the Temple of Consumerism›. Heated discussions of the controversial new development take place in the local media.

Musteretage eines Einkaufzentrums, Kunstverein Gera, 2008
Wellpappe, Wasserfarbe, Schaufensterfigur, Gips, Marmor-PVC
120 qm

Die Innenstadt Geras wird von einem hohen Leerstand an Gewerberäumen geprägt und hat ihre ursprüngliche Funktion in weiten Teilen an die neuen Shopping Malls abgegeben. Zusätzlich zu den beiden konkurrierenden Einkaufszentren ‹Gera Arcaden› und ‹Elsterforum› sollen nun in direkter Nachbarschaft die *Forum Arcaden* als dritte Shopping Mall auf dem Grundriss des barocken Marktplatzes etabliert werden.

Die Musteretage der *Forum Arcaden* wird im örtlichen Kunstverein installiert, der unmittelbar an das künftige Baugrundstück grenzt. Das Büro des Kunstvereins wird zum Centermanagement und Infopoint umgebaut. Mit Pappe werden Ausschnitte der baulichen Struktur der *Forum Arcaden* in die historischen Räume implantiert. Sämtliche Handelsketten und Hinweisschilder der beiden bereits existierenden Shopping Malls werden als Shopping Malerei in Kopie mit Wasserfarben gemalt. Zur Untermalung wird die Geräuschkulisse der benachbarten Einkaufszentren abgespielt.

Die historische Samson-Figur, die auf dem Geraer Marktplatz in einer Darstellung als Löwenbezwinger steht, wird in der Musteretage als ‹Samson im Konsumtempel› nachgebaut.

In den lokalen Medien wird über das anstehende Entwicklungsvorhaben kontrovers berichtet.

Samson in the Temple of Consumerism | Samson im Konsumtempel

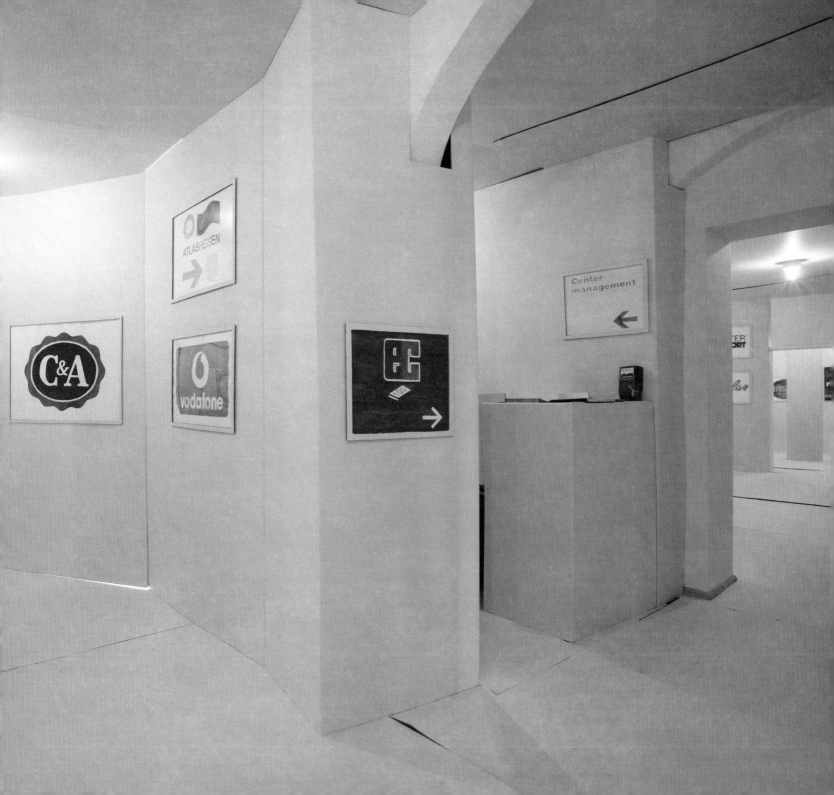

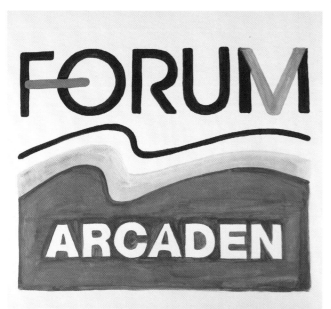

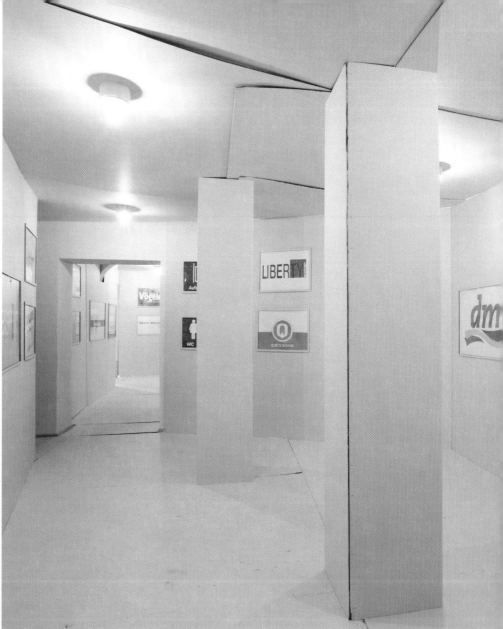

Forum Arcaden shopping mall, architect's impression of the new building on Gera's market square
Shopping Mall *Forum Arcaden*, Projektion des Bauvorhaben auf dem Marktplatz Gera

Chain stores, watercolours on paper
Handelsketten in Wasserfarbe auf Papier

Interieur

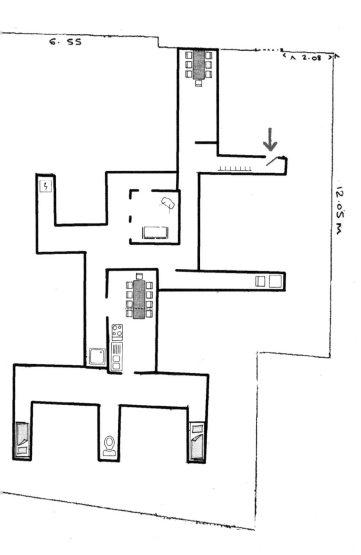

Walk-in wall piece, Faux Mouvement – Centre d'art contemporain,
Metz (France) 2004
Particleboard, white paint, wallpaper, carpet, furnishings and
home accessories
20 x 15 x 4 m, 13 rooms, 70 sq.m.
Video 12 min

A system of white walls is constructed in the exhibition space. No artworks
can be seen, but visitors to the gallery may discover a plain white door
which leads into the space inside the walls. Within this space, visitors dis-
cover a concealed, fully furnished apartment, which, although very
confined, contains a living room, conservatory, wine cellar, library, work-
shop, ironing room, fitness studio and sauna.
This ‹negative› space in the exhibition room offers a welcome refuge from
the sombre atmosphere of a White Cube, and opens up a secret, private
world which can be used collectively by caretakers, security staff, visitors,
the gallery owners' families and the artists themselves.

Begehbare Wandarbeit, Faux Mouvement – Centre d'art contemporain,
Metz (Frankreich) 2004
Spanplatten, weiße Farbe, Tapeten, Teppiche, Einrichtungsgegenstände
und Wohnaccessoires
20 x 15 x 4 m, 13 Räume, 70 qm
Video 12 min

In die Ausstellungshalle wird ein konventionelles System aus neutralen
weißen Wandkörpern gebaut. Bei dem Gang durch die leeren Kabinette
findet der Besucher keine Exponate vor, kann aber eine eingelassene
Tür entdecken, die ihn in das Innere der weißen Wände führt. In der
Zwischenwelt des White Cubes findet er sich in einer komplett eingerichteten
Einliegerwohnung wieder, welche auf kleinstem Raum über einen Salon,
einen Wintergarten, einen Weinkeller, eine Bibliothek, einen Arbeitsraum,
ein Bügelzimmer, einen Fitnessraum und eine Sauna verfügt.
Der Negativraum der Ausstellungsarchitektur stellt dem exklusiven Kunst-
ambiente ein gemütliches Refugium gegenüber und eröffnet eine ver-
borgene Privatwelt, die in häuslicher Gemeinschaft von Hausmeister,
Aufsichtspersonal, Ausstellungsbesucher, Galeristenfamilie und Künstler
zwischengenutzt werden kann.

Floor plan | Grundrisszeichnung

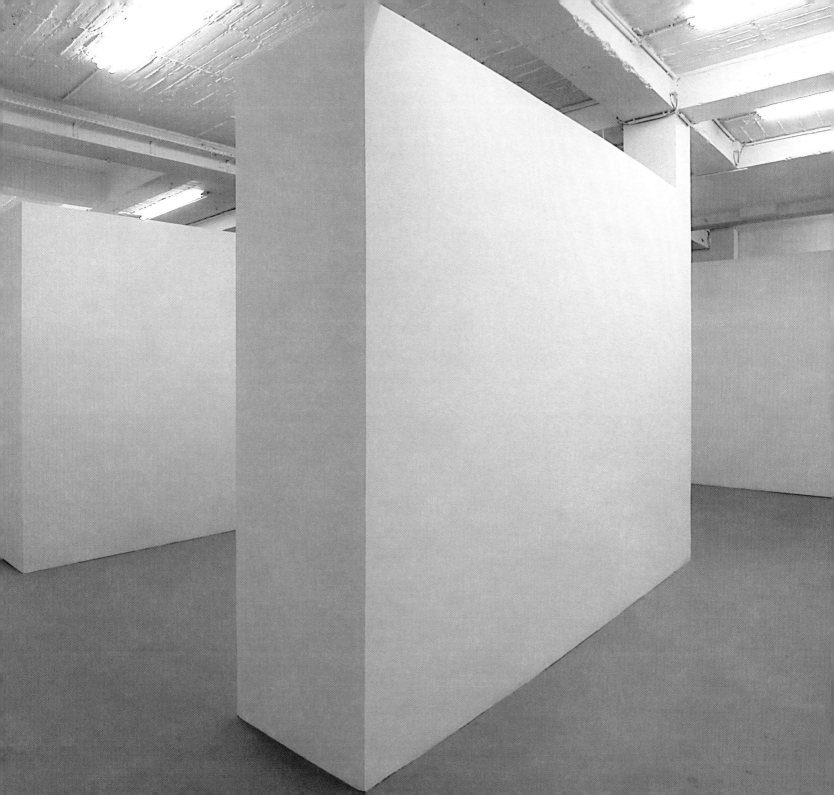

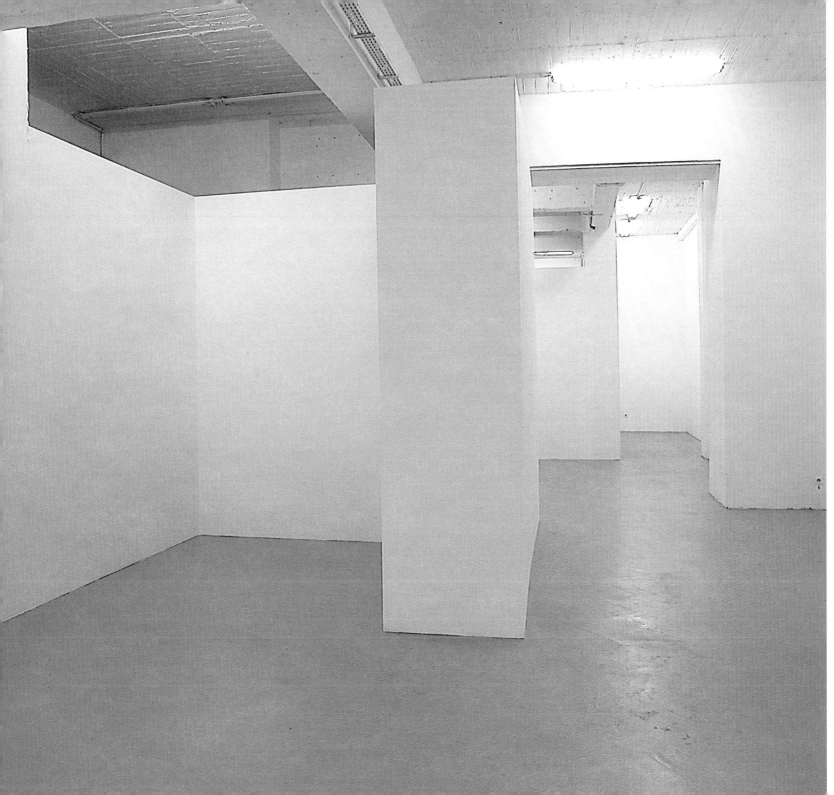

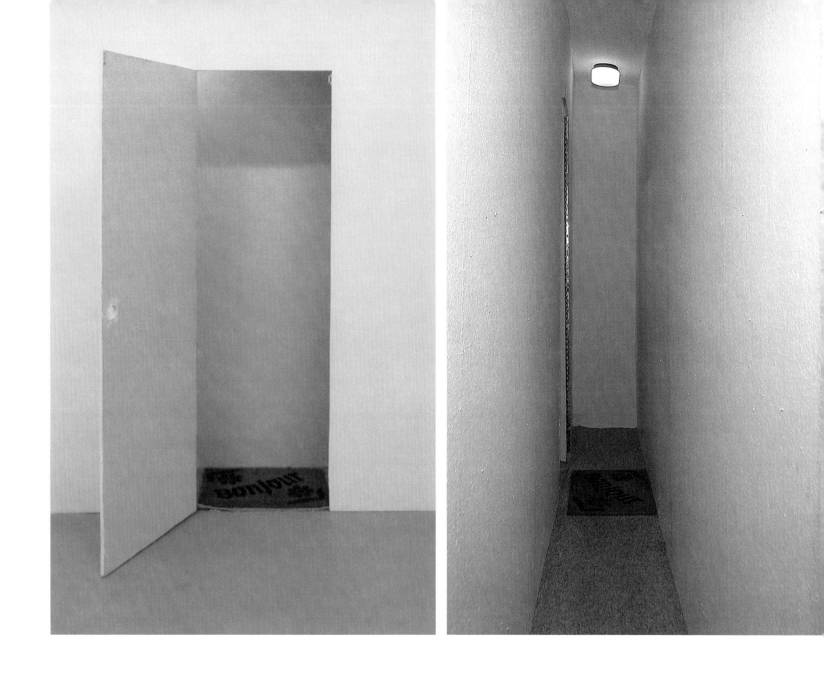

Entrance | Eingang Corridor | Korridor

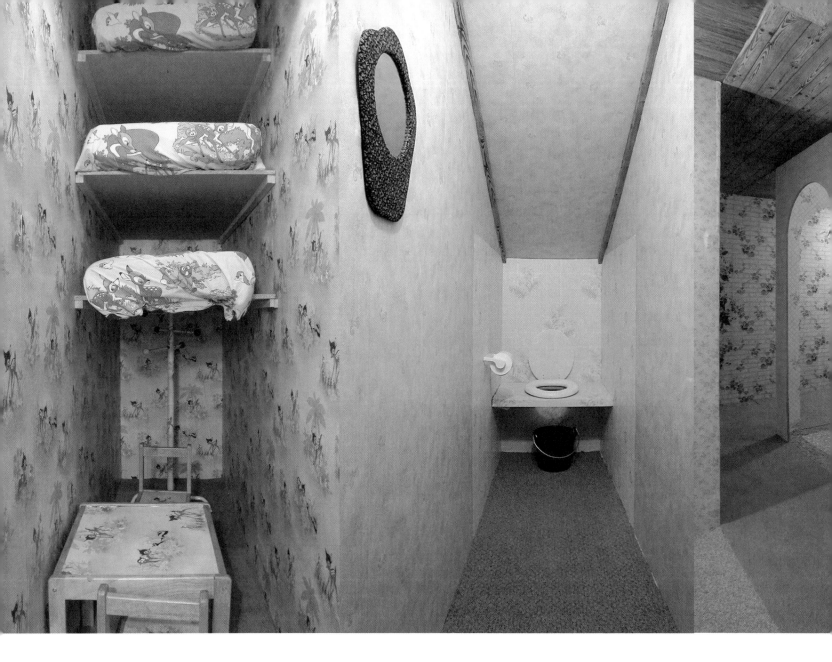

Children's room | Kinderzimmer Toilet | Toilette Conservatory | Wintergarten

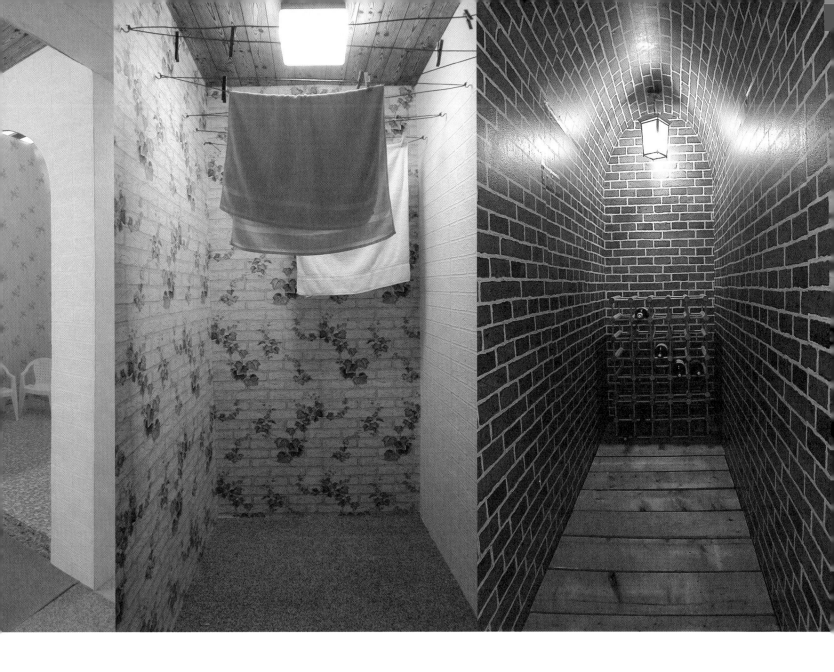

Laundry room | Waschküche

Wine cellar | Weinkeller

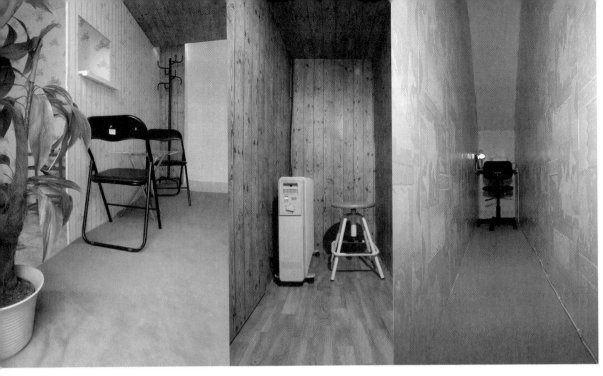

Living room | Wohnzimmer
Sauna | Sauna
Office | Arbeitszimmer

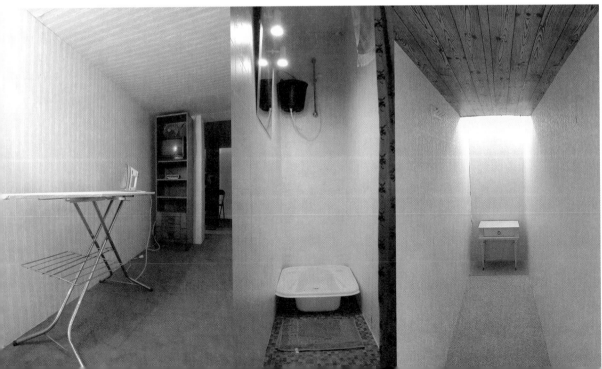

Ironing room | Bügelzimmer
Bathroom | Badezimmer
Bedroom with raised bed | Schlafzimmer mit Hochbett

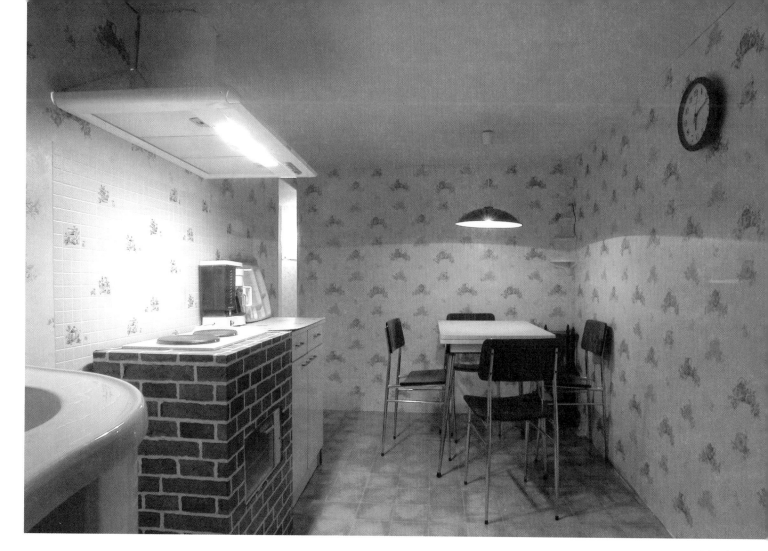

Kitchen | Küche

Interior decor | Ausstattungsdetails

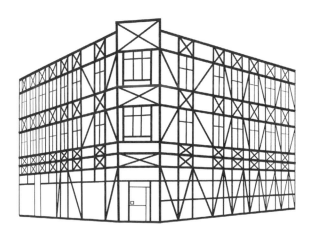

Rückbau

Historical building, Galerie invaliden1, Berlin 2007
Drywall, Venetian blinds, candles, spirits, aerated concrete blocks

In *Rückbau (Deconstruction)*, the exhibition space is transformed into a pseudo-historical location, a monument of itself, to mark the impending demolition of the building where the gallery itself is located.

Geometric shapes are sawn out of the walls, leaving a framework similar to that of a traditional German ‹timber house›. The cut-outs are then hung on the adjacent walls, creating the same ‹timber frame› in negative. Square shapes are cut from the gallery's Venetian blinds to let in light, and to create the impression of old-style window frames. A candelabrum is sawed out of the panels of the drop ceiling. Heat is provided by an open fireplace.

Baudenkmal, Galerie invaliden1, Berlin 2007
Gipskartonwände, Jalousien, Kerzen, Spiritus, Porenbetonsteine

Anlässlich des bevorstehenden Abrisses des Gebäudes wird in der Galerie eine denkmalwürdige Raumsituation geschaffen, die den Ausstellungsraum in einen fiktiven historischen Zustand versetzt.

Aus den bestehenden Trockenbauwänden werden geometrische Segmente ausgesägt und die Negativformen auf die gegenüberliegenden Wände übertragen, so dass sich ein fragiles Fachwerk ergibt. Für die Lichtversorgung werden quadratische Löcher als Fensterkreuze in die Jalousien eingeschnitten. Aus den Paneelen der abgehängten Decke wird ein Kerzenleuchter gesägt. Geheizt wird mit einem offenen Kamin.

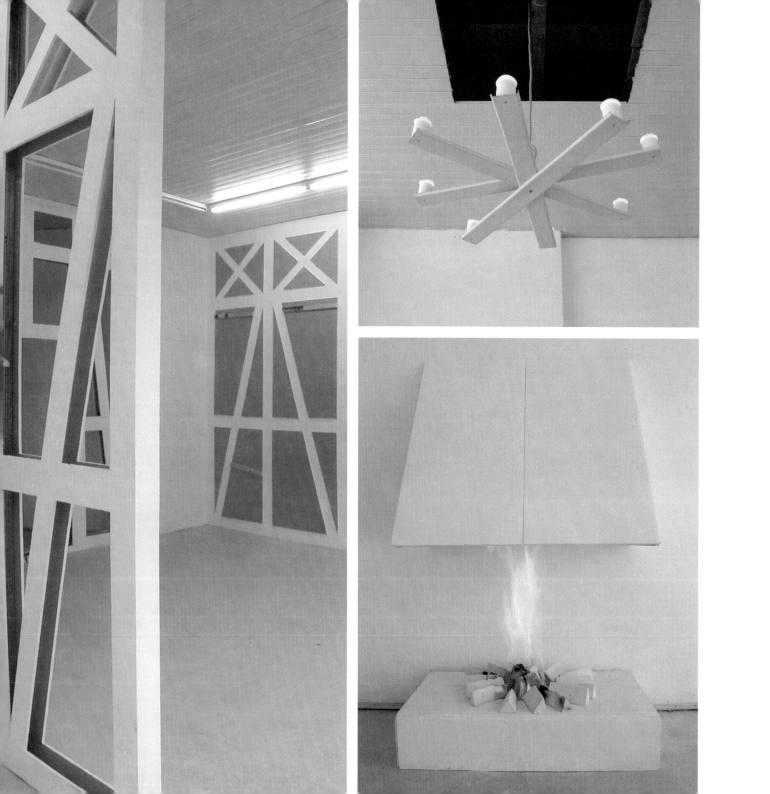

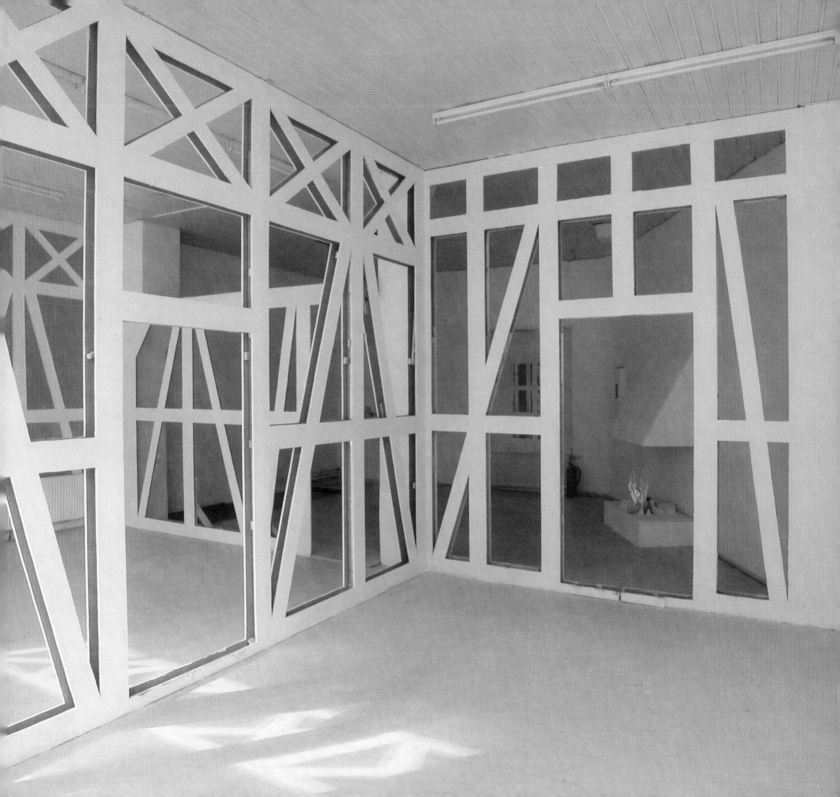

Row House

Perspective sculpture, deptfordX, London (Great Britain) 2004
Chipboard, brick-relief wallpaper, PVC roofing
10 x 3 x 4 m
Housing Program video, 9 min loop

A closet for a public toilet, the only construction in an otherwise empty exhibition hall, is cloned to form a repeating series with incrementally reducing sizes. Each new closet is built onto the side of the one before it, seamlessly connected with brick-relief wallpaper. Extending across the room, the construction intimates a white row house. The video, *Housing Program,* shows the construction of the installation and plays with the viewer's perception of space: shifting camera angles mean that the individual closets shown always appear the same size on the screen, whereas the construction workers look bigger or smaller in comparison. *Row House* is thus a public toilet, architectural model, sculpture and film set all in one.

Perspektivskulptur, deptfordX, London (Großbritannien) 2004
Spanplatte, Ziegelstrukturtapete, PVC-Dachplatten
10 x 3 x 4 m
Video *Housing Program*, 9 min loop

Ein Toilettenraum, der als einziger Einbau in der leeren Ausstellungshalle vorhanden ist, wird in regelmäßig sich verjüngenden Dimensionen mehrfach kopiert und zu einer weißen Reihenhauszeile ausformuliert.
Die tapezierten Anbauten setzen die Bausubstanz aus weiß getünchten Backsteinmauern nahtlos fort. Das Video *Housing Program* zeigt den Aufbau der Installation in rhythmischer Verschiebung. Die Raumwahrnehmung wird aufgelöst, indem sich in der anscheinend immer gleichen Einstellung die Größe der Protagonisten ständig verändert: *Row House* ist dadurch zugleich Besuchertoilette, Architekturmodell, Skulptur und Filmset.

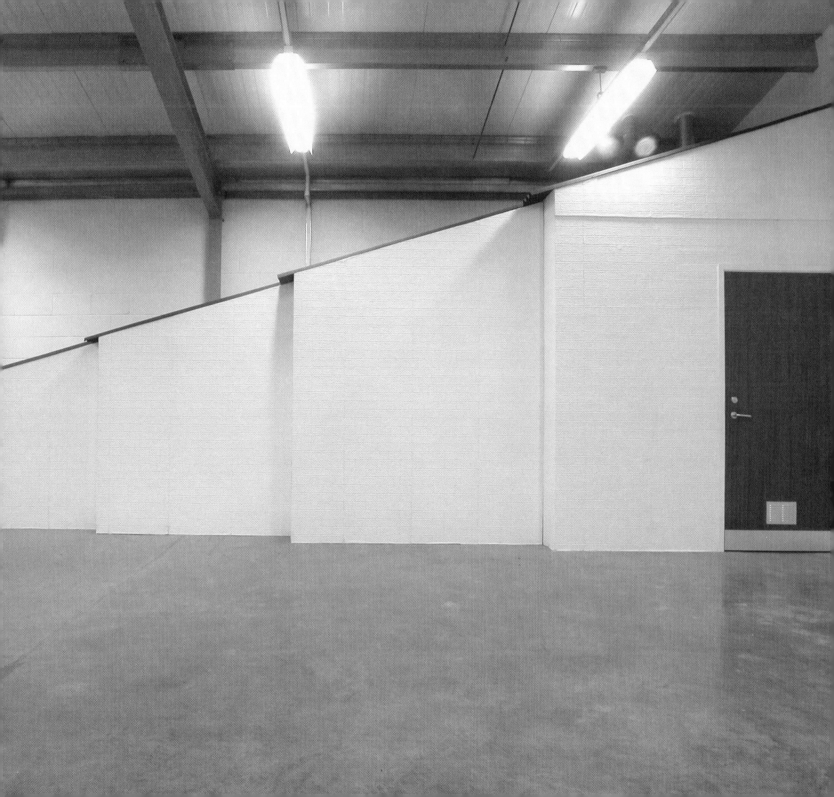

Privat

Underground apartment, Galerie Engler & Piper, Berlin 2004
Door, exterior light, doormat, drywall, entire contents of basement
8 rooms, 100 sq.m.
Video 12 min

The gallery's exhibition space is empty, apart from a simple construction in
the corner. A door, doorbell and doormat all suggest that this is the entrance
to a private home. Visitors who pass through this door can descend into the
gallery's basement, where they will discover a newly furnished apartment
for the gallery owners, Andreas Engler and Edmund Piper.
Previously, the basement was full of all sorts of junk, evidence of someone's
penchant for hoarding old objects. The objects are now tidied up and
rearranged according to a unifying concept. Similar to a garbologist, who
tries to identify the habits of previous generations by searching through
their rubbish, the artists reconstruct the private lives of the gallery owners
from the objects found in their basement. The intimate objects are employed
to furnish an eight-room apartment, which functions as a sort of personality
profile – partly fictitious, but at the same time personal and private.

Souterrainwohnung, Galerie Engler & Piper, Berlin 2004
Tür, Außenlampe, Fußabstreifer, Gipskartonwände, kompletter Bestand
des Kellers
8 Zimmer, 100 qm
Video 12 min

Die Ausstellungsräume der Galerie sind leer, bis auf einen architektonischen
Einbau, der mit Tür, Klingel und Fußabstreifer den Anschein einer Privat-
wohnung erweckt. Durch die Wohnungstür gelangt man in die Kellerräume
der Galerie und findet sich in der neu angelegten Souterrainwohnung der
Galeristen Andreas Engler und Edmund Piper wieder.
Der vorgefundene, komplett voll gestellte Keller, der die Sammelleiden-
schaft der Besitzer offenbart, wird aufgeräumt, geordnet und in einen
neuen Sinnzusammenhang gebracht. Ähnlich der Arbeit eines Garbologen,
der investigativ im Müll vergangener Epochen forscht, wird anhand aller
Fundstücke das Privatleben der beiden Galeristen rekonstruiert. Die intime
Spurensuche trägt in acht Zimmern psychogrammartig eine Wohnungs-
einrichtung zusammen, die zwar fiktiv ist, aber dennoch persönlich, bezie-
hungsweise privat.

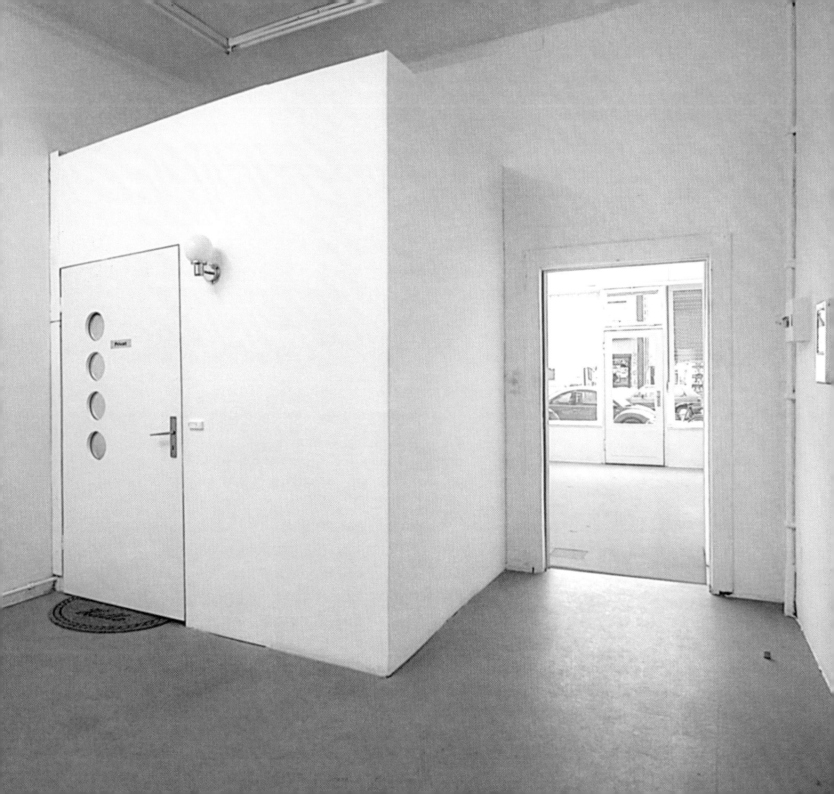

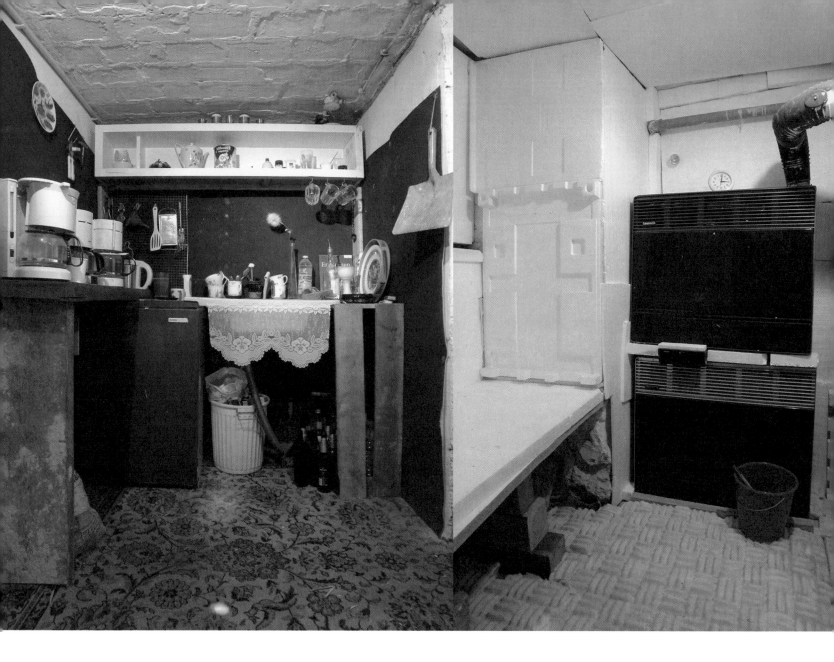

Kitchen | Küche

Sauna | Sauna

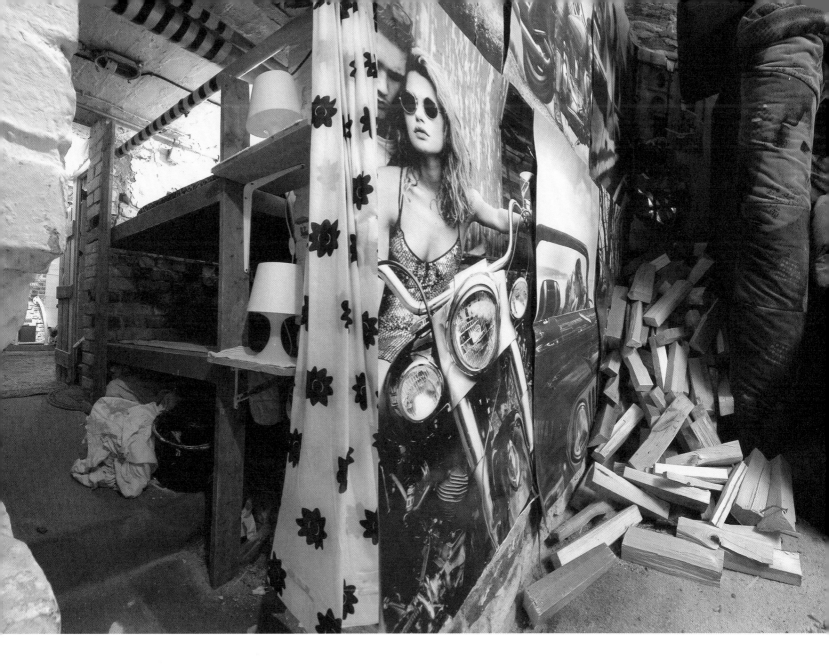

Bedroom | Schlafzimmer

Open fireplace | Offener Kamin

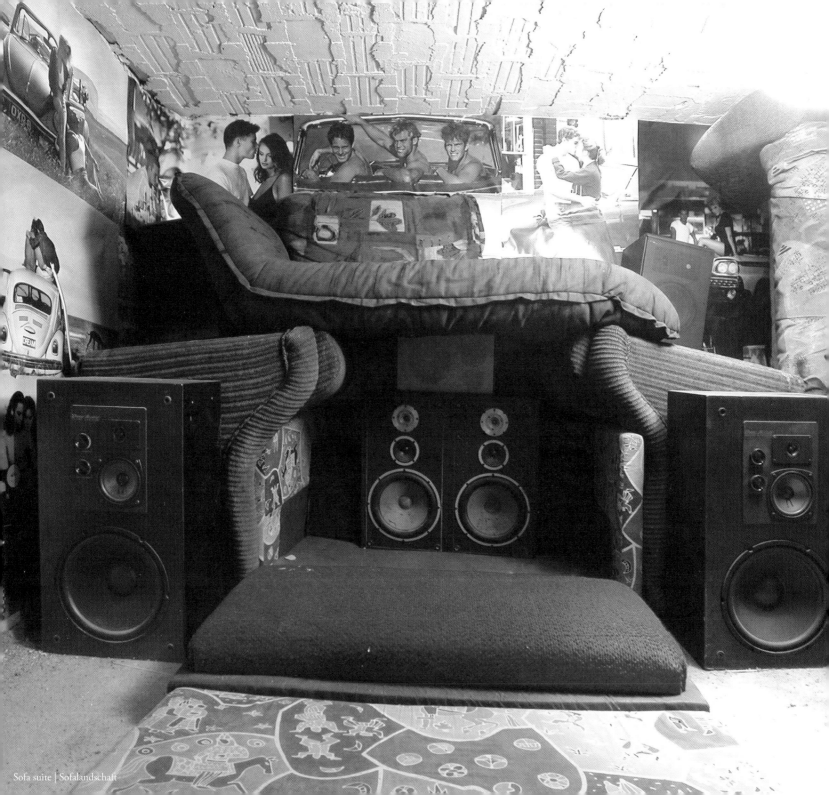

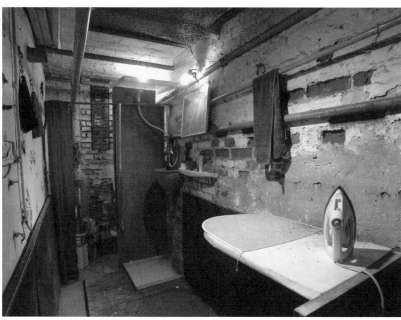

Lounge chair | Clubsessel Wall-mounted clock | Wanduhr Entrance area to conservatory | Eingangsbereich Wintergarten

Bathroom | Nasszelle Conservatory | Wintergarten

Tag Collector

--

Collective wall piece, Galerie Wendt+Friedmann, Berlin 2006
Spray paint on tile-relief wallpaper
40 sq.m. / 100 x 140 cm

White-tiled wallpaper covers the outside of a gallery's windows and doors. Passers-by can no longer see into the exhibition rooms. After a few days, the tags of graffiti artists begin to appear. One month later, the wallpaper is removed from the windows to be displayed inside the gallery. The street art is surreptitiously stolen from the street and mounted on the other side of the windows, creating a variation on ‹reverse glass painting›.

--

kollektive Wandarbeit, Galerie Wendt+Friedmann, Berlin 2006
Sprühtechnik auf Ziegeltapete
40 qm / 100 x 140 cm

Fenster und Türen der Galerie werden von außen mit weißer Ziegeltapete zugemauert, wodurch die Ausstellungsräume für Passanten nicht mehr einsehbar sind. Nach kurzer Zeit entstehen erste Tags von Straßenkünstlern. Nach einem Monat werden die Tapeten von den Fensterscheiben abgelöst und der permanenten Sammlung der Galerie übergeben. Die entstandene Street Art wird heimlich von der Straße gestohlen und als Hinterglasmalerei konserviert.

Hausen

City model, Kunstverein Göttingen, 2006
Rabbit figures, electric motors, plywood, paint
2 x 2 m

In *Hausen (Rabbit homes)*, a model of a resident-friendly housing estate is domesticated by three mechanical rabbits who look like over-sized, mutated garden gnomes. Within the context of the rampant growth of suburbia, the motor-driven rabbits gesticulate wildly with their arms and heads, grappling with the question of the right form of dwelling.

Stadtmodell, Kunstverein Göttingen, 2006
Hasenfiguren, Elektromotoren, Sperrholz
2 x 2 m

Eine Siedlung scheinbar artgerechter Einfamilienhäuser wird von drei Hasenfiguren domestiziert, die in Größe und Form wie mutierte Vorgartenzwerge erscheinen. Vor dem Hintergrund zunehmender Suburbanisierung erörtern die mit Kopf und Armen elektrisch gestikulierenden Hasen zwischen den Häusern die Frage nach der richtigen Behausung.

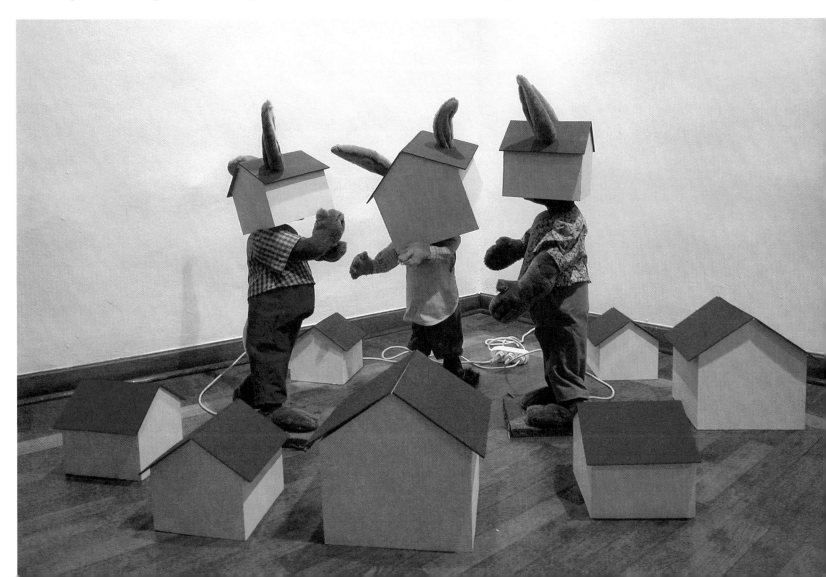

Sanierungsmaßnahmen

New real estate, Galerie Wendt+Friedmann, Berlin 2007
Haus der Vorstellung, Torstrasse 166, Berlin 2008
Corner sinks and bathtubs, taps, drywall, tiles, plywood, woodchip wallpaper,
PVC flooring and aerated concrete blocks

Refurbished apartments often feel more like some sort of a mass-produced
‹laminated hell› rather than being the elegant old apartments that they once
were. Nowadays, techniques in construction and renovation are generally dic-
tated by standardisation and cost-efficiency. As a result, the apartments behind
the facades of old buildings have become largely interchangeable. Within this
disposable, hardware-store style, materials are employed that will never age
well or develop their own patina. These materials can assume only one of two
discrete states: ‹brand new› or ‹old and broken›.
Sanierungsmaßnahmen (Refurbishment measures) breathes new life into these
materials and grants them a narrative new-building patina. They are modelled
into architectonic structures, and, as sacral-transcendental objects, they convey
something of the spirit of the residents who have been displaced and driven out
by modernisation and the resulting higher rents.

Neubau, Galerie Wendt+Friedmann, Berlin 2007
Haus der Vorstellung, Torstrasse 166, Berlin 2008
Eckwaschbecken, Eckbadewannen, Wasserhähne, Gipskartonplatten, Fliesen,
Laminat, Raufasertapete, PVC-Boden, Porenbetonsteine

Sanierte Wohnungen fühlen sich oft mehr nach normierter ‹Laminathölle›
als nach Altbau an. Zeitgenössisches Bauen folgt bei der Modernisierung in der
Regel standardisierten ökonomischen Prinzipien, wodurch die Wohnungen
hinter den Altbaufassaden austauschbar werden. Im Rahmen dieses Baumarkt-
klassizismus werden Materialien implantiert, die nicht patinafähig sind. Sie
kennen nur die Zustände neu und unversehrt oder alt und kaputt.
Sanierungsmaßnahmen haucht diesen Materialien Leben ein und dichtet ihnen
eine narrative Neubaupatina an. Sie werden zu architektonischen Kompositionen
modelliert. Als sakral-übersinnliche Objekte transportieren sie den Geist der
durch die Modernisierung verdrängten Bewohner.

Ae ' concrete block campfire | Ytong-Lagerfeuer
P\ ck lettering | PVC-Steinschrift
L: e dome | Laminat-Kuppel PVC marble column | PVC-Marmorsäule

Woodchip wallpaper mural | Raufaser-Wandbild

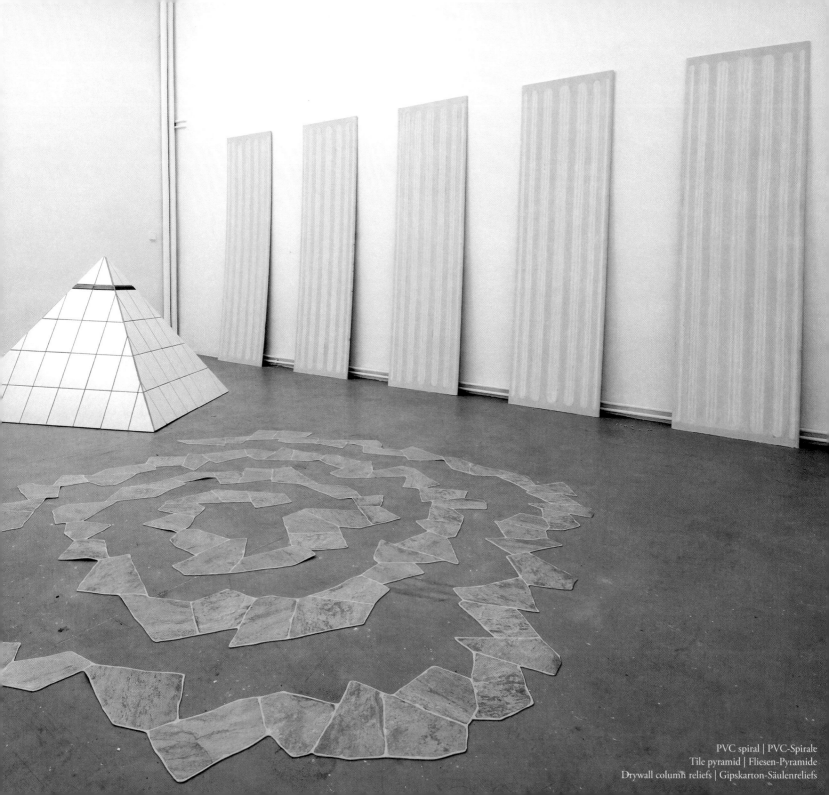

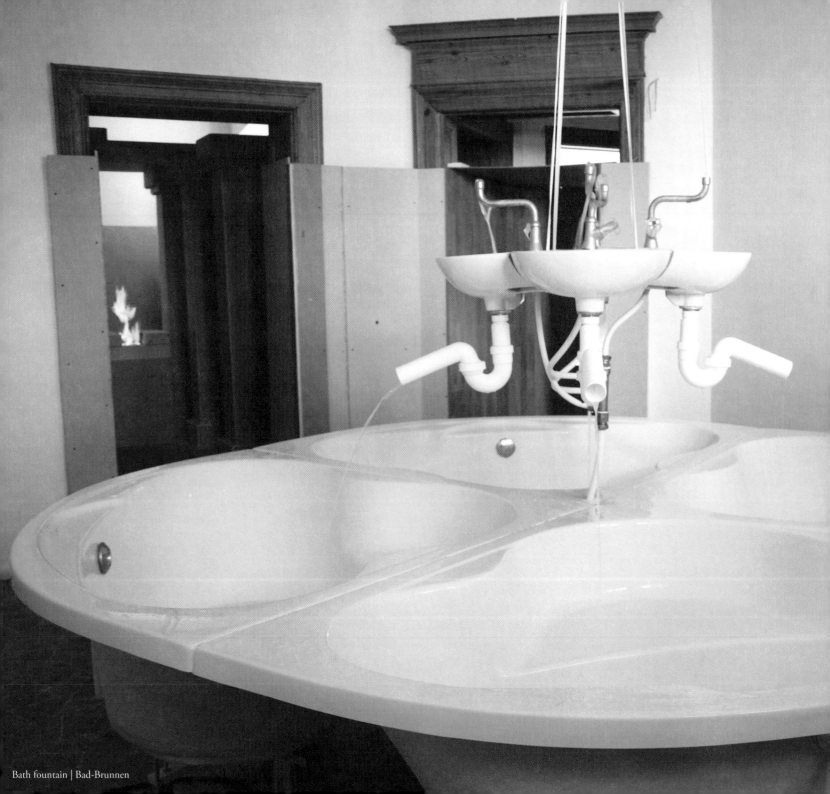

Bath fountain | Bad-Brunnen

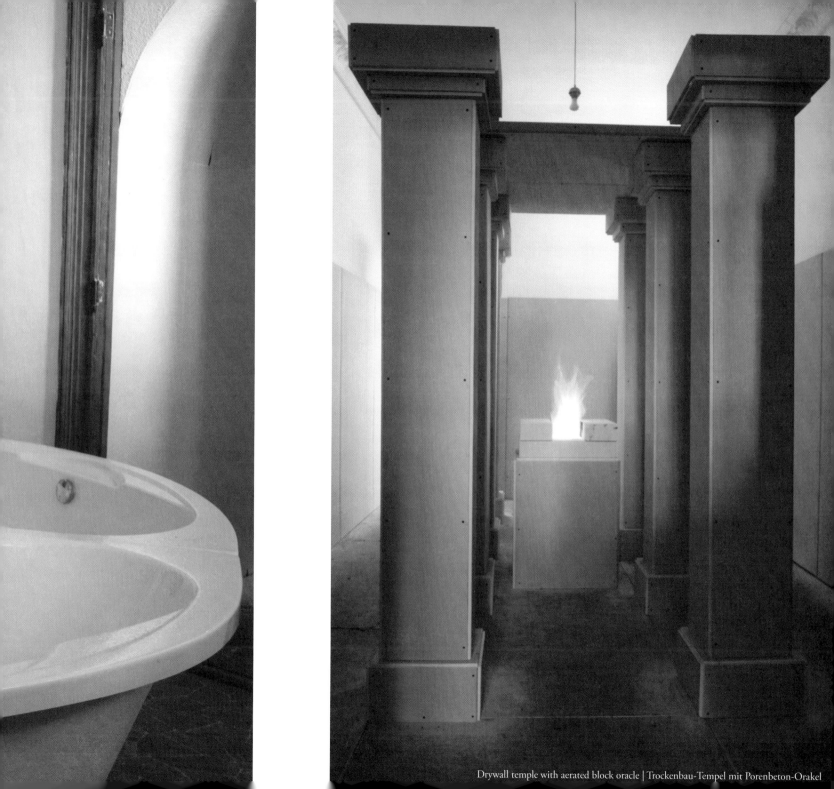

Drywall temple with aerated block oracle | Trockenbau-Tempel mit Porenbeton-Orakel

Heimkino

Furniture living room, Galerie Maerz, Linz (Austria) 2004
2 wall units, televisions, photographs
4 x 2 x 2 m
Video program with works including *Housing Program, Musterhäuser (Showhouses),
Neuhaus (New building), Privat, Interieur, Utrechter Huette (Utrecht hut)*

Two wall units, one from East Germany and one from West Germany, stand face-to-face.
On the outside, the two units form a minimalist cube with monochrome ochre tones.
On the inside, accessible through a flap at the side, a reunified German *Heimkino (Home
cinema)* can be enjoyed. In this miniature living room, a series of videos on the subject
of homes and better living is shown; stills from the videos are framed and displayed be-
hind glass, acting as domestic ‹trailers›.
Over the decades, the living room, once an elegant salon and the centre of social inter-
action in the home, has been increasingly subjugated by the television. As part of today's
home cinema and accompanied with specially designed furniture, the TV is a colourful
window onto the world and forms the centrepiece of our living rooms, around which all
other items of furniture must be arranged.

--

Schrankwohnzimmer, Galerie Maerz, Linz (Österreich) 2004
2 Schrankwände, Fernseher, Fotografien
4 x 2 x 2 m
Filmprogramm mit den Arbeiten *Housing Program, Musterhäuser, Neuhaus, Privat,
Interieur, Utrechter Huette*

Zwei Schrankwände, die jeweils aus der ehemaligen DDR und der BRD stammen, rücken
näher zusammen. Nach außen formieren die Schrankrückwände einen minimalistischen
Kubus in monochromen Ockertönen. Im Inneren befindet sich, durch eine seitliche
Klappe begehbar, ein gesamtdeutsches *Heimkino.* In dem minimalen Wohnzimmer
wird ein Filmprogramm aus Beiträgen zum Thema ‹Wohnwelten› gezeigt, das in den
Vitrinen durch gerahmte Programmhinweise und Standbilder ergänzt wird.
Das Wohnzimmer, einst repräsentativer Salon, ist über die Jahre zunehmend vom Fern-
sehen bestimmt worden. Vom Fernsehmöbel bis zum heutigen Kino im Heimformat
ist der Fernsehapparat ein buntes Fenster zur Welt, um das sich das restliche Mobiliar
gruppiert.

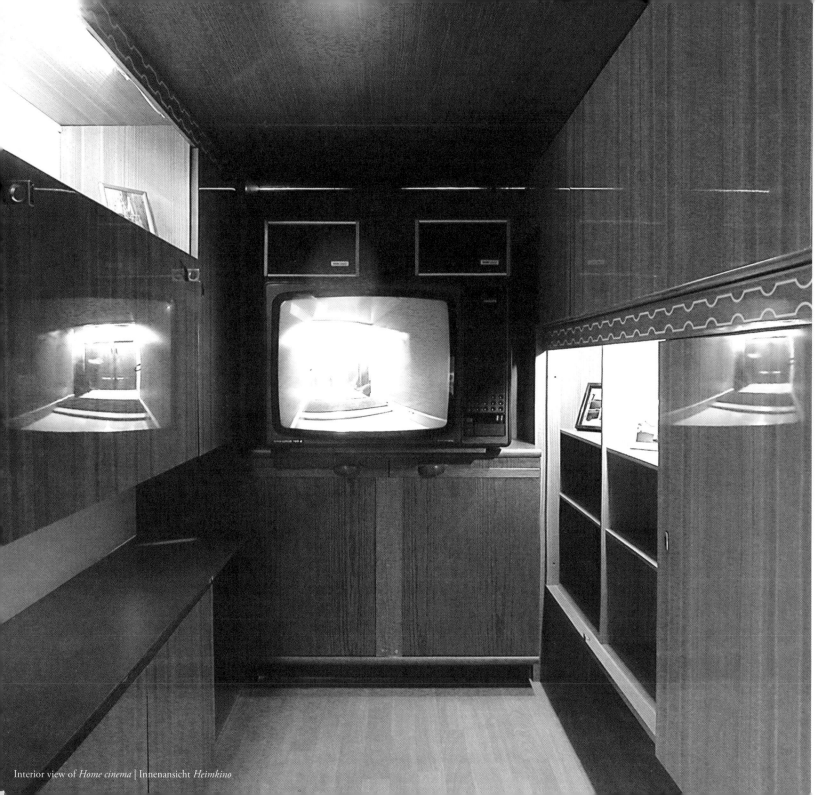

Interior view of *Home cinema* | Innenansicht *Heimkino*

Detail: *Mobiliar* photos on the display shelves | Detail: *Mobiliar* Fotografien in den Vitrinen

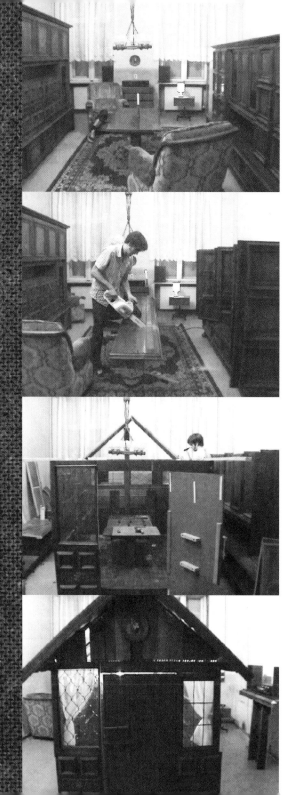

Utrechter Huette

Furniture house, lothringer13 Städtische Kunsthalle München, 2003
Wall unit with oak veneer, carpet, coffee table, ceiling lamp, television and
stereo system
2 x 3,5 x 2,2 m
Video 4 min loop, audio 3 min loop

The ‹Utrecht› wall unit is transformed into the *Utrechter Huette (Utrecht Hut)*
within the confines of a living room. Industrially fabricated period furniture
is disassembled by hand, sawed into pieces and reconstructed to form a historical
dwelling with timber framework profiling, crown glass and ornamental carv-
ings. The decorative cosiness and solidity of the furniture is captured and
transformed back into the archetypical original style of a rustic dwelling which
the furniture tries to suggest in the first place. After this transformation, the
centrepiece presents itself as a compact furniture house.

Möbelhaus, lothringer13 Städtische Kunsthalle München, 2003
Schrankwand (Eiche furniert), Teppich, Couchtisch, Deckenlampe, Fernseher
und Stereoanlage
2 x 3,5 x 2,2 m
Video 4 min loop, Audio 3 min loop

Auf dem Grundriss eines Wohnzimmers wird das Schrankwandensemble ‹Modell
Utrecht› zur *Utrechter Huette* umgebaut. Das industriell gefertigte Stilmöbel
wird in Handarbeit auseinandermontiert, zersägt und neu zu einem archaischen
Wohnhaus mit profiliertem Fachwerk, Butzenscheiben und Schnitzornamentik
zusammengefügt. Die dekorative Gemütlichkeit und Solidität des Möbels
wird in den von ihr suggerierten, archetypischen Urzustand einer rustikalen
Behausung zurückgeführt. Nach seiner Umwandlung zeigt sich das zentrale
Repräsentationsobjekt als kompaktes Möbelhaus.
Im Zeitrafferloop sieht man den wiederkehrenden Kreislauf zwischen Hütten-
architektur und Wohnzimmereinrichtung.

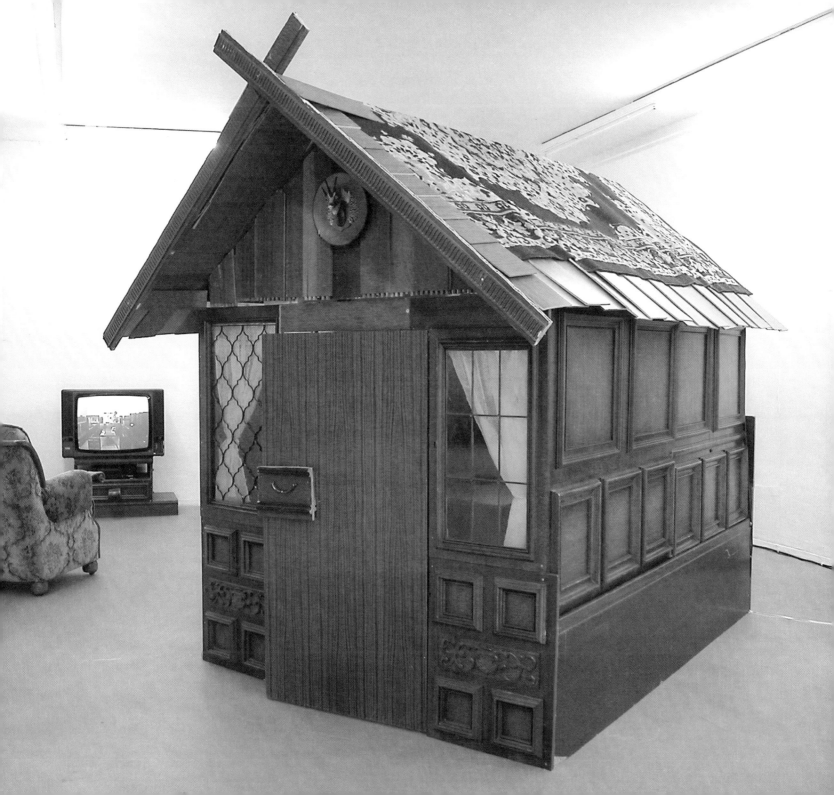

Schrankwand HöfnerSachs

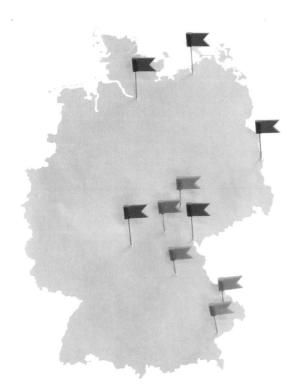

Wall cabinet units, Bundeskunsthalle Bonn, 1999
Wall units, televisions, stereo with favourite songs,
photographs, personal items
5 x 4 x 2m
Video 10 min loop, audio 18 min loop

The *Schrankwand HöfnerSachs (HöfnerSachs wall unit)* is analogous to scientific research carried out by Munich's Ludwig-Maximilian-Universität into the social perception of people's first names. The piece investigates how much people who share the same name actually have in common. Over the course of a two-week tour around Germany, eight people who share the same name, four Franz Höfners and four Harry Sachs, are visited in their living rooms. The field material collected in this empirical study is presented in two wall units as a pseudo social portrait. Televisions play videos of personal performances made with five of the subjects, while the hi-fi plays the individuals' favourite songs. Souvenirs and other personal items are displayed alongside framed portraits and transcripts of interviews which document the people's backgrounds, preferences and hobbies. Early in the journey, it became obvious that wall units were a common denominator among the subjects, providing a consistent background in each living room. Those visited often used their compact and homely wall units with built-in TVs and hi-fi's to display multimedia presentations of their own families. Hence, the wall unit is a fitting medium to display the results of this study about those who have the same name.

Franz Höfner, Paußing
Harry Sachs, Willersdorf

Franz Höfner, Seukendorf
Harry Sachs, Burgsinn

Franz Höfner, Schwickershsn.
Harry Sachs, Rostock

Franz Höfner, Weimar
Harry Sachs, Hamburg

Franz Höfner, Tüßling
Harry Sachs, Eisenhüttenstadt

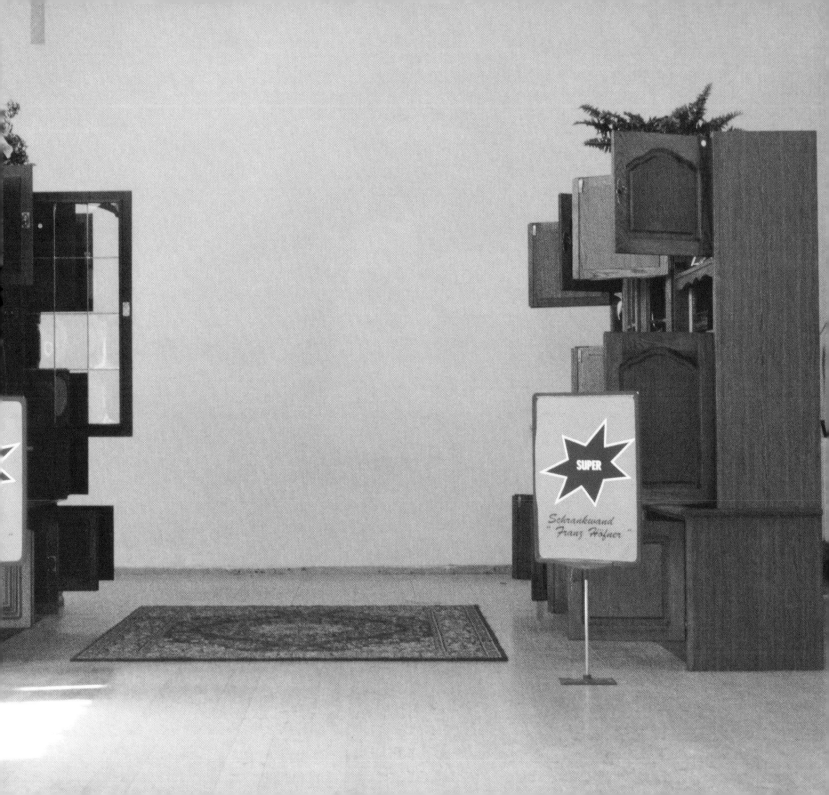

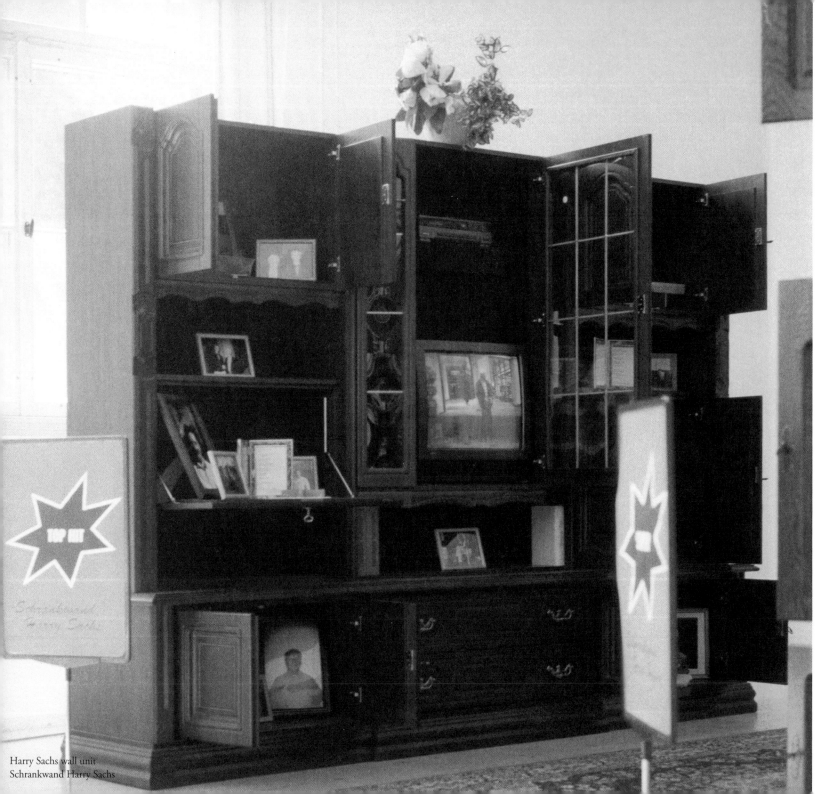

Harry Sachs wall unit
Schrankwand Harry Sachs

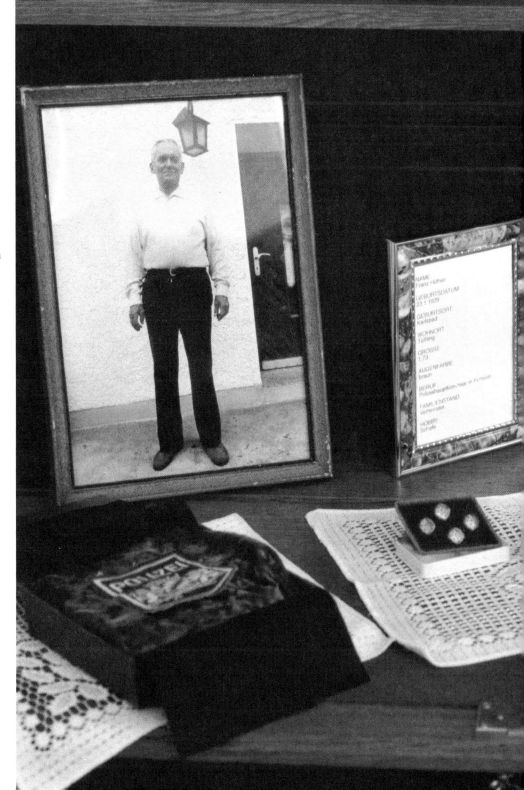

Schrankwandkabinett, Bundeskunsthalle Bonn, 1999
Schrankwände, Stereoanlage mit Lieblingsliedern,
Fernseher mit Videobeiträgen, Fotografien, persönliche
Ausstellungsstücke
5 x 4 x 2 m
Video 20 min loop, Audio 30 min loop

Analog zu einem wissenschaftlichen Forschungsprojekt der
Ludwig-Maximilian-Universität München, dass sich mit
der ‹sozialen Wahrnehmung von Vornamen› auseinander-
setzt, will die *Schrankwand HöfnerSachs* untersuchen,
inwiefern sich verschiedene Personen, die den selben Namen
tragen, ähnlich sind. Bei einer zweiwöchigen Reise durch
Deutschland werden jeweils vier Namensvetter von Harry
Sachs und Franz Höfner zu Hause in ihren Wohnzimmern
besucht. Das gesammelte Originalmaterial der empirischen
Studie wird als plastisches Sozialportrait in zwei Schrank-
wänden präsentiert.
Über Fernsehgeräte werden persönliche Videoperformances
der jeweiligen fünf Namenskollegen gezeigt und eine
Stereoanlage spielt ihre Lieblingslieder ab. Neben Porträt-
fotografien und gerahmten Interviews zu Herkunft,
Vorlieben und Hobbies sind Souvenirs und persönliche
Ausstellungsstücke zu sehen. Die Schrankwand stellt
bereits während der Deutschlandreise durch die verschiedenen
Wohnzimmer einen gemeinsamen Nenner als Hinter-
grundkulisse dar. Als heimisches kompaktes Möbelstück
mit integriertem Fernseher und Stereoanlage wird die
Schrankwand gerne zur multimedialen Ausstellung der
eigenen Familie verwendet und ist somit passender
Rahmen zur Präsentation der Namensverwandtschaft.

Franz Höfner wall unit, detail view
Schrankwand Franz Höfner, Detailansicht

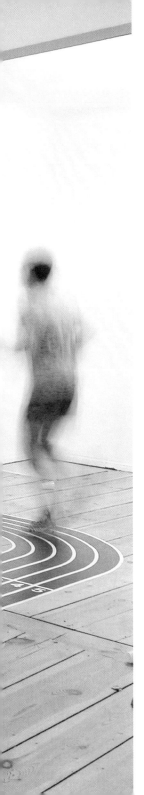

Home Run

Orbit track, Homie Galerie, Berlin 2005
PVC stickers, apartment furnishings
5 x 3 x 3 m, 1313 laps, 21 km, 2:09:15 h
Video 129 min loop

In a private apartment gallery, a 1:20-scale model of a stadium-style running track is installed. The 17-m track runs through the apartment's four rooms, hallway, and in and out through the stairwell. All of the furnishings in the apartment are stacked in the middle of the running track. Following the mathematical formula, *work = force x distance*, the gallery owner, Daniel Seiple, runs a half-marathon (21 km) around his possessions. He takes 2 hours, 9 minutes and 15 seconds for his home-workout, and in this time, becomes a satellite orbiting his earthly belongings, the Homie-sphere, in 1313 laps.

Umlaufbahn, Homie Galerie, Berlin 2005
PVC-Aufkleber, Wohnungseinrichtung
5 x 3 x 3 m, 1313 Runden, 21 km, 2:09:15 h
Video 129 min loop

In der Galeriewohnung wird im Maßstab 1:20 die Wettkampfbahn eines Leichtathletik-stadions installiert. Die 17 Meter lange Rundbahn durchläuft vier Zimmer und ein gerades Stück Treppenhaus. Alle Einrichtungsgegenstände der Wohnung werden im Innern des Laufradius aufgetürmt. Gemäß der Formel *Arbeit = Kraft x Weg* beginnt der Galerist Daniel Seiple, seinen komprimierten Besitz in Halbmarathondistanz (Strecke: 21 Kilometer) zu umkreisen. Er benötigt für seine Heimarbeit 2 Stunden, 9 min, 15 sec. Seine gesamte Liegenschaft wird zur Heimsphäre, um die er sich in 1313 Runden wie ein Trabant dreht.

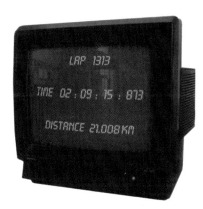

Lap counter | Rundenzähler

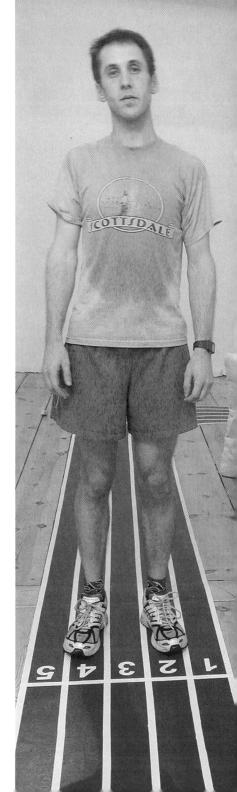

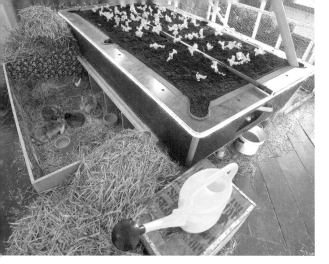

WG Tiergarten

Self-sufficient apartment, X-Wohnungen project,
Hebbel-Theater Berlin, 2005
UV lamps, mushrooms, peppers, cucumbers, tomatoes, potatoes,
lettuce, rabbits, chickens, and a goat
150 sq.m.

An apartment in the Berlin district of Tiergarten is transformed into
WG Tiergarten (Shared apartment), a self-sufficient living space with
vegetable plants and farm animals. Crops are planted on unused pieces
of furniture. Unoccupied floor space is turned into a field for efficient
farm activity. House-keeping becomes farm-keeping as the apartment's
decorative interior environment becomes home to sustainable agricul-
tural production.

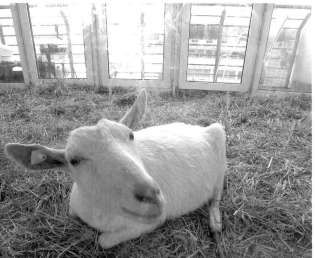

Selbstversorgungseinheit im Rahmen von X-Wohnungen,
Hebbel-Theater Berlin, 2005
UV-Lampen, Champignons, Paprika, Gurken, Zucchini, Tomaten,
Kartoffeln, Kopfsalat sowie Hasen, Hühner und eine Ziege
150 qm

Eine Wohngemeinschaft in Berlin-Tiergarten wird als *WG Tiergarten*
in eine autarke Selbstversorgungseinheit umgewandelt, die heimische
Nutzpflanzen und Nutztiere in die Infrastruktur der Wohnung integriert.
Unbenutztes Mobiliar wird bepflanzt und zuvor ungenutzte Wohn-
fläche verwandelt sich in einen effektiven landwirtschaftlichen Nutzraum.
Hauswirtschaft wird zur Agrarwirtschaft. Aus der dekorativen Wohn-
landschaft entsteht eine nützliche Kulturlandschaft.

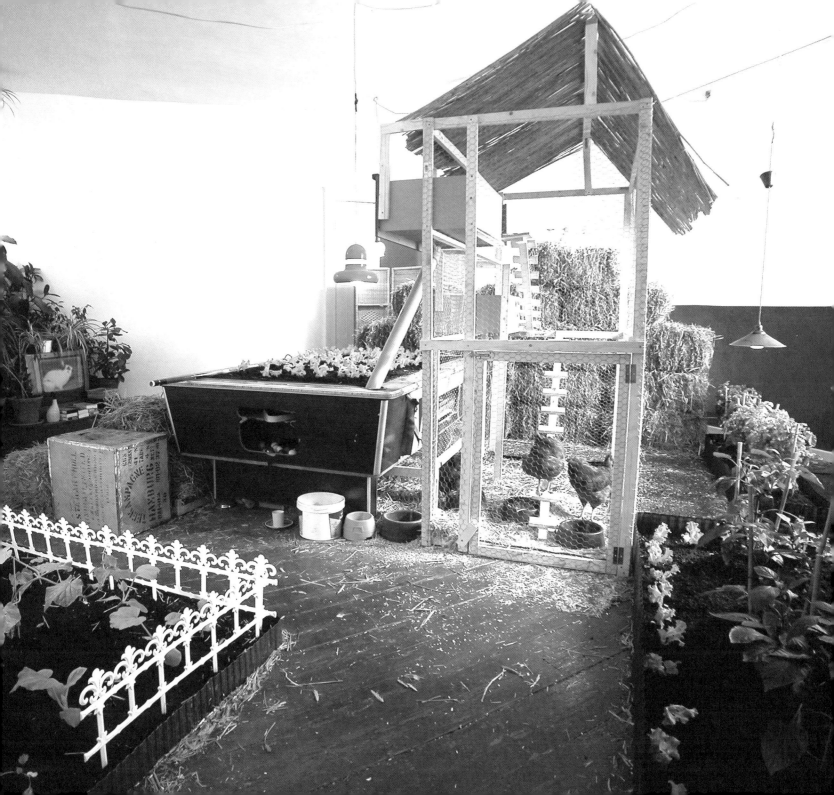

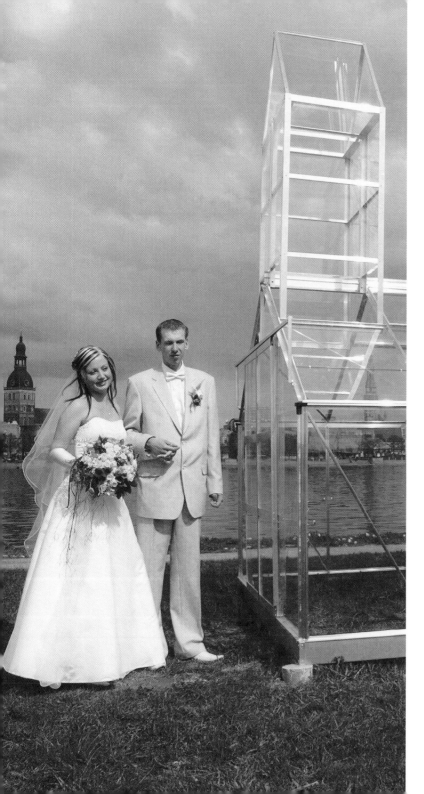

Gewächshaus Modell Riga

Botanic chapel, Culture and Arts Project NOASS, Riga (Latvia)
May–October 2008
Greenhouse, aluminium frames, Plexiglas, exterior lighting
6 x 2 x 4 m

With minimal structural alterations, an industrially manufactured greenhouse is transformed into *Gewächshaus Modell Riga (Greenhouse Model Riga)*, which has the shape of a chapel. Instead of just housing plants, it now becomes a public space for a wide range of groups and activities. The glass construction fits with the silhouetted background of the historical town centre. The chapel is located in a small park on a narrow protrusion into the river, locally referred to as ‹Love Island›. Newlyweds, who frequent this narrow strip to shoot wedding photos, now use the greenhouse chapel as a background. The chapel invites various functions. It provides shelter from the elements, is used as a tanning studio, and serves as a refuge for having a few beers with friends while escaping Riga's ban on drinking in public locations.

Botanische Kapelle, Culture and Arts Project NOASS, Riga (Lettland)
Mai–Oktober 2008
Gewächshaus, Aluminiumprofile, Acrylglas, Außenleuchten
6 x 2 x 4 m

Minimale formale Ergänzungen an einem industriell gefertigten Gewächshaus erweitern dessen Funktionsweise: In der Kontur einer Kapelle wird es vom einfachen Aufenthaltsraum für Pflanzen zu einem öffentlichen Raum unterschiedlicher Nutzergruppen.
Der gläserne Bau korrespondiert mit der Silhouette der gegenüberliegenden historischen Altstadt und befindet sich auf einer schmalen parkähnlichen Landzunge im Fluss, die im Volksmund auch als ‹Love Island› bekannt ist. Das Glashaus dient Hochzeitspaaren, die traditionell für Fotoaufnahmen auf den Landstreifen kommen, als Vordergrundkulisse. Wahlweise schützt es vor dem Wetter, wird als Bräunungsstudio genutzt, oder ist aufgrund des Alkoholverbots im öffentlichen Raum ein Ort für gesellige Zusammenkünfte.

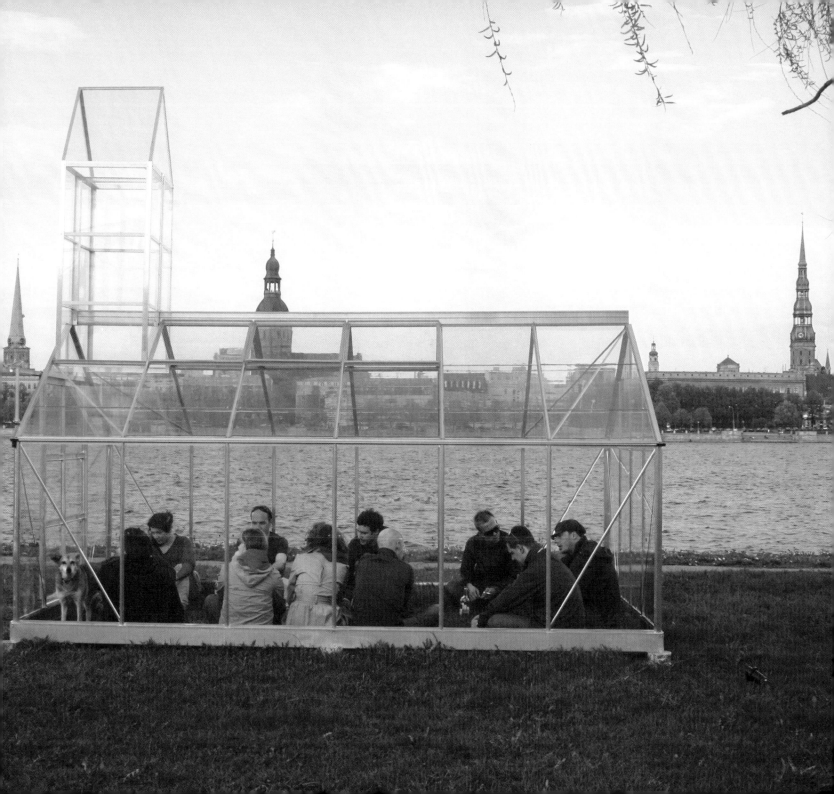

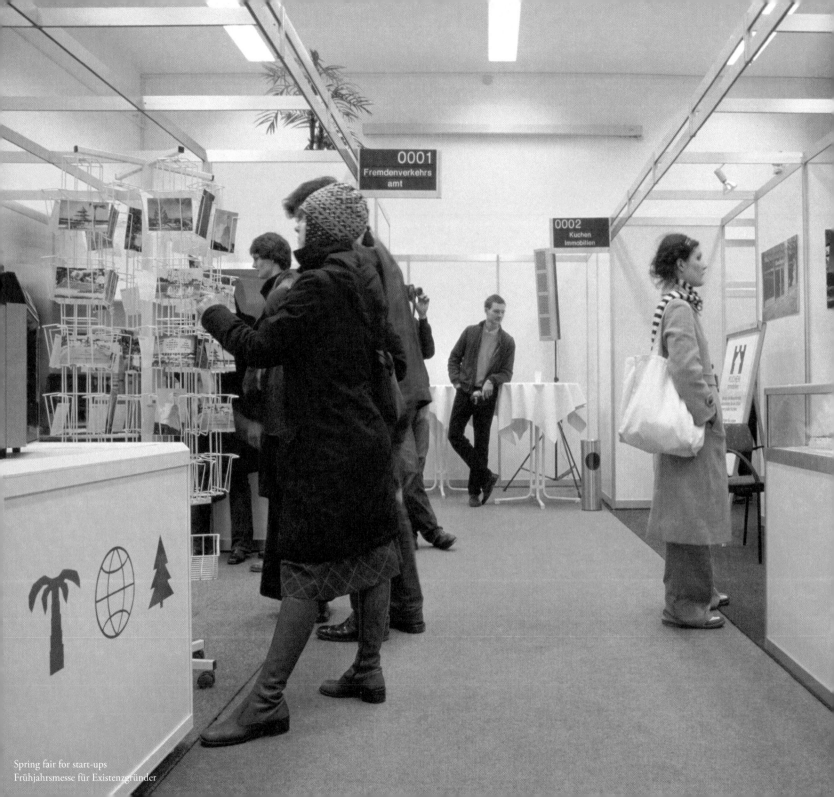

0001
Fremdenverkehrs
amt

0002
Kuchen
Immobilien

Spring fair for start-ups
Frühjahrsmesse für Existenzgründer

Neueröffnungen

2000–2003
Berlin, Hamburg, Weimar (Germany), Rennes (France), Venice (Italy)

In the first year of the new millennium, increasing numbers of new companies are being started while, at the same time, other firms are going out of business. Against this background, the business premises of bankrupt companies are taken over as part of the *Neueröffnungen (Newly opened)* series. The business models of the failed companies are transformed into new commercial ideas: *Fontane Buch Service (Fontane book service)*, *Kuchen Immobilien (Kuchen real estate)* and *Fremdenverkehrsamt (International tourist board)*. These are complemented by the *Kunst im ökonomischen Rahmen (Art in an economic framework)* business start-up seminar in the Dorint Hotel in Weimar. A start-up trade fair is held in Hamburg in 2002 to present new business ideas. The activities of the *Fremdenverkehrsamt (International tourist board)* lead to further international ventures: the *Club Ibis* project in Rennes, France, from 2001 demonstrates how a hotel chain can optimise its visitor experience; in 2003, a new branch of the *Fremdenverkehrsamt* is opened in Hamburg's ‹Alsterhaus› department store; *Spiral Office* opens in 2003 in Venice, Italy, and dedicates itself to working on new forms of tourism.

2000–2003
Berlin, Hamburg, Weimar, Rennes (Frankreich), Venedig (Italien)

Im Kontext zunehmender Existenzgründungen und gleichzeitiger Firmenpleiten werden im Laufe des Milleniumjahres in Berlin Gewerbeimmobilien insolventer Unternehmen übernommen und die ursprünglichen Geschäftsmodelle in neue Geschäftsideen übertragen: *Fontane Buch Service*, *Kuchen Immobilien* und *Fremdenverkehrsamt*.
Ergänzend findet im Dorint Hotel Weimar das Existenzgründerseminar *Kunst im ökonomischen Rahmen* statt. In Hamburg wird 2002 eine Existenzgründermesse veranstaltet, auf der die neuen Geschäftsideen präsentiert werden. Aus der Tätigkeit des *Fremdenverkehrsamts* entwickeln sich internationale Folgeaufträge: Das Projekt *Club Ibis* in Rennes (Frankreich) im Jahr 2001 veranschaulicht eine Optimierung des Erlebnisbereichs der Hotelkette. 2003 wird im Hamburger Alsterhaus eine Filiale des *Fremdenverkehrsamts* eingerichtet. In Venedig (Italien) öffnet 2003 das *Spiral Office* und widmet sich der Arbeit an neuen touristischen Formen.

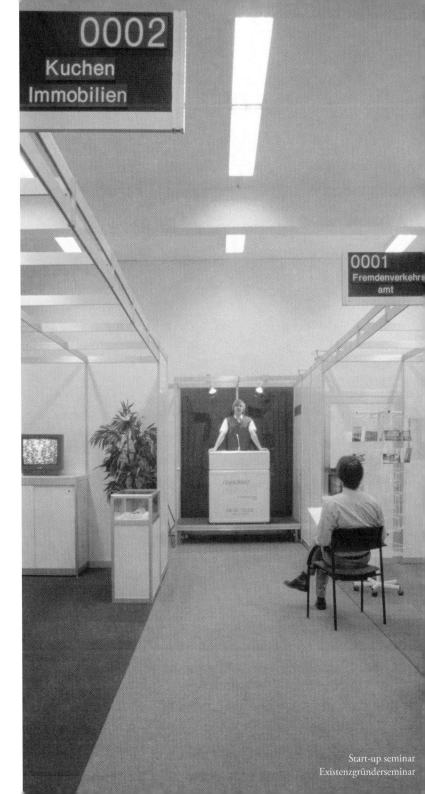

Start-up seminar
Existenzgründerseminar

Kuchen Immobilien

Newly Opened #2
Schönhauser Allee 188, Berlin August–October 2000
Showhouse exhibition, wall units made of chipboard, decorative and photo-image wallpaper, dummy office equipment, record player for pattern wallpaper LPs, ready-made cakes
With objects by Annekathrin Schreiber: *trousers* made of wood-pattern wallpaper, *negligee* made from silk wallpaper, *apron dress* with flower-pattern wallpaper, *cork tree* module system of cork wallpaper.
Videos: *Happy families* 3 min, *Sample wallpapers* 6 min, *Showhouses* 3 min loop

In the former premises of the kitchen store ‹Küchen Becker›, the *Kuchen Immobilien (Kuchen Real Estate)* property business is opened. The existing room layout is put to a new purpose.
Following the motto ‹Build within your own four walls – stay where you are, and your home will come to you›, *Kuchen Immobilien* anticipates the demands of the generation of townhouse dwellers in the years to come.
In its 100 square metre premises, *Kuchen Immobilien* has a wide variety of showhouses that can be rebuilt within the customer's own four walls.
Kuchen Immobilien guarantees: ‹Here, everyone can have their cake and eat it too›. Visitors are invited to enjoy a free slice of cake and receive individual consultation regarding house types in the showhouse estate. They can discover the five showhouse types for themselves: *Castle, Timber-frame design, Fort, Tower block* or *Tent*.
The noise from the wallpaper LPs incites visitors to dive in, feel and experience the surfaces and shapes of these dream homes which could soon be theirs. The synaesthetic spatial experience is completed by mimetic items of clothing by Annekathrin Schreiber, which are made from the construction materials of each of the houses.
Various specialist videos on the subject offer an iconographic analysis of happy, model families and dream houses. The lucky winner of a raffle can take home the indoor house of their choice.

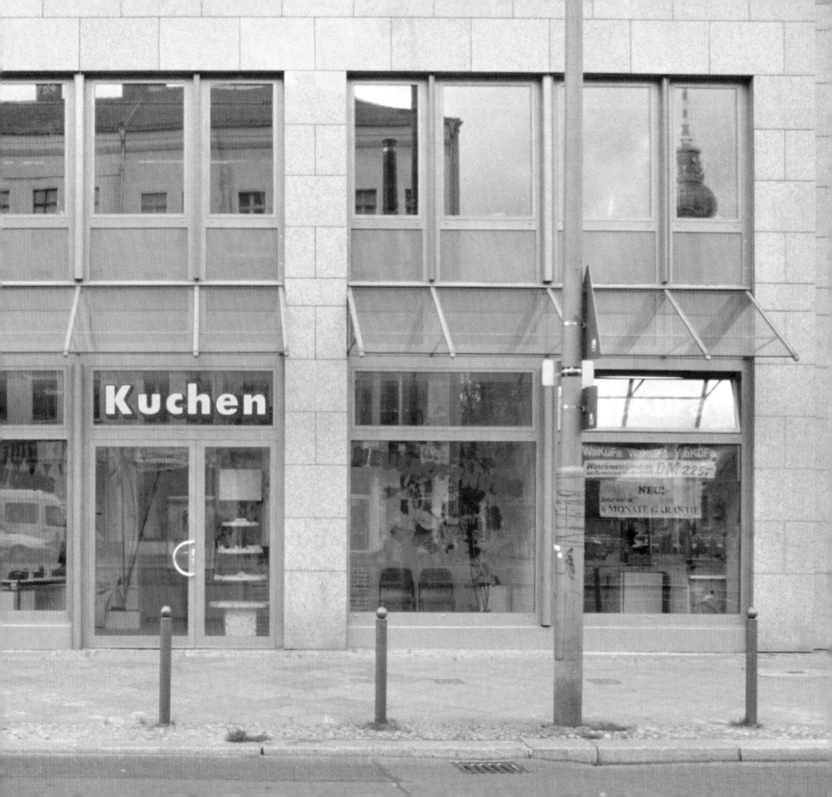

--
Neueröffnung #2
Schönhauser Allee 188, Berlin August–Oktober 2000
Musterhaus-Ausstellung, Wandsystem aus Spanplatte, Dekortapeten,
Fototapeten, Bürotechnikattrappen, Mustertapetenplattenspieler,
Fertigkuchen
mit Objekten von Annekathrin Schreiber: *Hose* aus Holztapete, *Negligé* aus
Seidentapete, *Kittelschürze* aus Blümchentapete und Modulsystem *Korkeiche*
aus Korktapete
Videos: *Musterfamilien* 3 min, *Mustertapeten* 6 min,
Musterhäuser 3 min loop

In den Räumen des ehemaligen Küchenfachgeschäfts ‹Küchen Becker›
wird das Immobiliengeschäft *Kuchen Immobilien* eröffnet. Die bestehende
Raumstruktur wird in den neuen Funktionszusammenhang übertragen.
Getreu dem Leitspruch ‹Bauen in den eigenen vier Wänden – Sie bleiben
wo Sie sind. Ihr Haus kommt zu Ihnen› nimmt *Kuchen Immobilien* die
Ansprüche künftiger Townhouse-Generationen vorweg.
Kuchen Immobilien hält auf einer Fläche von 100 Quadratmetern eine
Vielfalt verschiedener Musterhäuser zum Aufbau in den eigenen vier Wänden
bereit. *Kuchen Immobilien* garantiert: ‹Hier bekommt jeder ein Stück vom
großen Kuchen›. Der Besucher ist eingeladen, bei einem Stück Gratiskuchen
an einer individuellen Haustypberatung in der Musterhaussiedlung
teilzunehmen und einen der fünf Musterhaustypen *Burg, Fachwerk, Fort,
Hochhaus* oder *Zelt* für sich zu entdecken.
Der Klang von Tapeten-Schallplatten bewirkt ein sinnliches Eintauchen in
die Oberflächen und Formen des Traums vom Eigenheim. Das synästhetische
Raumerlebnis wird vollendet durch mimetische Kleidungsstücke von
Annekathrin Schreiber, die in den entsprechenden Baumaterialien der
einzelnen Häuser bereit stehen.
Diverse Sachvideos zum Thema halten eine ikonographische Analyse
von Musterfamilien und Musterhäusern bereit. Im Rahmen einer Verlosung
erhält ein glücklicher Gewinner die Möglichkeit ein Einbauhaus seiner
Wahl mit nach Hause zu nehmen.

Office view
Büroansicht

Timber-frame design showhouse beside *Cork oak* module system
Musterhaus *Fachwerk* neben Modulsystem *Korkeiche*

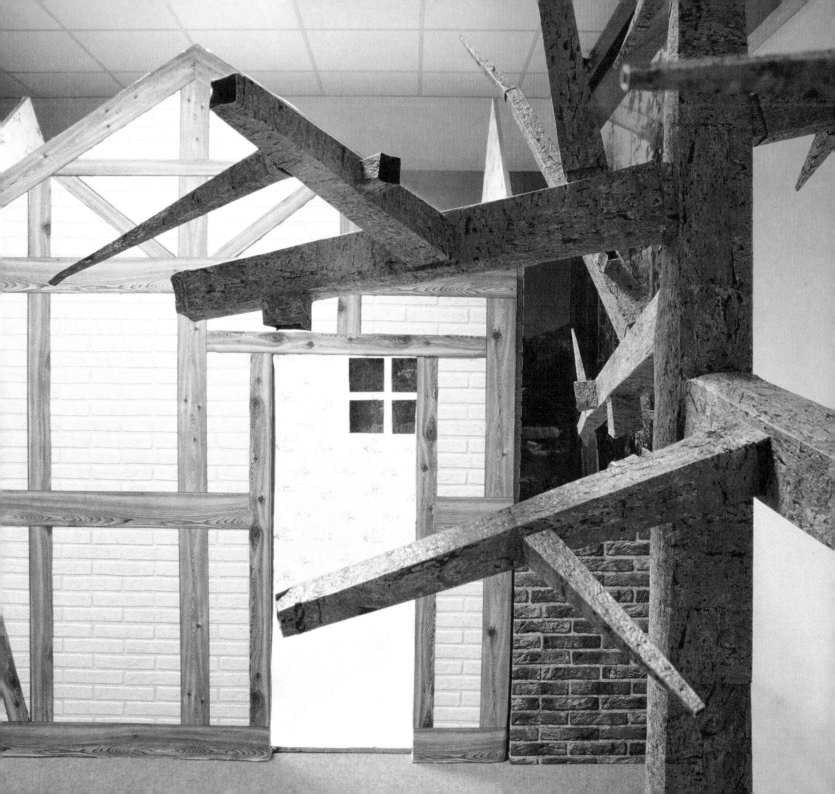

Castle showhouse
Musterhaus *Burg*

Tower block showhouse
Musterhaus *Hochhaus*

Tent showhouse
Musterhaus *Zelt*

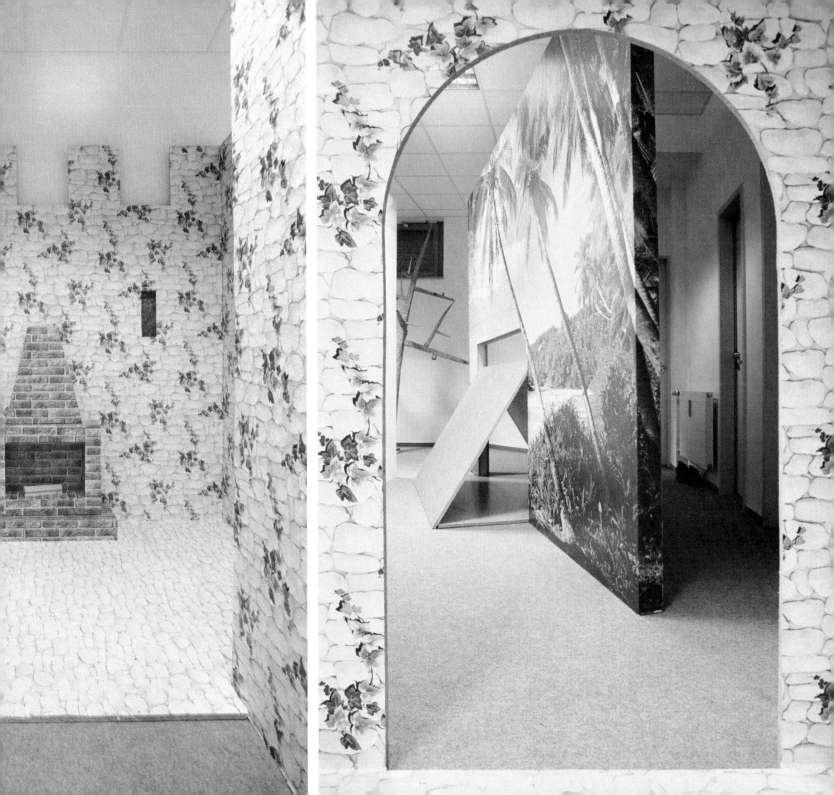

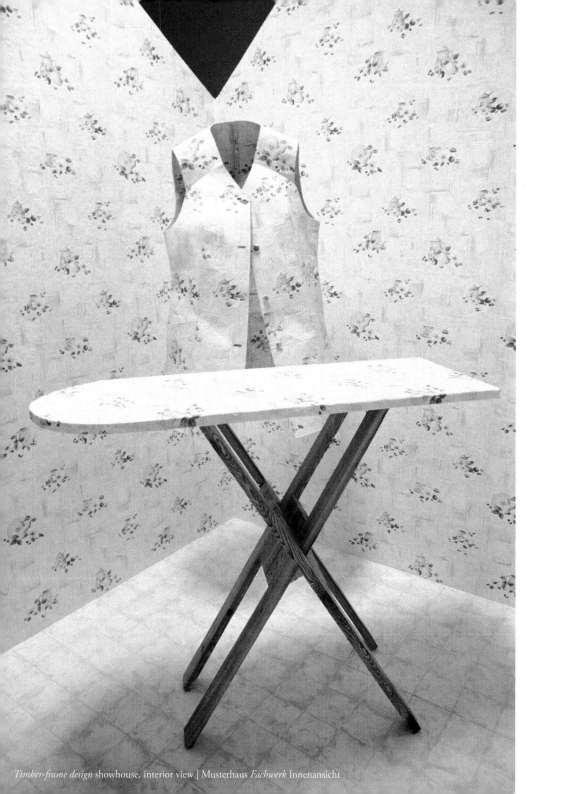

Timber-frame design showhouse, interior view | Musterhaus *Fachwerk* Innenansicht

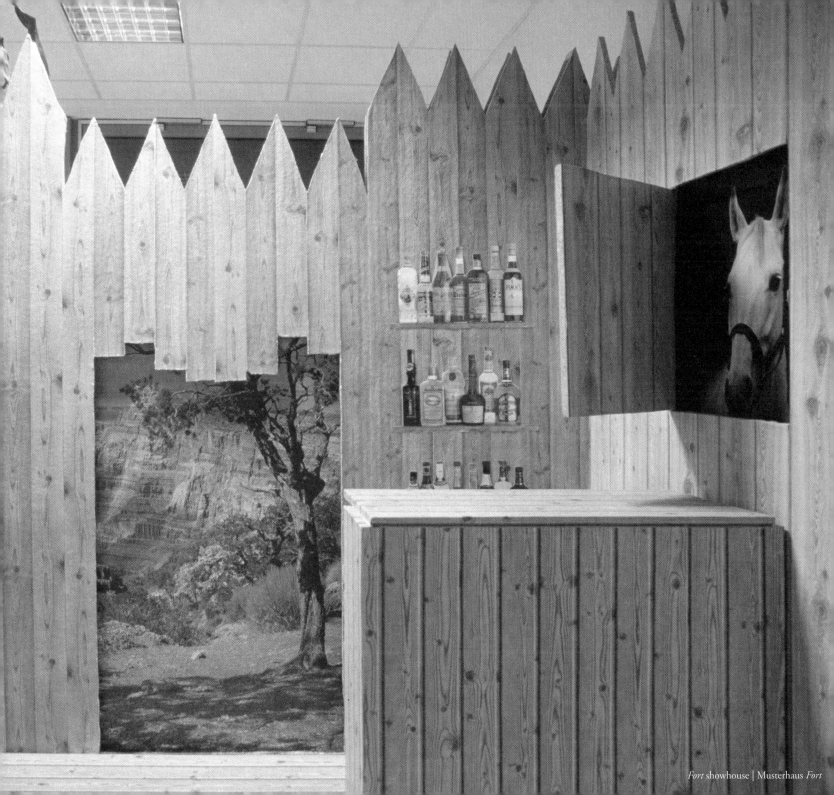

Fort showhouse | Musterhaus *Fort*

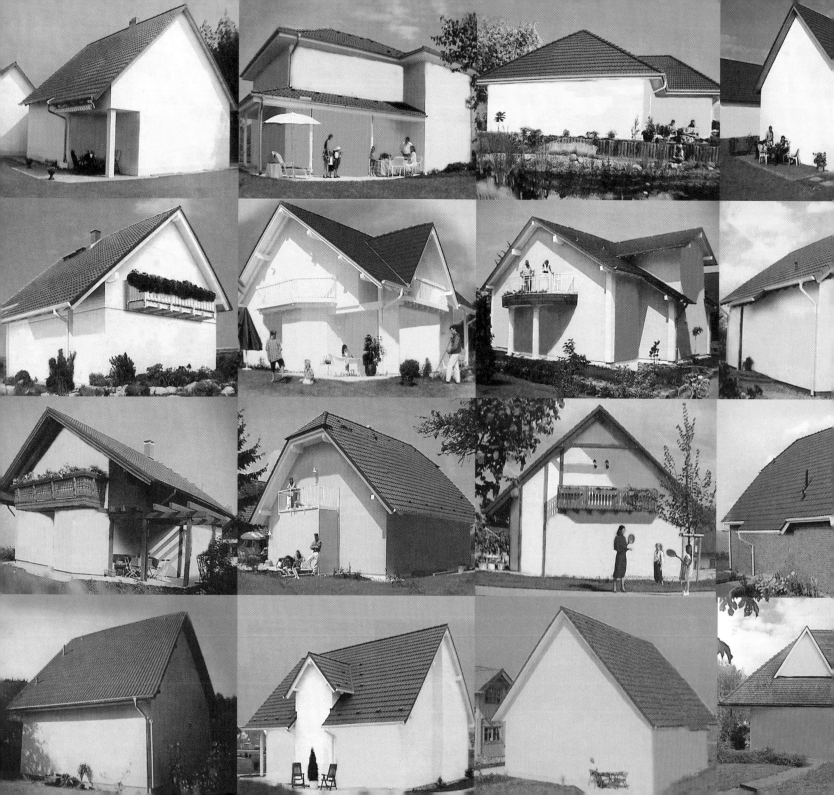

Showhouse collection, video stills
Archiv *Musterhäuser*, Videostills

Happy family collection, video stills
Archiv *Musterfamilien*, Videostills

Fremdenverkehrsamt

Newly Opened #1
Kochstrasse 74, Berlin, April–June 2000
Three furnished floors, furniture and shelf units from bankruptcy clearance sales,
office equipment decorations, dummy books from a travel library, travel videos,
world music, postcards etc.
Audio: *world music* 25 min loop
Videos: *Standard rooms, Eating, Drinking, Dancing* 5 min loop each,
International greetings 1 min

In the premises of the former Bulgarian tourist agency, the *Fremdenverkehrsamt
(International tourist board)* is opened over three floors. The *Fremdenverkehrsamt*
deals with all forms of tourism worldwide. Local attractions and exotic voyages to
far-away lands are all represented. With these products, *Fremdenverkehrsamt*
offers a typically standardised world of experiences.
Alongside detailed photos and audio material, holiday complexes are also presented
– from the palm-tree forests of Wunsiedel on the German-Czech border to the
fir-tree-lined beaches of Honolulu. As part of the globalised travel industry, *Fremden-
verkehrsamt* covers the whole world – for example, by hosting a trade fair stand
at the ITB tourism exhibition in Berlin.
Fremdenverkehrsamt combines the basic motifs of the tourism business – the fir
tree and the palm tree – and promises a standard level of service and quality.
‹Wherever you see our symbol in the future, you can be guaranteed our worldwide
standard of service›. In *Fremdenverkehrsamt*'s three-storey headquarters on Koch-
strasse in Berlin, some elements of the holiday complexes have been recreated as
models: on show are a standard hotel room, a beach, and numerous items of
entertainment and sport equipment. Visitors can come and see the quality on
offer for themselves.

Entrance with
palm column
Eingang mit
Palmensäule

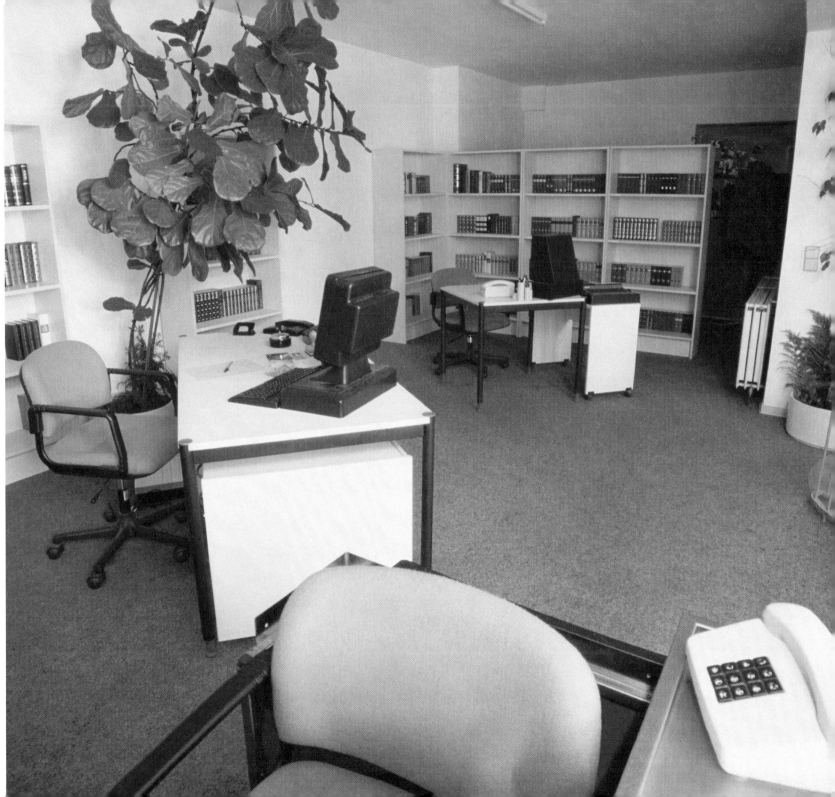

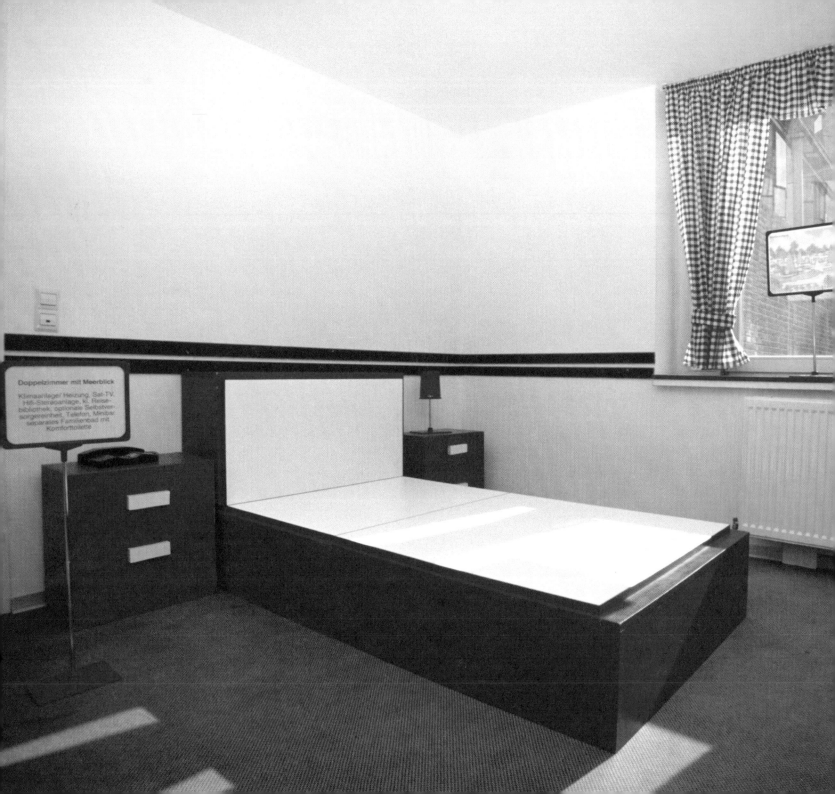

Doppelzimmer mit Meerblick

Klimaanlage/ Heizung, Sat-TV,
Hifi-Stereoanlage, kl. Reise-
bibliothek, optionale Selbstver-
sorgereinheit, Telefon, Minibar
separates Familienbad mit
Komforttoilette

Neueröffnung #1
Kochstrasse 74, Berlin, April–Juni 2000
Einrichtung auf drei Stockwerken, aus Insolvenzmassen über-
nommene Möbel und Regalsysteme, Bürotechnik-Dekorationen,
Reisebibliothekattrappen, Weltmusik, Reisevideos, Postkarten etc.
Audio: *Weltmusik* 25 min loop
Videos: *Beispielzimmer, Essen, Trinken, Tanzen* je 5 min loop,
Internationaler Gruß 1 min

In den Räumlichkeiten des ehemaligen bulgarischen Fremdenver-
kehrsamts wird auf drei Stockwerken das internationale *Fremden-
verkehrsamt* eröffnet. Das *Fremdenverkehrsamt* beschäftigt sich mit
allen touristischen Formen weltweit. Sowohl lokale Attraktionen,
als auch exotische Reiseangebote in weiter Ferne werden vertreten.
Vor diesem Hintergrund bietet das *Fremdenverkehrsamt* eine
beispielhaft standardisierte Erlebniswelt.
Neben detaillierten Bild- und Tonmaterialien werden Ferienanlagen
präsentiert, die sich von den Palmenwäldern Wunsiedels bis hin
zu den Tannenstränden Honolulus erstrecken. Innerhalb der globali-
sierten Reisewelt erkundet das *Fremdenverkehrsamt* die ganze Welt,
u. a. im Rahmen eines Messeauftritts auf der Internationalen Tou-
rismus Börse (ITB) Berlin.
Das *Fremdenverkehrsamt* vereint die Grundmotive des Kosmos
Tourismus – die Tanne und die Palme – und verbürgt sich für ein
allgemeines Leistungs- und Qualitätsniveau. ‹Überall wo Sie in
Zukunft unser Zeichen sehen, ist Ihnen unser hauseigener Standard
garantiert›. In dem dreistöckigen Hauptsitz des Fremdenverkehrs-
amts in der Kochstraße sind einige Elemente der vertretenen
Ferienanlagen exemplarisch aufgebaut: Ausgehend von einem Bei-
spielzimmer, über zahlreiche Unterhaltungs- und Sportanlagen, bis
hin zu einer Strandanlage ist alles mustergültig installiert, damit
sich der Besucher selbst vor Ort von der Qualität überzeugen kann.

Standard room
Beispielzimmer

Tennis court
Tennisanlage

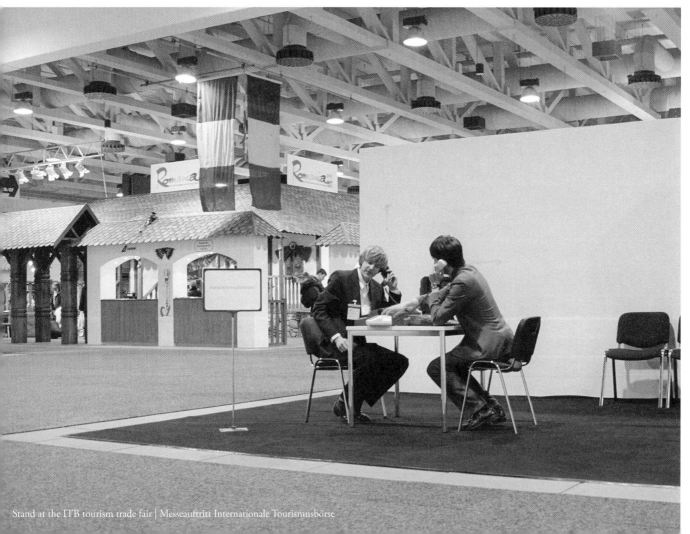

Stand at the ITB tourism trade fair | Messeauftritt Internationale Tourismusbörse

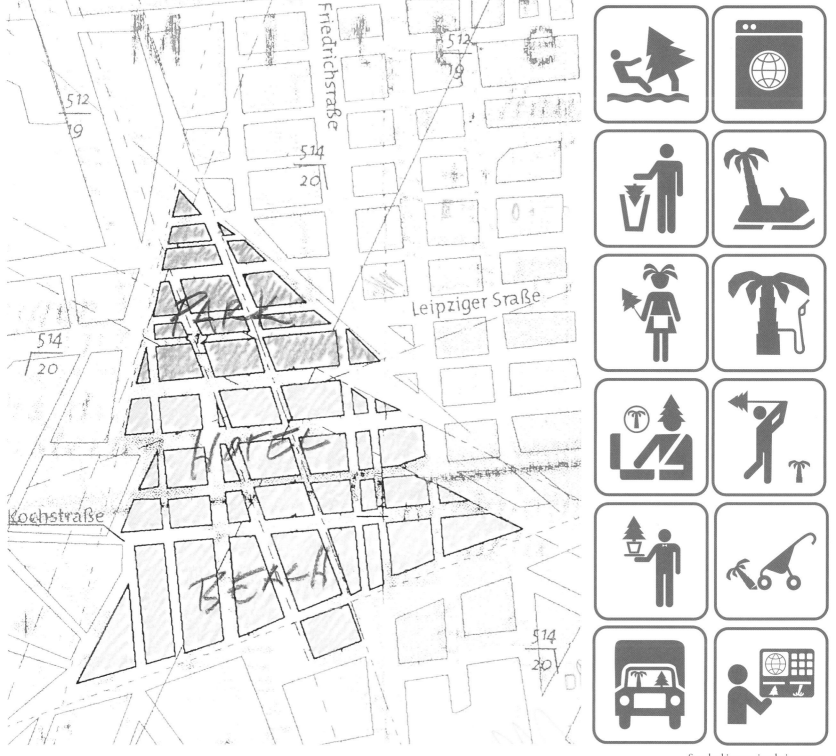

Development plan for Berlin's city centre | Planwerk Innenstadt Berlin

Standard international pictograms
Internationaler Piktogramm-Standard

International greetings collection, video stills | Archiv *Internationaler Gruß*, Videostills

as déranger

ot disturb

nicht stören

Club Ibis

Newly Opened #3
Activity programme, Ibis Hotel, Rennes (France) 2001
Interior furnishings from various Ibis hotel rooms
Video 12 min loop

Over the course of a stay of a number of days in a hotel of
the *Ibis* chain in Rennes, a television-oriented activity
programme for hotel guests and exhibition visitors is created
to extend the hotel company's repertoire of services.
In the hotel's standardised rooms, the TV set is the sole source
of entertainment. Practically the only window on the out-
side world, it offers a mass of different entertainment formats,
24 hours a day. The activity programme developed by *Club
Ibis* can be viewed for free on the hotel's own channel. This
programme shows how you can transform the hotel room
into a mini adventure park with the help of a television set.
Two members of the *Club Ibis* service staff create a world
of images using the furnishings present in the room. They
synchronise their activities in the hotel room with the pictures
and sound environment coming from the TV.

Neueröffnung #3
Animationsprogramm, Ibis Hotel, Rennes (Frankreich) 2001
Innenausstattung verschiedener Ibis Hotelzimmer
Video 12 min loop

Während eines mehrtägigen Aufenthalts in einem Hotel der
Ibis-Kette in Rennes entsteht ein fernsehorientiertes Ani-
mationsprogramm für Hotelgäste und Ausstellungsbesucher,
welches das Service-Repertoire des Hotelunternehmens
erweitert.
In den standardisierten Zimmern des Hotels sind die Enter-
tainment-Möglichkeiten auf das TV-Gerät reduziert. Als
einziges adäquates Fenster zur Außenwelt steht es mit einer
Fülle unterschiedlicher Unterhaltungsformate 24 Stunden
zur Verfügung. Das von *Club Ibis* entwickelte Animations-
programm kann kostenlos auf dem Hotelkanal abgerufen
werden. Es führt vor, wie sich das Hotelzimmer mit Hilfe
des Fernsehers in eine aktive Erlebniswelt verwandeln lässt.
Zwei Mitarbeiter des *Club Ibis*-Service Teams tauchen in die
Bildwelt der Einrichtungsgegenstände ein, synchronisieren
das übertragene Fernsehbild mit dem Hotelzimmer und
erfüllen die Tonkulisse mit ihrer selbst erzeugten Bildwelt.

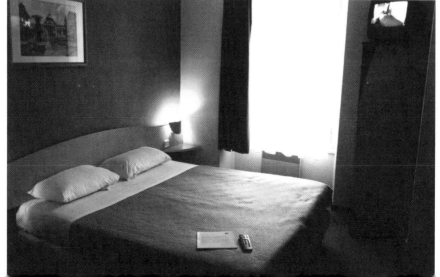

Club ibis, room 207
Club ibis, Zimmer 207

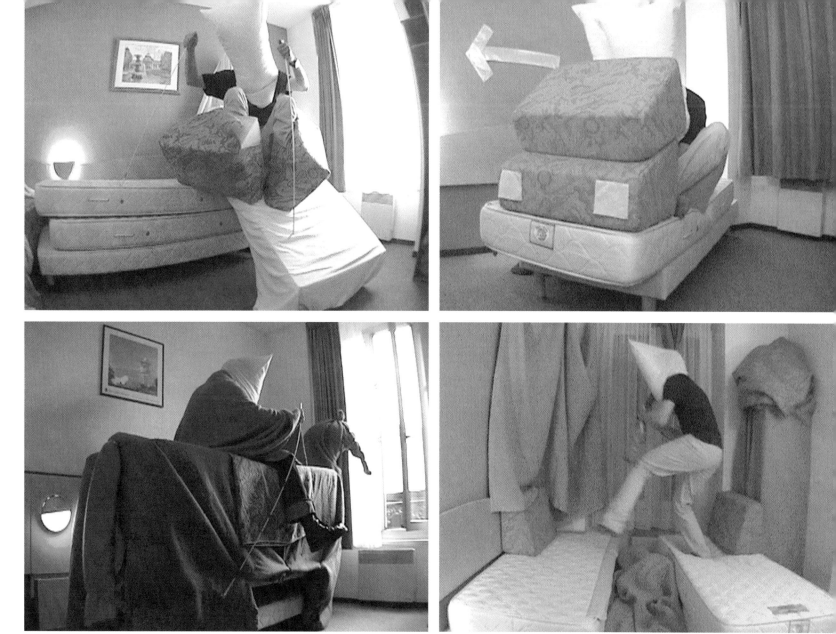

Alpine skiing | Ski Alpin

Formula1 | Formel1

Western | Western

Tarzan | Tarzan

Spiral Office

Newly Opened #4
Centro Civico Guidecca, 50th Biennale di Venezia, Venice (Italy) 2003

The temporary tourist attraction *Tourist Spiral San Marco* is dedicated to the inhabitants of Venice, who live in an open-air museum and have to put up with masses of tourists every day.

Visitors from all over the world who are standing in line at the entrance to the cathedral on St. Mark's Square are guided by the twenty service staff of the *Servizio San Marco* so that the queue takes the shape of a spiral on the ground.

Inspired by ‹Spiral Jetty›, the iconic piece of land art by Robert Smithson (1970, Great Salt Lake, Utah, USA), *Tourist Spiral San Marco* is a process-oriented piece. Randomly fluctuating streams of tourists are harnessed to form a concrete shape in time and space. The behaviour of this shape is impossible to define. With its flowing dynamics, the spiral becomes a universal form.

As part of the 50th Venice Biennale, documentation of *Tourist Spiral* and preliminary sketches and collages from the project are all exhibited as *Spiral Office*.

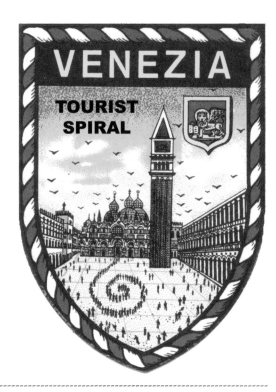

Neueröffnung #4
Centro Civico Guidecca, 50. Biennale di Venezia, Venedig (Italien) 2003

Als temporäre Sehenswürdigkeit ist die *Tourist Spiral San Marco* den Einheimischen Venedigs gewidmet, die in einem Freilichtmuseum leben und täglich von unzähligen Touristen heimgesucht werden.

Internationale Besucher, die am Eingang des Doms auf dem Markusplatz Schlange stehen, werden von dem zwanzigköpfigen Servicepersonal des *Servizio San Marco* angeleitet, ihre Warteprozession in Form einer auf dem Boden vorgezeichneten Spirale abzuwickeln.

Inspiriert von der ‹Spiral Jetty›, der Ikone der Land Art (Robert Smithson 1970, Great Salt Lake, Utah/USA), ist die *Tourist Spiral San Marco* auf Prozesshaftigkeit angelegt. Willkürlich fluktuierende Touristenströme werden gebündelt und in eine konkrete raum-zeitliche Form gebracht, deren Verlauf ungewiss ist, die in ihrer fließenden Dynamik zugleich über sich selbst hinaus verweist.

Im Rahmen der 50. Biennale von Venedig werden im *Spiral Office* eine Dokumentation der *Tourist Spiral* sowie Konzeptskizzen des Projekts ausgestellt.

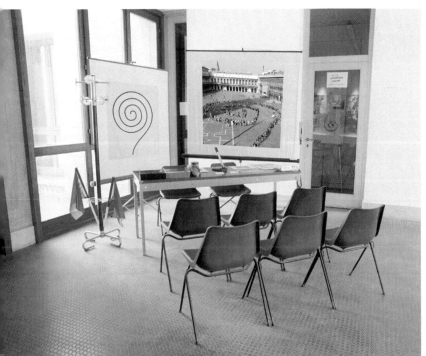

Press conference, Centro Civico Giudecca
Pressekonferenz, Centro Civico Giudecca

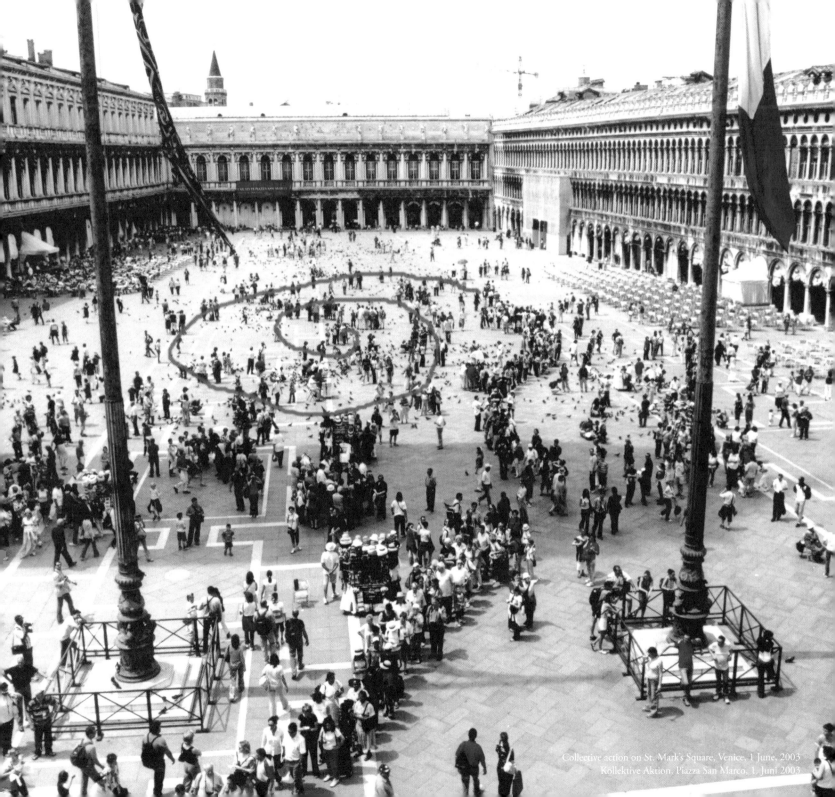

Collective action on St. Mark's Square, Venice, 1 June, 2003
Kollektive Aktion, Piazza San Marco, 1. Juni 2003

BaumWall

Mobile afforestation measure, Neukölln district, in the context of ‹space thinks›, Berlin 2009
Nylon fabric, fans, generator, backpack frames
Tree height 8–10 m

The centre of Neukölln, an area with very few trees but a lot of outdoor advertising, is subjected to some demonstrative afforestation. *BaumWall (TreeWall)* is a mobile mini-forest of blow-up trees that attracts attention to locations where there are advertising installations disguised as street furniture. This urban forest, carried by lumberjacks on their backs, moves around with the wind generated by fans and conceals the advertising structures.
So-called street furniture is actually a monopolistic-capitalist partnership that the city has entered into with an outdoor advertising company. Despite claims to the contrary, this equipment in public spaces is not intended primarily for the community's benefit, but rather serves the economic motives of the advertising industry. The *BaumWall* campaign employs forms more familiar from the event and promotion sector, and poses the question as to who should be furnishing public space.

mobile Bewaldungsmaßnahme, im Rahmen von ‹space thinks›, Berlin-Neukölln 2009
Nylongewebe, Gebläse, Stromgenerator, Rucksackgestelle
Baumhöhe 8–10 m

Das Kerngebiet von Neukölln, in dem es wenige Bäume, aber sehr viel Außenwerbung gibt, wird demonstrativ aufgeforstet. Ein mobiler Kleinwald aus aufgeblasenen Bäumen macht auf die Stellen aufmerksam, an denen als Stadtmöbel getarnte Werbeträger stehen. Dieser städtische Forst, welcher von Waldarbeitern auf dem Rücken getragen wird, bewegt sich im Wind der Gebläse und überwuchert die Werbeanlagen.
Die sogenannte Stadtmöblierung ist ein monopolistisches Bündnis, das die Stadt mit einem Unternehmen für Außenwerbung unterhält. Entgegen deren Selbstdarstellung findet die Ausstattung des öffentlichen Raums primär nicht für die Gemeinschaft, sondern zum Wohl der Werbewirtschaft statt. Die Kampagne *Baum-Wall* tritt mit Formen aus dem Promotion- und Eventbereich in Aktion und stellt die Frage, wer den öffentlichen Raum einrichten soll.

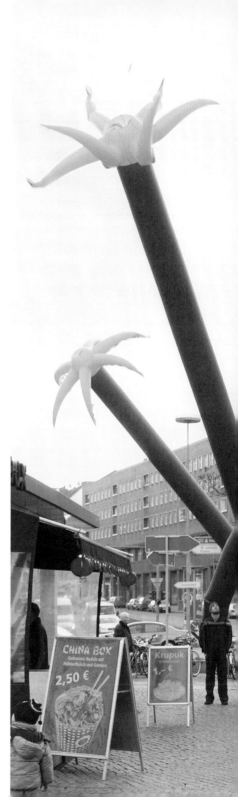

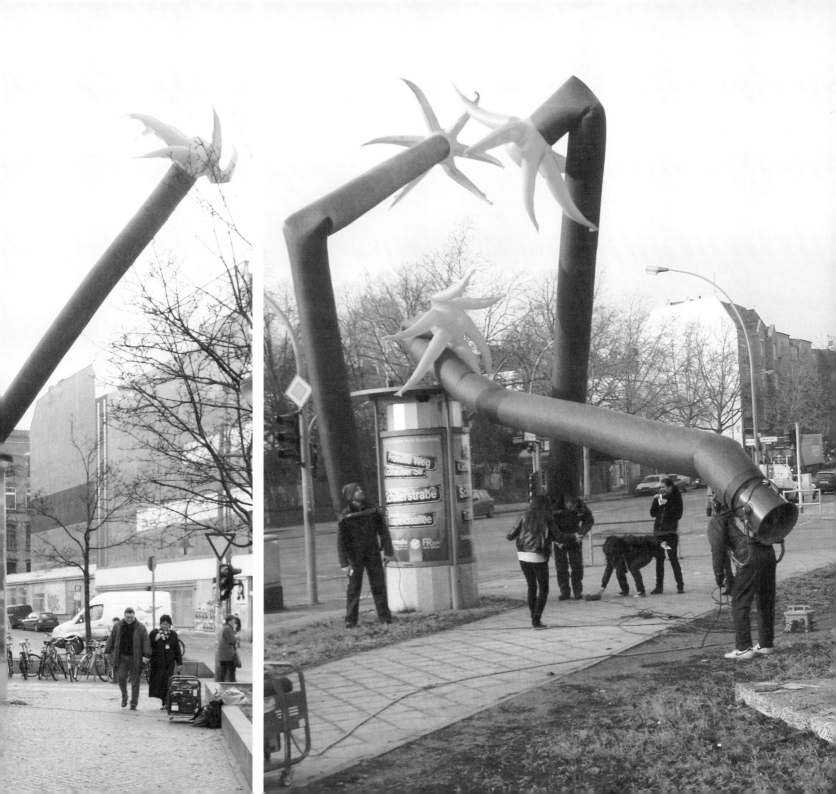

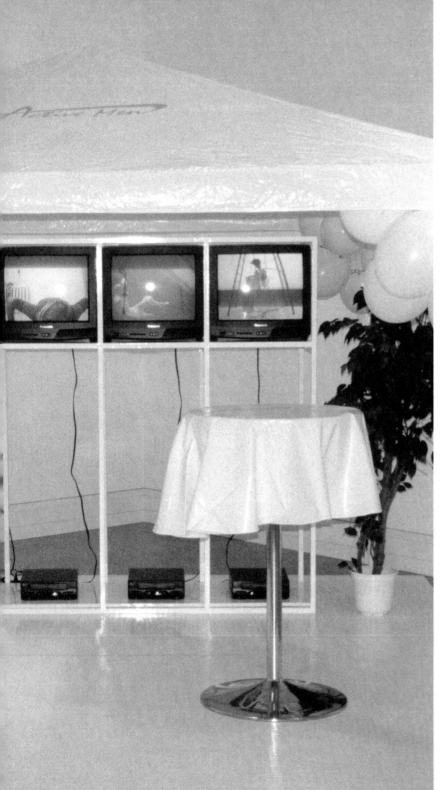

Active Men

Michael Boehler / Franz Hoefner / Harry Sachs

Movement with trade fair appearances in Berlin, Bonn, Dessau, Metz, Munich, Weimar, 1998–2000
pavillon, monitors, high table, air balloons
3 x 3 x 2.4 m
Video programme 35 min loop

Active Men presents its new range of courses and encourages people to take part themselves. On the monitors, the five columns of the *Active Men* philosophy are introduced: *Body Styling, Power Burner, Pump and Go, Spinal Gymnastics* and *Dyna Work*.
Active Men demonstrates how sculptural interventions and manipulations can be carried out on one's own body with simple exercises – using a simple bellows, an electric compressor or the power of a car engine. The pump technology in *Active Men* gets people into shape and guarantees quick success combined with good performance.

Bewegung mit Messeauftritten in Berlin, Bonn, Dessau, Metz, München und Weimar, 1998–2000
Pavillonzelt, Monitore, Stehtisch, Luftballons
3 x 3 x 2,4 m
Videoprogramm 35 min loop

Active Men präsentiert sein neues Kursprogramm und lädt zum Mitmachen ein. Auf Monitoren werden die fünf Säulen der *Active Men* Philosophie vorgestellt: *Body Styling, Power Burner, Pump and Go, Wirbelsäulengymnastik* und *Dyna Work*.
Active Men demonstriert, wie mit einfachen Leibesübungen skulpturale Interventionen und Manipulationen am eigenen Körper vorgenommen werden können, vom einfachen Blasebalg über elektrische Kompressoren bis hin zur Kraft von Automotoren. Die Pumptechniken von *Active Men* bringen in Form und garantieren schnellen Erfolg bei guter Performance.

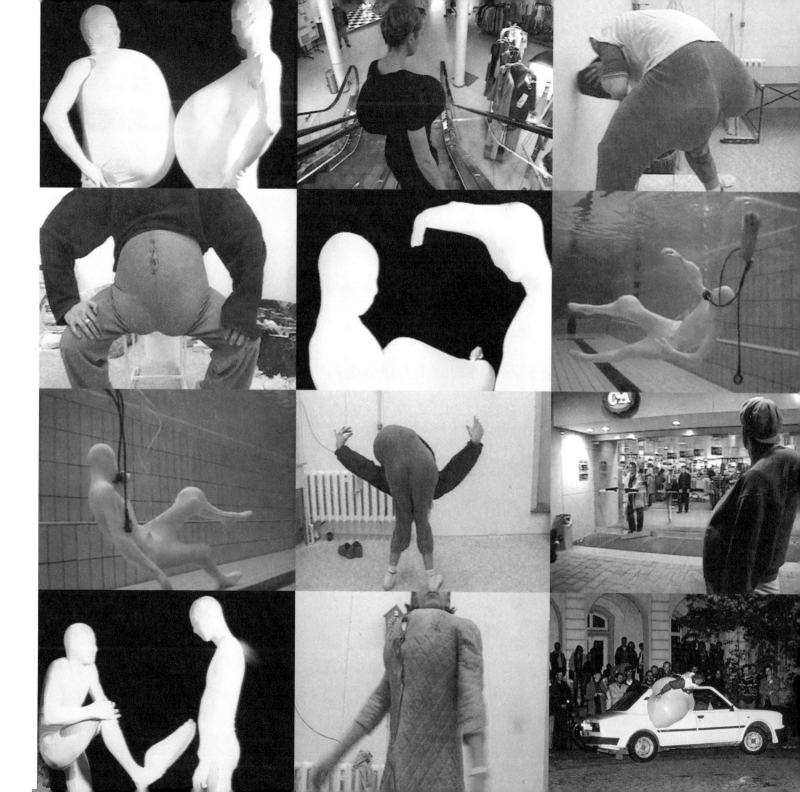

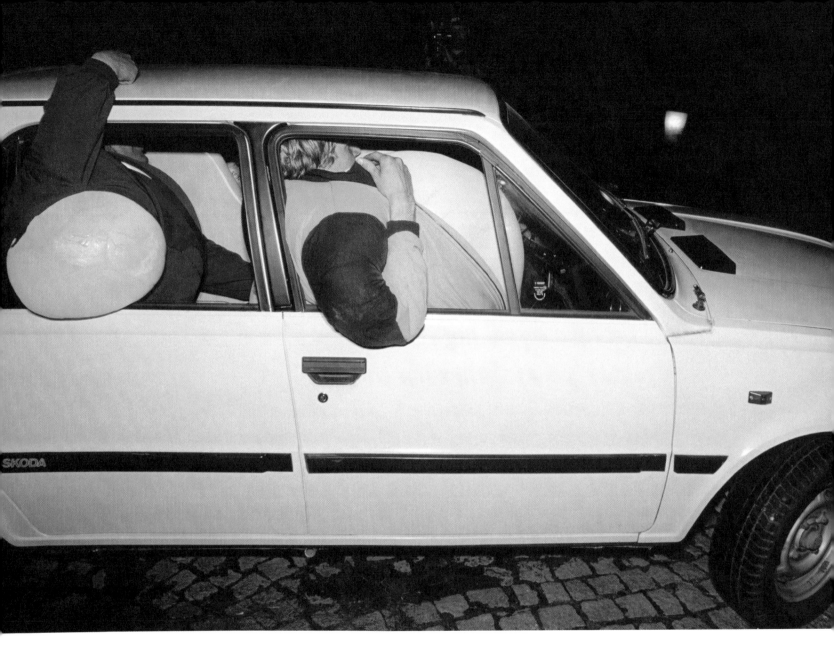

Skoda Elan

Test drives #1, Muzeul National de Arta, Cluj-Napoca (Romania) 1998
Skoda 105 Elan, exhaust pipe extension, tubes, rubbish bags
Video 7 min

Testfahrten #1, Muzeul National de Arta, Cluj-Napoca (Rumänien) 1998
Skoda 105 Elan, Auspuffverlängerung, Schläuche, Müllsäcke
Video 7 min

Testfahrten

1998–2004
Cluj-Napoca (Romania), Hamburg and Leipzig (Germany), Venice (Italy)

Testfahrten (Test drives) is a series of trials dealing with our perception of the whole subject of automobiles.

The *Skoda Elan* test drive is an airbag performance where the exhaust emissions are fed through tubes back into airbags that the car occupants wear under their clothes. The airbags gradually fill up over the course of a few laps, until the interior of the car is eventually taken up entirely by the volume of its occupants.

In an analogous manner, the inside of a car is also filled to a maximum during the *Opel Kapitän (Opel Captain)* test drive. With 3,500 litres of water in the interior of the car, the driver and passenger drive through a surreal exterior environment. The optical refraction, sensation of weightlessness, and slowed movements in the water result in a new perception of automobility. The cityscape passing by takes on the appearance of a calm aquarium landscape.

Swapping interior and exterior, the test drive *Venice by Car* journeys through the canals of Venice. The automobile is sealed tight against water from the outside, and travels upside-down through the waterways of the ‹City of Water›, driven by an outboard motor.

Drive In is an experiment with space and time. A red sports car is driven repeatedly along a white exhibition wall, until the markings on the wall no longer change with each new trip. A one-kilometre car journey becomes visible, engraved on a 30-metre section of wall.

Road Movie is an experiment in unmanned space travel, where a car takes a short trip into the third dimension. With the right acceleration, the vehicle escapes the usual confines of gravity by taking off in reverse gear from a wooden ramp on the top floor of a multi-storey car park. The car follows a ballistic arc through the air, which can be seen in reverse afterwards in a film: after a short explosion, the vehicle jumps forward onto the building from a stationary position.

1998–2004
Cluj-Napoca (Rumänien), Hamburg, Leipzig, Venedig (Italien)

Testfahrten besteht aus einer Serie von Versuchsanordnungen, die sich mit der automobilen Erfahrungswelt auseinandersetzen.

Im Rahmen einer Airbag-Performance werden bei der Testfahrt *Skoda Elan* die Fahrzeugemissionen über ein Schlauchsystem in Luftkissen geleitet, welche die Insassen unter ihrer Kleidung tragen. Während einiger Kreisfahrten blasen sich die Luftkissen langsam auf, bis schließlich das Fahrzeuginnere mit dem Volumen der Insassen komplett ausgefüllt ist.

Analog dazu ist das Fahrzeuginnere auch bei der Testfahrt *Opel Kapitän* maximal gefüllt. Mit 3500 Liter Wasser im Fahrgastraum fahren die Insassen durch eine surreale Außenwelt. Die optische Verzerrung, die Schwerelosigkeit und die verlangsamte Bewegung unter Wasser erzeugen eine neue Wahrnehmung der automobilen Fortbewegung. Die vorbeifahrende Stadtlandschaft erscheint als ruhige Modelllandschaft eines Aquariums.

Venice by Car setzt in umgekehrter Perspektive die Testfahrt auf den Kanälen in Venedig fort. Das Automobil ist nun nach außen wasserdicht versiegelt und fährt, angetrieben von einem Außenbordmotor, kopfüber auf den Wasserstrassen der Lagunenstadt.

Eine Versuchsanordnung zu Raum und Zeit ist die Testfahrt *Drive In*. Ein roter Sportwagen bearbeitet in geradlinigen Fahrten solange eine weiße Ausstellungswand, bis sich die entstehende Wandzeichnung nicht mehr verändert. Sichtbar wird eine Autofahrt von einem Kilometer, eingraviert auf einer Wandlänge von 30 Metern.

Die Testfahrt *Road Movie* ist ein Experiment zur unbemannten Raumfahrt, in dem ein Automobil für einen kurzen Moment einen Ausflug in die dritte Dimension unternimmt. Bei entsprechend hoher Beschleunigung verläßt das Fahrzeug im Rückwärtsgang über eine Holzrampe die Grenzen der Schwerkraft und hebt vom obersten Deck eines Parkhauses ab, um in einem ballistischen Bogen durch die Luft zu fliegen. In dem anschließenden Filmprodukt ist die Sequenz rückwärts zu sehen: Nach kurzer Explosion springt das Fahrzeug aus dem Stand vorwärts auf das Haus.

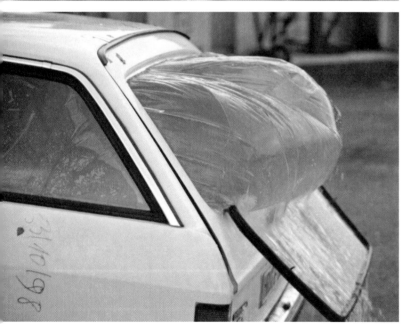
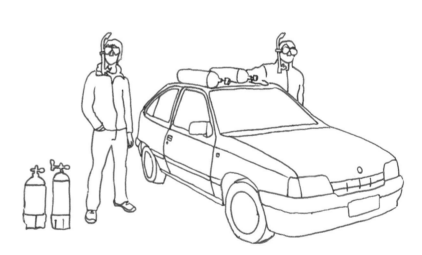

Opel Kapitän

Test drives #2, Hamburg 1998–99
Opel Kadett, 3500 litres of water, PVC sheets, silicone, snorkels, breathing masks, oxygen cylinders
Video 8 min and wall painting 3 x 2 m

Testfahrten #2, Hamburg 1998–99
Opel Kadett, 3500 Liter Wasser, PVC-Folie, Silikon, Schnorchel, Atemmaske, Sauerstoffflaschen
Video 8 min und Wandzeichnung 3 x 2 m

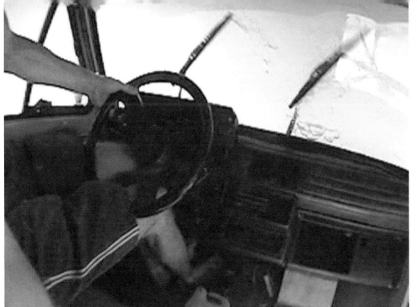

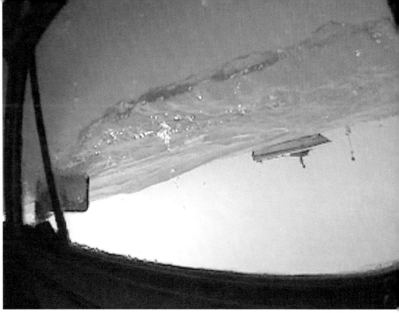

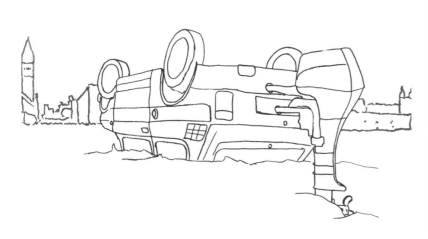

Venice by Car

--

Test drives #3, Venice (Italy) 2003
Fiat 126, construction foam, silicone, outboard motor
Video 3 min and wall painting 3 x 2 m

Testfahrten #3, Venedig (Italien) 2003
Fiat 126, Bauschaum, Silikon, Außenbordmotor
Video 3 min und Wandzeichnung 3 x 2 m

Drive In

Test drives #4, B/2-Baumwollspinnerei, Leipzig 2002
Mazda 626
Video 5 min and wall piece 30 x 1 m

Testfahrten #4, B/2-Baumwollspinnerei, Leipzig 2002
Mazda 626
Video 5 min und Wandarbeit 30 x 1 m

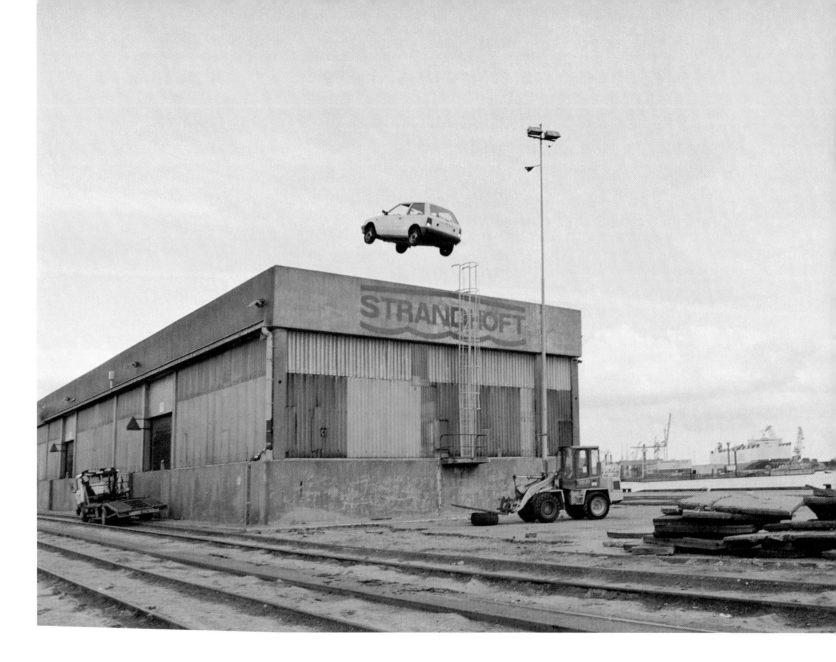

Road Movie

--

Test drives #5, Hamburg 2001
Daihatsu Charade, wooden ramp, fire extinguishers
Film 1 min and Polaroid photo

--

Testfahrten #5, Hamburg 2001
Daihatsu Charade, Holzrampe, Feuerlöscher
Film 1 min und Polaroidfoto

Spunk Seipel
Reappropriations

The fragility of material and perception

A dreary East German ‹Plattenbau› tower block development in the centre of Berlin – there it stands, forsaken and desolate. Bees are the only creatures to be seen, flying around and searching for an opening in order to get into one of the towers. Even today, some twenty years after the fall of the Berlin Wall, the former ‹no man's land› between the districts of Mitte (which was in East Berlin) and Kreuzberg (in West Berlin) is still largely a wasteland. The area remains dull and lifeless, with hardly a person to be seen on the streets. Only the bees fly around, busying themselves with honey-making.

However, the bees are not taking up residence in real, deserted dwellings left over from the East German era. Instead, they are flying in and out of eight miniature scale models. The artist duo of Franz Hoefner and Harry Sachs constructed this model ‹Plattenbau› development in summer 2006, with each building outfitted on the inside like a normal beehive with stacked honeycomb frames. The architecture is based on the so-called dormitory cities that were built close to many East German cities. One example is the district of Halle-Neustadt, one of the largest GDR urban development projects, which was constructed for the labourers who worked nearby in the chemical plants in Leuna. Hoefner and Sachs named their work *Honey-Neustadt* for this reason. The artists see a clear analogy between the image of the chemical labourer and that of the industrious bees. These prefab housing blocks were always standardised, just as beehives are. The motivation behind the use of prefab buildings was to achieve efficiency and cost-effectiveness, while at the same time providing residents with comfortable apartments. With the advent of these tower block developments, the perfect template had been realised to complement the Socialist ideal of a nation of workers and farmers. However, people everywhere are forced to conform to standard models for living – the phenomenon was not just something specific to the GDR – and architecture often helps to achieve this standardisation. When the Berlin Wall fell, the social ideal of the GDR was not the only thing that collapsed: these housing projects also became largely superfluous as the residents left them in large numbers, migrating to places where they could get work. Nowadays, the state even offers financial support for the demolition of these ‹Plattenbau› blocks. Here, too, there is an analogy with the habits of bees. They simply abandon their homes when there is no more food in the area, or alternatively, the beekeeper must move the boxes to another location.

Honey-Neustadt is an installation that looks like a playful idea dreamt up by a bee-lover or someone who is nostalgic for East Germany … but in fact, it deals directly with the meaning and purpose of architecture. The installation is a commentary on our working environments. Architecture and working habits have a huge effect on people and our environment.

In another installation in 2007, Franz Hoefner and Harry Sachs – together with Markus Lohmann and Michael Boehler, with whom they regularly collaborate – dealt even more specifically with the changed significance of work. Harburg is an area of Hamburg that has always been shaped and defined by workers and factories. Here – in a former train station waiting room which has now found a new use as an exhibition space for art – they used old wooden pallets to build a walk-in pyramid.

The pallet is a relatively recent invention. The pallet and the standardisation of shipping and transport have helped to make globalisation possible, and thus also contributed to the transformation of our working environment. A pallet is essentially a rough and dirty shipping component. There is an inherent contradiction in the choice of this particular industrial material to build a pyramid, a structure regarded as symbolising eternity. The piece is also a commentary on developments in the use of monuments over recent years. Monuments, their form and their significance are all changing. However, Hoefner and Sachs haven't created a typical monument to the working classes, as one might suspect at first glance, but have instead built a ‹leisure world› out of tools and working materials. For example, a conveyor belt is transformed into a model train, and a forklift is employed to support a balcony. The working machines become the infrastructure for a new culture of leisure. If work at specific locations is no longer necessary, what are we to do with all the leftover equipment? And how can we fill the newfound free time of redundant employees?

This installation, titled *Das Beschäft* (an invented German word intended to be a cross between ‹Beschäftigung› and ‹Geschäft›, i.e. between ‹activity› and ‹business›), is representative of the work of Hoefner und Sachs, who met while studying at the Bauhaus University in Weimar and have been collaborating on performances and installations since 1998. Their works, which often consume every cubic centimetre available in an exhibition space, usually operate somewhere between the twin poles of art-historical motifs and contemporary site-specificity. The materials they use are often ‹cheap› items and have a patina of their own. They are generally used, and often found lying around on site. They are appropriated by Hoefner and Sachs, put to an entirely new purpose and often given a revealing new meaning. In their outdoor installation *erikaLand* (2008), the artists constructed the façade of an American fort with old cellar doors and other found objects. The juxtaposition and choice of the particular objects triggers reflection on the cliché-laden images of America and American history that are so pervasive in German culture.

The artists do not attempt to conceal their working process; instead, their pieces deliberately retain the rough traces of how they were assembled, and often the artists explicitly document the work process in a video which then becomes an integral part of the installation. Hoefner and Sachs produce and direct their own installations – employing their own ideas and initiative. Far removed from the world of commercially commissioned art, the works of Hoefner and Sachs present an aura all their own.

The artists invite viewers to participate actively in their art and to be more than passive observers. Indeed, the visitors often make the installations come alive. The works are transformed by the participation of the observers, and as a result, take on an entirely new dimension.

For example, consider the labyrinth that they constructed with Natascha Rossi and Markus Lohmann in 2004 in a deserted housing block in Halle-Neustadt by knocking down certain walls and converting the furnishings left behind by the former residents. This construction only becomes a work of art when visitors crawl and climb through it. Hoefner and Sachs create artistic worlds that we can physically experience and that are dense and full of irony.

A proposal entitled *Neuhaus*, which was unfortunately never realised, takes advantage of the vacant apartments in the abandoned ‹Plattenbau› high-rises in Halle-Neustadt. Several buildings were to be connected to each other via a huge rollercoaster, with the entire housing project transformed into one giant fairground ride. Here, the empty buildings were to serve as the infrastructure for a new world that has metamorphosed from a working-class culture into a leisure society.

The *Interieur* installation in the Faux-Mouvement gallery in Metz in 2004 also offered a rich visitor experience, albeit one of a very different type. Upon entering the gallery, the visitors found nothing more than empty walls. Hoefner and Sachs went to great efforts to construct an exhibition space that came across like a commentary on Brian O'Doherty's book, ‹Inside the White Cube›. Initially, the piece looks like an ideal museum, a commentary on the environment and conditions where exhibitions take place, and on the aura and the significance of museum architecture. In their installation, Hoefner and Sachs did not only comment on the mechanics of exhibiting, which are often discussed just as much as the actual artworks, but also added a further dimension: visitors to the gallery who were particularly curious and ignored museum decorum (e.g. ‹Please don't touch› signs) were able to gain access to a second level of the exhibition located behind a plain door, which looked inconspicuously like a door to a storage closet. Here, the artists had built a hidden apartment within the walls of the main exhibition space. All the familiar trappings of an apartment could be found within its claustrophobically narrow hallways: a kitchen, bathroom, bedroom and living room. In addition to these rooms, there were also chambers devoted to facilities normally only found in luxury apartments, such as a private gym and a conservatory.

Of course, everything was altered to fit in these narrow spaces. The children's room contained only a three-level bunk bed, and was decorated with gaudily coloured wallpaper. The living room was more akin to a narrow hallway, while the loo appeared like one of those long, tapered bathrooms built into old German apartments, only now much narrower than usual.

Today, after the disclosure of certain well-publicised criminal cases in Austria, this work has gained a completely new dimension. However, when Hoefner and Sachs built the installation in 2004, these horror-scenarios were still unimaginable to us. The artists deal with issues concerning our living quarters/habits and the manner in which our requirements can and should be met. These issues are constant and enduring.

The fact that the living environment in this piece is accessible despite its narrowness raises questions regarding our relationship to spatial dimension, the functionality of our living spaces, and our expectations from living spaces in general. In France, the country where modern architecture has had the greatest freedom to realise radical experiments in residential architecture (for example consider Le Corbusier, who rejected hallways that were wider than 80 cm as being wasteful for social housing), this is certainly a charged subject. In Germany, the housing situation has been altered by new forms of social architecture on many occasions. Today, this issue has taken on an added significance in the context of Hartz IV, a recent reform of the German unemployment and welfare system which includes limits on the size of apartment that welfare recipients are entitled to. What living requirements is a human allowed to have? And how much space does a person and their family really need?

Hoefner and Sachs have produced other related, site-specific work in Berlin: for example in the cellar rooms of Galerie Engler & Piper in the Berlin district of Prenzlauer Berg in 2004, where the contents of the gallery owners' storage space were taken and put to new uses. Using the rubbish stored, a dream luxury basement apartment was created for the gallery owners.

As part of a theatre festival in 2005, Hoefner and Sachs attempted to create a self-sufficient utopia in a shared apartment in downtown Berlin. Due to the lack of space in the narrow rooms, conditions resulted that no resident could reasonably be expected to tolerate. Here, the living utopia failed for entirely different reasons.

Other transformations of our private living spaces, for which we are largely personally responsible, have been presented by the artists in the *Sanierungsmaßnahmen (Refurbishment measures)* installation at Galerie Wendt und Friedmann in Berlin in 2007 and in the *Neubau (New building)* installation in the Haus der Vorstellung in Berlin in 2008.

In these projects, the artists only used products sold in German home & garden centres, which are intended to be used by individuals in creating a cosy home for themselves. These particular products use trompe l'oeil effects to give the impression of being something else, such as stone-print vinyl flooring, imitation

marble tiles, plywood with hardwood veneer, woodchip wallpaper and drywall. Here again, Hoefner and Sachs create new interpretations of art-historical and cultural motifs in a style all their own by using affordable materials. Scored sheets of drywall recall both classical columns as well as large-scale works by American minimalist artists. Shapes are cut out of floor panels and give a referential nod to Richard Long. At the same time, the works poke fun at the spiritualisation of private living quarters. Circular patterns, etched into woodchip wallpaper, reference the ‹crop circle› mythology perpetuated by hoaxes pulled by juveniles in English corn fields. The artists build pyramids out of tiles which are easy to maintain, utterly free of any purpose, but charged with the esoteric notions often associated with pyramids.

The 2007 installation *Rückbau (Deconstruction)* at Galerie Invaliden1 offers a critical commentary on the manner in which Berlin is being renovated and gentrified. The gallery is housed in a building that has been threatened with demolition for many years now. Hoefner and Sachs removed parts of the drywall and cut sections out of the Venetian blinds in such a manner as to mimic the timber framework familiar from the ‹Fachwerkhaus› architectural style found in Germany and elsewhere. The cut sections of drywall were then transferred to the opposite walls, creating an interplay of positive and negative patterns. With subtle irony, they also built useful furnishings from their waste: a candelabrum for light and a fireplace for warmth.

Through their play with negative and positive forms, the artists address fundamental and aesthetic issues inherent in sculpture and art, but challenge their exclusivity. These concerns are not only the domain of Henry Moore or Rachel Whiteread.

Hoefner and Sachs follow in the tradition of Gordon Matta-Clark, who questioned accepted architectural forms with his ‹building cut› projects. Hoefner and Sachs are definite and resolute in their critique. They create something new by deconstructing objects that already existed and, at the same time, play with the fragility of material and of perception.

In a city where historical buildings are torn down without hesitation while older and long since vanished histories are rebuilt and memorialised, they criticise superficial reconstruction and the craze for historicisation. *Rückbau (Deconstruction)* may recall a quintessentially German tradition of timber-framed architecture, but this tradition actually does not exist in Berlin. Down the street from the gallery at the opposite end of Invalidenstrasse, on the corner of Chausseestrasse, one can see an example of the type of project that prompted their installation. Here, there is a building that was adorned with elaborate moulding and plasterwork in the 1990's and is now considered ‹historical›. The transformation, privatisation and commercialisation of public space and the effects of this are also recurring themes in the work of Hoefner and Sachs. The urban landscape of Gera, a city in Thuringia with a population of around 100,000, has been drastically altered since the 1990's by the construction of oversized shopping malls. These shopping centres have fundamentally changed the appearance of the city's historical district. Almost all public interaction in the city has now migrated into these temples of consumerism.

At Gera's ‹Kunstverein› (Art Association), Hoefner and Sachs presented a fictitious proposal for another shopping centre, which is surprisingly realistic if you consider recent trends in urban planning in Germany. The new shopping centre was planned to be built directly on the city's market square, which has, over time, lost its original function as both the centre of social life and commerce. In the ‹Kunstverein›, the artists constructed a ‹ghost mall› out of cardboard, and hung watercolours of hand-painted logos of the chain stores that one would expect to find in German shopping centres. The office of the ‹Kunstverein› was also transformed into an information centre for prospective clients and tenants of this development.

Our service-based economy is a constant theme in the art of Hoefner and Sachs. Gera was not the only occasion that they examined marketing strategies – for instance, in the real estate sector or the tourist industry – and altered them *ad absurdum*.

A further conversion of public space was thematised by Harry Sachs in collaboration with Markus Lohmann and Michael Boehler in 2002 with their *Mehrzweckhalle (Multi-purpose hall)* adjacent to Hamburg's ‹HafenCity› (Harbour City) area.

‹HafenCity› is a massive building project in Hamburg which is transforming an entire district in the city centre and creating living quarters for the wealthier classes. The area is to be enhanced by prestigious cultural institutions such as the planned ‹Elbphilharmonie› concert hall by the renowned architecture firm, Herzog & de Meuron. However, the majority of the population is excluded: not only the poor, but also middle-income groups for whom no living or recreational space has been planned.

During the construction phase of ‹HafenCity›, the artists built a temporary multi-purpose hall out of greenhouses and containers, corresponding to the location and activities pursued there. The multi-purpose hall was advertised in newspapers as serving a spectrum of purposes, ranging from gun clubs to karate groups. The users were able to determine the usage. With this temporary multi-purpose hall, ‹HafenCity› was turned into that what it actually should have been in the first place: an urban city centre for all of Hamburg's residents.

A similar adoption of a Hoefner and Sachs piece by the local population occurred in 2008 in Riga, Latvia, where the artists transformed a greenhouse into a glass chapel by making minimal alterations. Located on an island across from the city's historical district with its church steeples, the greenhouse chapel became a popular background setting for wedding photographs for newly married couples. Since drinking alcohol in public areas is prohibited by law in Riga, citizens who enjoy a drink also discovered that the completely transparent greenhouse was a good place to meet and enjoy themselves, safe

from the weather and outside of the jurisdiction of the authorities. This was an unanticipated use … but art which depends on interaction from visitors must always expect unexpected uses and interpretations.

Just as the citizens in Riga appropriated the Hoefner and Sachs work as a legal grey zone, Hoefner and Sachs created another legal no man's land in Hamburg in their 2004 project *Douaneville*, carried out in collaboration with Michael Boehler and Markus Lohmann. The artists set up a small trailer park on top of a former customs checkpoint located on the access bridge to the freeport. With its shabby appearance, audible music and lights being turned on and off sporadically by a timer, the settlement appeared to be inhabited. The idea that people had taken up residence here angered both the tabloid media and authorities. The absurdity of this happening on top of a customs office (an official state building!) was lost on everyone, and only seemed to make people more outraged. The fear that public space had been invaded by gypsies, squatters, homeless or permanent campers was so great that nobody bothered to take a closer look. The authorities were also powerless in putting an end to this Potemkin village. Legally, the flat roof was a location which no authority was responsible for from an urban-planning point of view. The larger questions posed by the installation were hardly discussed: who can live where and under what circumstances, and how do we want to deal with alternative forms of living, with migrants and with other groups that make us feel uneasy.

In their most recent piece, Franz Hoefner and Harry Sachs also play with and cross boundaries that are not always perceptible in everyday life. The invasion and colonisation of public space by advertising installations that masquerade as street furniture can be seen all around us. City-branding and marketing campaigns promise us a higher quality of life, but there is still no money for providing more greenery in Berlin's district of Neukölln. Hoefner and Sachs played with the name of the advertising company Wall, which is omnipresent in Berlin, by covering up the company's advertising installations with a small mobile jungle of inflatable plastic palm trees. The portable installations lasted only for a few moments. Without warning, they transformed dismal, wintery intersections of the city into idyllic and artificial South Pacific landscapes.

The targeted advertisting installations were located in dull and depressing areas of Neukölln where hardly a soul strays. Hoefner and Sachs have a penchant for places on the periphery which have not yet been culturally charted, but still influence and shape the way people live. These are places on the outskirts, in provincial areas or right in the centre of the city, that have been previously ignored or overlooked by the majority. Hoefner and Sachs open our eyes to these places and what is happening to them.

Spunk Seipel
Zweckentfremdungen

Die Fragilität von Material und Vorstellung

Eine triste Plattenbausiedlung mitten in Berlin. Einsam und verlassen steht sie da. Nur Bienen fliegen herum und suchen sich ein Loch, um in die Plattenbauten einzufliegen. Der ehemalige Todesstreifen zwischen den Stadtteilen Mitte (Ost) und Kreuzberg (West) ist seit dem Fall der Mauer noch immer weitestgehend eine Brachfläche. Es ist eine öde, leere Gegend, in die sich kaum ein Mensch verirrt. Nur die Bienen fliegen herum und sammeln Honig.

Aber es sind keine aufgegebenen Wohnbauten der ehemaligen DDR, in denen die Bienen Unterschlupf gefunden haben, sondern acht maßstabsgerechte Miniaturnachbauten. Das Künstlerduo Franz Hoefner und Harry Sachs hat im Sommer 2006 eine Modellplattenbausiedlung aufgestellt, die im Inneren wie normale Bienenkästen mit Wohnwaben für die Insekten ausgestattet sind. Es ist eine Reminiszenz an die Architektur der so genannten Schlafstädte wie zum Beispiel in Halle-Neustadt, einem der größten städtebaulichen Vorhaben der DDR, das für die Chemiearbeiter im nahen Leuna errichtet wurde. Deshalb nannten Hoefner und Sachs die Arbeit auch *Honey-Neustadt*. Für die Künstler ergibt sich eine Analogie zwischen dem Bild des Chemiearbeiters und dem der fleißigen Biene. Plattenbauten sind wie Bienenstöcke normiert, Kosteneinsparung und Effizienz waren ein Ziel, dass man mit hohem Komfort für die Bewohner verbinden wollte. Mit den Plattenbausiedlungen wurde die adäquate Wohnform für das gesellschaftliche Ideal des Arbeiter- und Bauernstaates realisiert. Menschen werden, nicht nur in der DDR, zu Arbeitsnormen gezwungen. Architektur hilft, diese Normierung zu ermöglichen. Mit dem Mauerfall zerbrach nicht nur das gesellschaftliche Ideal der DDR, auch die Plattenbauten wurden zum Teil überflüssig, da die Menschen an die Orte zogen, wo es Arbeit gibt. Inzwischen werden Abrissprämien für Plattenbauten gezahlt. Auch das ist eine Analogie zu den Bienenvölkern, die ihre Kästen dann verlassen, wenn es keine Nahrung mehr in der Umgebung gibt. Oder der Imker setzt die Kästen einfach um.

Honey-Neustadt ist eine Installation, die wie eine verspielte Idee von Bienenliebhabern oder DDR-Nostalgikern aussieht, aber von Sinn und Zweck von Architektur handelt. Die Arbeitswelt ist ein weiterer Aspekt. Die Auswirkungen auf die Menschen, auf unsere Umwelt, sind durch Architektur und Arbeitswelt immens.

In einer anderen Installation aus dem Jahr 2007 beschäftigen sich Franz Hoefner und Harry Sachs zusammen mit Markus Lohmann und Michael Boehler, mit

…enen sie immer wieder zusammenarbeiten, noch viel konkreter mit der Ver-
…nderung der Bedeutung von Arbeit.

…arburg ist ein Stadtteil von Hamburg, der immer schon von Arbeitern und
…abriken geprägt wurde. Hier, im ehemaligen Wartesaal des Bahnhofs, der
…eute als Kunstraum eine neue Verwendung gefunden hat, bauten sie eine
…egehbare Pyramide aus Mehrweg-Europaletten.

…aletten sind eine relativ neue Erfindung, die durch die Standardisierung
…es Transports erst die Globalisierung und damit die Veränderung unserer
…rbeitswelt möglich gemacht haben. Sie sind ein Verpackungsmaterial, das
…reckig und schäbig ist. Aus genau diesem Industriematerial eine Pyramide,
…ie das Sinnbild für Ewigkeit schlechthin ist, zu bauen, bildet einen span-
…ungsreichen Widerspruch. Es ist ein interessanter Kommentar zur Denk-
…malkultur der letzten Jahre. Denkmale, ihre Form und ihre Bedeutung
…ndern sich. Aber Hoefner und Sachs haben kein klassisches Arbeiterdenkmal
…eschaffen, wie man auf den ersten Blick vielleicht denken mag, sondern eine
…Freizeitwelt› aus Werkzeug und Arbeitsmaterialien. Ein Transportband wird
…u einer Modelleisenbahn umgewandelt, der Hubwagen trägt einen Balkon.
…Die Maschinen der Arbeit bilden nun die Grundlagen der Freizeitwelt. Wenn
…rbeit vor Ort nicht mehr nötig ist, wohin mit den Geräten? Was machen mit
…er Lebenszeit der entlassenen Arbeiter?

…Das Beschäft, so der Titel der Installation ist geradezu eine exemplarische
…rbeit für Hoefner und Sachs, die sich während ihres Studiums an der Bau-
…aus-Universität in Weimar kennengelernt haben und seit 1996 performativ
…nd installativ zusammenarbeiten. Sie bewegen sich bei ihren zumeist den
…anzen Raum einnehmenden Arbeiten in einem Spannungsfeld zwischen
…unsthistorischen Motiven und einem tagesaktuellem und geografisch ver-
…rteten Bezug. Ihre Materialien sind ‹arme›, meist vor Ort gefundene und
…ebrauchte Dinge, die ihre eigene Patina aufweisen. Sie werden von Hoefner
…nd Sachs zu einem neuen Zweck benutzt. Oft wird ihnen ein aufschluss-
…eicher neuer Sinn gegeben, wie zum Beispiel in erikaLand (2008), ein Pro-
…ekt, in dem u. a. aus gebrauchten Kellertüren ein amerikanisches Fort gebaut
…urde. Eine Assoziation, die anregt, sowohl über amerikanische Klischeebil-
…er und Geschichte wie über deutsche Kultur nachzudenken.

…ie verbergen den Arbeitsprozess nicht, sondern lassen grobe Arbeitsspuren
…estehen oder zeigen in einem in der Installation integrierten Video den Auf-
…au derselben. Hoefner und Sachs fertigen ihre Installationen in Eigenregie.
…n Zeiten der Diskussion um Künstlerwerkstätten und um das steigende
…ngebot von Produktionsfirmen für Kunst zeugen die Arbeiten von Hoefner
…nd Sachs von einer eigenen Aura.

…Die Künstler ermöglichen den Besuchern Teil des Kunstwerkes und nicht nur
…assiver Betrachter zu sein. Die Installationen werden durch den Besucher
…rlebbar. Sie verändern sich durch die Nutzung der Besucher und erhalten
…uweilen so eine ganz neue Dimension.

Ein Labyrinth etwa, dass sie in einem aufgegebenen Plattenbau in Halle-
Neustadt zusammen mit Natascha Rossi und Markus Lohmann 2004 mit-
tels Wanddurchbrüchen und der Umnutzung von zurückgelassenen Möbeln
und Einrichtungen der vormaligen Bewohner gebaut haben, wird erst durch
das Kriechen und Klettern der Besucher zum Kunstwerk. Hoefner und Sachs
schaffen künstlerische Erlebniswelten voller Ironie und Dichte.

Ein anderes Projekt in Bezug auf den Leerstand von Wohngebäuden in Halle-
Neustadt, Neuhaus genannt, wurde leider nie realisiert. Mehrere Plattenbauten
sollten durch eine Riesenachterbahn miteinander verbunden und durchfahren
werden. Der Leerstand als Stützbau für eine Welt, die sich von einer Arbeiter-
kultur in eine Freizeitgesellschaft gewandelt hat.

Auch die Installation in der Galerie Faux-Mouvement in Metz aus dem Jahr
2004 bot eine Erlebniswelt, allerdings von einer ganz anderen Art. Als die
Besucher die Galerie betreten haben, war nichts als leere Wände zu sehen.
Hoefner und Sachs hatten mit viel Aufwand eine Ausstellungsarchitektur
errichtet, die wie eine Stellungnahme zu Brian O'Dohertys berühmten Auf-
satz ‹Inside the White Cube› wirkte. Ein Idealmuseum, ein Kommentar zu
den Bedingungen des Ausstellens, zur Aura und Bedeutung von Museums-
architektur. Doch Hoefner und Sachs kommentierten nicht nur das Aus-
stellungswesen, dass im Kunstdiskurs oft wichtiger genommen wird als die
eigentlichen Kunstwerke selbst, sondern fügten eine weitere Dimension ein.
All die Besucher, die genau hinsahen und die gewohnte Grenzen des ‹Bitte
nicht Berühren› im musealen Kontext missachteten, konnten hinter einer
neutralen Tür, wie sie normalerweise zu den Technikräumen eines Museums
gehört, die zweite Ebene der Ausstellung erkunden. Zwischen den Wänden
der Ausstellungsarchitektur versteckt, hatten die Künstler eine Wohnung
gebaut. In klaustrophobisch engen Gängen gab es alles, was eine Wohnung
braucht: Küche, Bad, Schlaf- und Wohnzimmer. Ergänzt wurden diese
Räume durch Kammern, in denen Funktionen untergebracht waren, wie sie
sonst nur Luxuswohnungen beherbergen, wie einen eigenen Fitnessraum oder
Wintergarten. Natürlich war vieles schon allein wegen der Enge des zur Ver-
fügung stehenden Raumes ganz anders, als wir es von ‹normalen› Wohnungen
kennen. Das Kinderzimmer bestand lediglich aus einem Stockbett mit drei
Etagen, aber mit knallbunten Tapeten. Das Wohnzimmer erinnerte eher an
einen schmalen Durchgang, während die Toilette wie einer dieser nachträg-
lich eingebauten Kloschläuche in deutschen Altbauten wirkte, nur noch viel
enger als sonst.

Heute, nach der Aufdeckung einiger grausamer Kriminalfälle u.a. in Öster-
reich gewinnt diese Arbeit eine ganz neue Dimension. Aber als Hoefner und
Sachs 2004 die Installation bauten waren solche Horrorszenarien in unserer
Vorstellung nicht denkbar. Die Künstler beschäftigten sich mit den Themen
rund um das Wohnen und welche Bedürfnisse wie dabei befriedigt werden
können und sollen. Fragen, die nichts von ihrer Bedeutung verloren haben.

Die trotz der Enge begehbare Wohnlandschaft stellt unser gewohntes Verhältnis zu Raumdimensionen, der Funktionalität unserer Wohnungen, unseren Erwartungen am Wohnen überhaupt in Frage. In Frankreich, dem Land, in dem die moderne Architektur wohl die meisten und radikalsten Wohnexperimente ausprobieren durfte (erinnert sei hier nur an Le Corbusier, der im sozialen Wohnungsbau Flure von mehr als 80 Zentimeter Breite als Verschwendung abtat), hat dies sicherlich eine besondere Brisanz. Aber auch in Deutschland wurde die Lage des Wohnmarktes immer wieder durch neue Formen sozialer Architektur aktualisiert. Heute, im Rahmen von Hartz IV, bekommt die Diskussion eine zusätzliche Bedeutung. Welche Wohnbedürfnisse darf ein Mensch haben, wie viel Raum steht ihm und seinen Kindern zu?

Weitere solcher ortsspezifischer Arbeiten entstanden in Berlin zum Beispiel 2004 in den Kellerräumen der Galerie Engler & Piper in Berlin-Prenzlauer Berg, wo das gesamt Lager der Galeristen zweckentfremdet und umgeformt wurde. Aus deren Müll entstand zugleich ihr Traum vom Luxusappartement unter der Erde.

In Berlin-Tiergarten versuchten Hoefner und Sachs im Rahmen eines Theaterfestivals 2005 in einer Wohngemeinschaft mitten in der Großstadt für einige Tage die Utopie einer Autarkie zu realisieren. Dabei wurden aber letztendlich für die Bewohner auf Dauer unzumutbare Zustände aufgrund der Enge des Raums geschaffen. Es handelt sich um eine andere Form des Scheiterns von Wohnutopien.

Andere Formen der Umwandlung unseres privaten Lebensraumes, an dem wir selbst zu einem großen Teil beteiligt sind, haben die Künstler in den Ausstellungen *Sanierungsmaßnahmen* in der Galerie Wendt und Friedmann in Berlin 2007 sowie in der Rauminstallation *Neubau* in der Torstraße in Berlin 2008 gezeigt. Die Künstler benutzten Materialien, die in jedem deutschen Baumarkt zur Renovierung von Privatwohnungen angeboten werden, um ein gemütliches Flair zu Hause zu erzeugen. Es sind Materialien, die etwas vorspielen, wie PVC-Boden, der vorgibt Naturstein zu sein, marmorierte Kacheln, Laminat mit Holzimitat, Raufasertapeten und Gipskartonwände.

Auch hier realisieren Hoefner und Sachs auf ihre eigene Art mit billigem Materialien Neudeutungen von Motiven der Kunst- und Kulturgeschichte. Die geritzten Gipskartonplatten erinnern sowohl an antike Säulen wie an großformatige Arbeiten der amerikanischen Minimalisten. Aus Bodenplatten werden Formen gelegt, wie es Richard Long tut. Aber sie nehmen auch die Spiritualisierung des privaten Wohnens auf die Schippe. An Raufasertapeten wird kreisförmig das Sägemehl freigelegt. Eine Reminiszenz an die Kornkreismythologie, die sich um die Streiche von Jugendlichen in England gebildet hat. Sie bauen aus Fliesen Pyramiden, leicht zu pflegen, völlig zweckfrei und doch aufgeladen mit den esoterischen Ideen, die viele in den Pyramiden sehen. Eine andere Kritik an der Art und Weise, wie in Berlin die Stadt saniert wird, fand in der Ausstellung *Rückbau* 2007 in der Galerie invaliden1 statt, einem

Haus, dass seit Jahren von Abriss bedroht ist. Hoefner und Sachs entfernte aus Gipskartonplatten, die als Wandverkleidung und Raumteiler dienten, un aus den Jalousien, Teile so, dass eine Fachwerkarchitektur entstand. Die ent fernten Elemente brachten sie zum Teil an der gegenüberliegenden Wand ar so dass ein Spiel aus positiven und negativen Formen entstand. Sie bauten m dem ‹Baumüll› aber auch in ihrer ironischen Art wieder ‹sinnvolle Dinge› wi einen Kronleuchter als Lichtquelle und einen Kamin als Heizung.

Mit dem Negativ-Positiv-Verfahren sprachen sie grundlegende Fragen de Bildhauerei und Kunst an, die nicht nur Henry Moore und Rachel Whiterea intensiv beschäftigt haben.

Hoefner und Sachs stehen in der Tradition eines Gordon Matta-Clark, de mit seinen Cuttings die Architektur kritisierte. Sie werden konkret in ihre Kritik, sie erschaffen etwas Neues, indem sie etwas Bestehendes dekonstruie ren und spielen zugleich mit der Fragilität von Material und Vorstellung.

In einer Stadt, in der historische Gebäude bedenkenlos abgerissen werden un zugleich an anderer Stelle verschwundene historische Gebäude wieder aufer stehen zu lassen, üben sie Kritik an diesem falschen Rekonstruktionswahn, a Historisierungsphantasien. Was sie in der Galerie geschaffen haben, mag zwa an die urdeutsche Fachwerkarchitektur erinnern, aber in Berlin gibt es gerad diese Tradition nicht. Am anderen Ende der Invalidenstraße, Ecke Chausee straße, findet man ein reales Vorbild für ihre Installation. Ein Haus, dem i den 1990ern der Stuck angeklebt wurde und das heute als historisch gilt.

Auch die Umwandlung, die Privatisierung und Kapitalisierung des öffentli chen Raums und ihre Auswirkungen werden immer wieder von Hoefner un Sachs in Frage gestellt.

Gera, eine knapp 100.000 Einwohner zählende Stadt in Thüringen, wird sei den 1990er Jahren durch den Bau von überdimensionierten Shoppingmall geprägt, die das Bild der alten Stadt grundlegend verändert haben. Fast da gesamte öffentliche Leben hat sich in diese Konsumtempel verlagert.

Im dortigen Kunstverein stellten Hoefner und Sachs ein fiktives Projekt für ei weiteres Einkaufszentrum vor, dass gar nicht einmal so abwegig ist, wenn ma städtebauliche Vorhaben in Deutschland beobachtet. Das neue Shoppingcen ter sollte nach ihren Plänen den gesamten Marktplatz, der seine ursprüngli che Funktion als sozialer Sammelpunkt und als Haupteinkaufsmöglichke verloren hat, überbauen. Im Kunstverein bauten sie aus Pappe eine ‹Geister shoppingmall› und hängten mit Wasserfarben selbstgemalte Logos von den i Einkaufszentren normalerweise vertretenen Ketten auf. Das Kunstvereinsbür wurde kurzerhand zu einem Informationszentrum für zukünftige potentiell Kunden und Mieter umgewandelt.

Die Dienstleistungsgesellschaft ist ein durchgängiges Thema in der Kunst vo Hoefner und Sachs. Nicht nur in Gera werden Marketingstrategien, zum Bei spiel der Immobilienbranche oder der Tourismusindustrie untersucht und i Absurde verdreht.

Eine weitere Umnutzung von öffentlichem Raum thematisierte Harry Sachs zusammen mit Markus Lohmann und Michael Boehler 2002 mit der Mehrzweckhalle in der Hamburger HafenCity.

Die HafenCity ist ein gigantisches Bauprojekt in Hamburg, das einen ganzen Stadtteil im Zentrum der Stadt umwandelt und Wohnraum für die besserverdienenden Schichten schafft. Angereichert wird es durch Prestigekultur wie der geplanten Elbphilharmonie der Stararchitekten Herzog & de Meuron. Ein Großteil der Bevölkerung wird ausgeschlossen, nicht nur Arme, sondern auch Normalverdiener, für die weder Wohn- noch Aufenthaltsräume geschaffen werden.

In der Bauphase der HafenCity konnten die Künstler eine temporäre Mehrzweckhalle aus Gewächshäusern und Containern in Bezug auf den Ort und das Geschehen dort, errichten. Durch Zeitungsannoncen wurde die Mehrzweckhalle zur Nutzung angeboten und vom Schützen- bis zum Karateverein genutzt. Die Nutzer bestimmten das Programm. Die HafenCity wurde durch diese temporäre Mehrzweckhalle zu dem was sie eigentlich sein sollte, zu einem Zentrum für alle Hamburger mitten in der Stadt.

Eine ähnliche Aneignung eines Kunstwerkes von Hoefner und Sachs durch die Bevölkerung geschah 2008 in Riga, wo sie ein Gewächshaus durch eine geringfügige Veränderung zu einer gläsernen Kapelle verwandelt hatten. Auf einer Insel, gegenüber der historischen Altstadt mit ihren Kirchtürmen gelegen, wurde die Glashauskapelle zu einem beliebten Fotomotiv für Brautpaare. Weil es in Riga ein generelles Verbot gibt, im öffentlichen Raum Alkohol zu trinken, entdeckten trinkfreudige Bürger in dem voll einsehbaren Glashaus einen geselligen Schutzraum vor Wetter und Polizei. Eine Nutzung, die so nicht geplant war. Aber eine Kunst, die erst durch die Besucher erfahrbar wird, rechnet programmatisch mit unerwarteten Nutzungen und Interpretationen.

So wie sich in Riga Bürger eine Arbeit von Hoefner und Sachs als rechtsfreien Raum aneigneten, fanden Hoefner und Sachs für das Projekt *Douaneville* 2004, in Zusammenarbeit mit Michael Boehler und Markus Lohmann, in Hamburg einen rechtsfreien Raum. Am Übergang zum Freihafen gibt es ein Zollhaus, auf das sie eine kleine Wohnwagensiedlung stellten, die aufgrund ihres schäbigen Charakters, aber auch der Musik und des durch Zeitschaltuhren unregelmäßig aufleuchtenden Lichts wie bewohnt wirkte. Der Eindruck, dass sich jemand dort niedergelassen hatte, erzürnte die Boulevardmedien ebenso wie die Behörden. Das Absurde, dass sie dies ausgerechnet auf dem Gebäude eines Zollamtes, also einer deutschen Behörde, getan haben sollten, fiel niemanden auf, sondern erregte um so mehr die Gemüter. Die Panik vor der Okkupation des öffentlichen Raumes durch Roma, Hausbesetzer, Obdachlose oder Dauercamper war so groß, dass niemand genauer hinsah. Doch die Behörden waren machtlos dem potemkinschen Dorf ein Ende zu bereiten. Das Flachdach befand sich rein rechtlich gesehen in einer städtebaulichen Situation, in der keine Behörde zuständig war. Über den interessanten Aspekt der Installation, an welchem Ort wer unter welchen Umständen leben kann, will oder muss, wie wir mit anderen Wohnformen, mit Migranten und Feindbildern umgehen wollen und können, wurde dagegen kaum diskutiert.

Auch mit ihrer jüngsten Arbeit überschreiten Franz Hoefner und Harry Sachs Linien, die im Alltag nicht immer auffallen. Die Aneignung des öffentlichen Raumes durch Werbeträger, die als Sponsor für Stadtmöbel auftreten, ist schleichend. Das Städtemarketing verspricht erhöhte Lebensqualität, aber das Geld für eine Begrünung des Problembezirks Berlin-Neukölln fehlt. Hoefner und Sachs spielen mit dem Namen der in Berlin dominierenden Werbefirma Wall und verdecken mit einem mobilen Kleinwald aus aufblasbaren Palmen die Werbeträger für kurze Augenblicke. Sie verwandeln für Momente, ohne jede Ankündigung, die tristen winterlichen Kreuzungen der Stadt in einen Traum von der Südsee.

Die Straßenkreuzungen von Neukölln sind manchmal eine öde triste Gegend, in die sich kaum ein Mensch verirrt. Aber Hoefner und Sachs haben eine Vorliebe für Orte, die an der Peripherie liegen, die kulturell noch nicht determiniert sind, aber dennoch das Leben von vielen Menschen prägen und formen. Es sind Orte am Rand, in der Provinz oder eben auch in der Mitte der Stadt, die nur bislang von vielen ignoriert worden sind. Hoefner und Sachs öffnen uns die Augen für diese Orte und was mit ihnen geschieht.

Arne Winkelmann
Home Art

--

An approach to the work of Franz Hoefner and Harry Sachs

Are you still just living …?

The advertising slogan ‹Wohnst Du noch oder lebst Du schon?› used by IKEA in Germany since 2002 is intended as a clever piece of sophistry that potential consumers will find catchy. It roughly translates as: ‹Are you still just living or have you started to really live yet?› (One aspect gets lost in translation here: the first ‹living› means simply ‹dwelling› or ‹residing›, while the second ‹live› implies ‹living life›.) One could easily dismiss this slogan as being nothing more than a witty turn of phrase. However, this hackneyed marketing catchphrase actually offers an approach to understanding the works of Franz Hoefner and Harry Sachs which considers issues such as living, homes, housing, houses, space and furnishings. For more than ten years, the Hoefner & Sachs team (sometimes in collaboration with Michael Boehler and Markus Lohmann) has been working with a broad range of issues concerning everyday human dwellings, and with other locations and spaces that appear ordinary at the first glance.

The IKEA slogan inherently classifies the value of habitation and home-life as somehow being below that of really living one's life, which raises the question as to what axiological system of relative values can justify this hierarchy. Is inhabiting or residing to be equated with ‹not really living›? And does domestic home-living merit a lower ranking on the value scale? Franz Hoefner and Harry Sachs would probably answer this question by saying that living, in the sense of residing at home, and the unconscious, passive shaping of the patterns of everyday life can be regarded as something distinct from the active, affirmative process of experiencing our surroundings. In their works, Hoefner and Sachs deal with the paradox of people who are surrounded by their houses, offices and home furnishings all the time, yet hardly seem to pay any attention to them, let alone arrange them in a comfortable way. The very thing that should really be of burning interest to the user of an office building, shopping centre, hotel or private home because of its omnipresence and unavoidability – i.e. shaping the built or spatial environment in a pleasant, quality manner – is often of little importance to the user and is not even consciously perceived. People's numbness with regard to their immediate environment is a bottomless reservoir of inspiration for the two artists.

In their *Privat* installation in Galerie Engler & Piper, the artists present home-living as an easily-satisfied vegetative existence, as if a mere ‹roof over your head› is enough. Visitors pass through the empty white exhibition space and arrive at an apartment door adorned with a name, doorbell and outside light in the back corner. The door provides access to what is intended to be the home of the two gallery owners. Visitors pass through this door into the basement, where they discover an unimaginably messy and neglected apartment. The labyrinth formed by the low-ceiling rooms is stuffed with old furniture, sheets and planks of wood, old electrical devices, carpet off-cuts, car tyres, posters, leftover pieces of fabric … in short, everything that you would expect to find in a storage room after a few years. Hoefner and Sachs convert this detritus of our affluent, modern lifestyles – furnishings, construction materials and other waste – into a living room, bedroom, kitchen, bathroom, sauna, and even a patio garden of sorts. They moved, tidied, piled up, combined, stuffed, sawed, screwed, hammered, bent, improvised, tinkered, pieced together, arranged, hung, decorated, draped, adorned, sorted and highlighted. Ugly, worn-out couch coverings made out of gaudy fabrics and brown corduroy become comfy, welcoming corners in which to lie down, cuddle and listen to some good music, a pastime suggested by the plethora of loudspeakers. The walls are covered with posters from the 1980's. Artificial flames in a fireplace flicker in the corner. In front of the fireplace, there is a huge pile of firewood. In another little room, Styrofoam panels (once the packaging for some shiny new device) and two gas heaters are combined to give the impression of a sauna. This particular construction is absurd, but at the same time visitors wonder if this sauna could actually work. In another corner, two bed-side lamps indicate that the two dirty wooden pallets beside them are bunk beds and that this room is the bedroom.

The density and claustrophobia of this environment is reminiscent of 17th-century cabinets of curiosities (‹Wunderkammer›) where baroque princes displayed random collections of unique objects that were intended to impress viewers with their workmanship and rareness. Just like a Wunderkammer, *Privat* elicits a gasp of astonishment and marvel, followed by a chuckle or laugh. Despite all the smiling when you first view this elaborate interior of objets trouvés, the viewer might also experience a slight sensation of disgust, and notice some striking parallels with contemporary social issues. The ‹organised chaos› is reminiscent of temporary shelters built under bridges by homeless people. Other allusions include: cluttered apartments of compulsive hoarders; apartments left in haste by renters in arrears, who move before the landlord catches up with them; or spartan living quarters of illegal foreign workers who are powerless to complain. This is how things look when society's outcasts vegetate, living one day at a time and thus remaining on the lower level of IKEA's two-tier system. They only have a home instead of having a real life. Through these parallels, a critical commentary on contemporary society emerges from behind the irony and humour that Hoefner and Sachs employed when building this underground dwelling. Is it possible to call this living, or are we dealing with another form of existence here?

The *Douaneville* installation in Hamburg posed similar questions. Caravans, tents and camping furniture were set up on the roof of a customs checkpoint at the entry to the port in Hamburg. Satellite dishes facing the skies, clothes hung out to dry and interior lights all gave the impression that a group of squatters or vagabonds had set up a small community. Here too, it looked like a marginalised group in our society had established an abode where they would be able to exist in peace. The idea of living is reduced to sheltering oneself from the wind and the elements, and demands a permanent state of improvisation with temporary and imperfect solutions. This open display of the people's private sphere became a public nuisance to the people of Hamburg. Is living really something private?

In their installations *Interieur (Interior)*, *Neuhaus Wohnerlebniswelt (Neuhaus home-experience world)* and *Utrechter Hütte (Utrecht hut)*, Hoefner and Sachs examined the cultural and sociological aspects of living. Home furnishings and paraphernalia such as furniture, pictures, accessories, and electrical and electronic equipment are not only an expression of a person's personality; they can also indicate which social class the owner belongs to. The sociologist Pierre Bourdieu was not the first to point out that people's social status is reflected in their homes and how they are furnished.[1] A individual's home is the symbolic manifestation of the social milieu to which he or she belongs.

In their installations, Hoefner and Sachs offer us revealing and intimate insights into milieus that are often not very familiar to art connoisseurs, such as the ‹Harmoniemilieu› (constituted by folks who tend to be older and value comfort and cosiness) and the ‹Unterhaltungsmilieu› (constituted by younger individuals in pursuit of entertainment and the next kick).[2] The *Neuhaus Wohnerlebniswelt (Neuhaus home-experience world)* installation saw visitors crawl through a labyrinth-like series of tunnels constructed from left-behind wall units, doors, lamps, carpets and wallpaper in an East German ‹Plattenbau› tower block in Halle-Neustadt that was soon to be demolished. Just like *Alice in Wonderland* or *Gulliver* in the land of *Lilliput*, the visitor was able to creep through a miniature ‹architecture› made from mass-produced furniture. The visitor encountered close-up just how cheap, fake and fragile these items are/were, and saw for themselves the products' designed obsolescence. The altered perception combined with the narrowness of this environment caused the decors, patterns, and the pseudo-materiality of the wood, tiles and plaster to take on a new, eerie character. In a poetic and entertaining manner, Hoefner and Sachs, in collaboration with Markus Lohmann and Natascha Rossi, exposed these items of furniture for the imitations, representations and fakes that they are. Chipboard or particle board, the raw material for these furnishings, symbolises the contradiction between the furniture's inner structure, where cost-efficient manufacturing is the goal, and its surface design, which attempts to imitate a high-quality finish. There is a discrepancy between materiality and surface, and between essence and appearance[3], which leads us back to the dichotomy of ‹still just residing› or ‹living the real, beautiful life›. This project raises the pointed question as to whether the materials the artists work with are rich man's or poor man's waste.

In his book ‹Über das Neue (The new)›, Boris Groys differentiates between ‹cultural archive›, formed by collections, archives, museums and the like, and ‹profane space›, which contains everyday and trivial items.[4] However, the profane space is actually a source of new material for the cultural archive, with the crossover process governed by certain selection mechanisms, transformations and shifts. This approach can be applied to the interpretation of *Neuhaus Wohnerlebniswelt (Neuhaus home-experience world)*. Banal, trivial and otherwise un-aesthetic objects and materials are presented as items worthy of our attention.

However, it must be said that the artists are not arrogantly deriding the tower block residents and their taste in interior decoration. They are not patronising these people's aesthetic judgements or sense of style. The *Utrechter Huette (Utrecht hut)* piece brings the trappings of cosiness and domestic comfort to their natural conclusion by subjecting a wall unit to a deconstructive transformation and rebuilding it into a little hut. A homely wall unit with wood veneer, moulded doors, crown glass and beading is cut-up and reconfigured into a wooden hut that represents people's desire for homely comfort and simple layouts. This transformation corresponds very closely to the description of home-furnishing styles preferred by the ‹Harmoniemilieu› (those who value home comforts above all else) as ascribed by Schulze: ‹Interior space is adopted and made one's own by filling gaps and creating other gaps (which themselves are to be filled – such as the shelving in wall units or the space under a television table), by introducing shade, breaking up flat surfaces, using patterns, and by creating that unmistakable homely smell that is given off by home-comfort objects.›[5] The small, cosy hut captures the taste of the more conservative elements of our society, and also represents their desire for an ideal, dream house.

Desires and dreams relating to home-life are the driving force behind the uninterrupted success enjoyed in recent decades by the furniture industry, interior furnishing outlets and DIY hardware stores; indeed, this success seems to continue regardless of the economic climate. The commercial exploitation of people's longing for dream houses, for their own castles in the sky, is another question that shapes the work of Franz Hoefner and Harry Sachs.

‹… have you started to really live yet?›

Surely the next step up from simply residing is to progress to the fulfilment of your interior design dreams. This is what furniture stores like IKEA and major home-improvement stores promise with their advertising slogans: the customer will finally be able to become an individual! These stores' marketing tells us that there are no limits to our creativity, that everything is possible,

and that the customer's individual taste alone will shape their dream home. The reality is that these slogans are just empty promises and clever phrases that try to con us into believing that the act of selecting a few items from the stores' (admittedly large) product range actually has anything to do with creativity and individuality. The truth is that making an individual selection from a limited range of goods is not the same thing as individuality.

IKEA is a symbol of the standardisation of home furnishing which has resulted in interiors all over the world now looking largely the same. The standardisation and conformity of industrially produced goods has lead to a certain monotony of everyday aesthetics. A similar monotony also existed, for quite different reasons, in the Warsaw Pact countries before the fall of the Berlin Wall. Customers may be convinced of their aesthetic independence and the individuality of their tastes, but in fact they are often buying nothing other than lowest-common-denominator, mass-produced goods.

Hoefner and Sachs address the way business trades in people's desires and ideals for home-living in their *Neueröffnungen (Newly opened)* series of works, which included the installations *Kuchen Immobilien (Kuchen real estate)*, *Fremdenverkehrsamt (International tourist board)* and *Club Ibis*. As suggested by the subtitle of *Kuchen Immobilien*, this ‹Showhouse exhibition› deals with people's dream of owning their own home. Using the terminology of the property and mortgage sectors, Hoefner and Sachs create a range of home ambiences that promise certain well-defined life experiences and moods. The prospect of ‹living under your own roof›, which has represented the ideal form of living in the minds of most Germans for decades, is sold to a social class that can't actually afford to build its own house, but for whom this dream is to become reality anyway, regardless of their financial situation. Using wallpaper with photos and other patterns, the artists have created interiors that expose and mock these empty promises of ‹living happily ever after›. Wallpaper with an ivy-and-brick print was used to create the *Burg (Castle)* model; wallpaper with wooden panels was used for the *Fort* model; a combination of these two types of wallpaper was used to create *Fachwerk (Timber-frame design)*; and photo wallpaper showing the New York skyline appeared on the *Hochhaus (Tower block)* model. Modest in scale and with mediocre workmanship, these interiors are the opposite of the dreams and illusions created in the customers' heads by the marketing slogans. Visitors to the exhibition simply have to laugh when they walk past these crude façades made from chipboard and wallpaper. However, the sense of disappointment generated by empty promises is the real, bitter downside to the real estate industry's marketing strategies. Perhaps even more tragic is that this deception is not even noticed, as many customers do not complain, and instead simply lower their expectations when faced with what is really on offer.

Dreams are thus only fulfilled when customers' fantasies are corrupted by the fantasies of the marketing slogans. After one has purchased the advertised fur-nishings, such as furniture, lifestyle products and other accessories, he or she is forced to answer the second half of IKEA's question ‹… *or have you started to really live yet?*› with a resounding ‹Yes!› Today, dreams are no longer fulfilled by fairies, but rather by big industry. The magic words are ‹standardised›, ‹cheap› and ‹economical›. Hoefner and Sachs play with the desires that are triggered by promising slogans, and also with the cheap shabbiness which is often the underlying reality. Such is the case in the duo's fictitious *Fremdenverkehrsamt (International tourist board)* that they set up in the former Bulgarian tourist office in Berlin.

In this installation, they dealt with the artificial ‹experiences› offered by the tourist industry, which are supposed to allow us to really live and enjoy new experiences, even if only for a few days, as some sort of compensation for our dull, everyday existences[6]. Hoefner and Sachs adopt the language and countless catchphrases of the tourist industry that are used to market exotic and idyllic ‹paradise destinations› and the entertainment and leisure activities on offer there. The mismatch between the flowery language of these marketing campaigns and the grim reality that tourists eventually discover is so stark that countless hours of television shows have been dedicated to investigating the more shady sections of this market.

Using panelled chipboard and furniture acquired from bankruptcy clearouts, Hoefner and Sachs furnish a sample hotel room, sports facilities, health spa and beach – all done ironically, following the ‹as cheap as possible› principle. The hotel room is furnished in such a way as to leave no doubt that corporate identity and ease of maintenance and cleaning are much more important than any comforts a tourist might enjoy. The so-called ‹guests› are more regimented and confined than they would be at home, and their living conditions are even more standardised. The promised spectacular holiday experience turns out to be ruled by guidebooks and instructions from holiday organisers.

Uniformity and standardisation are also the focus of the *Club Ibis* video installation. Many hotel chains aim to provide the same level of comfort worldwide. They are characterised by a well-defined, uniform hotel experience no matter where you are in the world – reproduced by interior designers and architects right down to the last trivial detail. The rooms in these hotel chains actually represent the very opposite of what a trip or vacation should be all about – i.e., new and unusual experiences in foreign, exotic places. Instead, what the tourist gets is the certainty of uniformity and normality. Hoefner and Sachs' video is shot as an intimate play, documenting a human experiment where they lock themselves for a few days in a room of the Hotel Ibis in Rennes, France. The video is intended as a user manual for how to break the monotony of standardised hotel rooms. They come up with imaginative scenes and activities which squeeze some fun and life from the standardised furnishings: an evening around a campfire, a thrilling ski descent and a horse ride. Hoefner and Sachs describe this piece by saying that the video ‹shows

how you can transform the hotel room into a mini activity park with the help of a television set›. Here, the ‹living› that begins after mere passive habitation has ended actually takes place on TV. The modified question here is: Are you just sitting around or have you finally started to live vicariously via your TV?

‹…… .. …. …. ….. .. ….. ?›

Marketing slogans, promises, logos and jingles are omnipresent aesthetic phenomena. Hoefner and Sachs take a critical stand against them in their own graphic images and mock-advertising. A logo is associated with almost all of their works, such as palm and fir trees for *Fremdenverkehrsamt (International tourist board)*, the city coat of arms for *Honey Neustadt,* dually derived from the hexagonal form of honeycombs and of benzene rings in chemistry, and the house and castle for *Kuchen Immobilien.* Each of these logos captures the central idea of the installation, while at the same time mocking the commercial intent always present behind such simple emblems. Consider, for example, the *Kuchen* logo with its stylised outline of an archetypical house in front of the tower of a caste, which can be construed as a reference to the familiar saying ‹my home is my castle›. Other cliché-laden advertising slogans expose the platitudes contained in real marketing language.

In their *erikaLand* project, Hoefner and Sachs satirise the omnipresence of emblems, symbols and icons in their ironic, humorous manner. For the *Amerika Festival,* the disused buildings of the *Werkleitz Gesellschaft Halle / Saale* industrial site are converted into a collection of symbols of the USA. This work is an oversized objet trouvé where Hoefner and Sachs, together with Michael Boehler, take found objects, remove them from their original context, and rearrange them to present a whole new meaning. Using insulation boards found on site, the façade of the industrial building is covered with a huge star-spangled banner (emblem). Another hall is transformed by adding a flag. A white marquee is turned into the White House (icon). Using basement doors, the artists build a fort as a symbol of the Wild West and the age of westward expansion in America. By draping a camouflage net over a hedge, they create a symbol of recent American cultural imperialism, which alludes to the wars and ‹pre-emptive strikes› of the George W. Bush era. The omnipresence of symbols and images leads to sensory overload, and actually serves to reduce the power of other forms of communication too.

For the *Forum Arcaden* installation in the Kunstverein Gera, framed watercolours of the logos of well-known German retail chains ridicule these logos by elevating them to the status of art. Hoefner and Sachs intend that these watercolours will serve as the base coordinates for a fictitious, planned shopping mall aimed at bringing life back to Gera's city centre – a plan shared by many towns in former East Germany. The reverential representation of these logos is meant to present them as good luck charms which promise salvation in the form of readily available consumer goods. It is regrettable and even sad

to think just how self-evident, inflationary and free of criticism the use and perception of logos has become, and we should be thankful to Hoefner and Sachs for their ironic commentaries on this phenomenon.

All together now in your best Swedish-German accent: ‹Wohnst Du noch oder lebst Du schon?›

1 Pierre Bourdieu et al., Der Einzige und sein Eigenheim. (~The individual and the home.) Hamburg 1998, p. 26.

2 See Gerhard Schulze, Die Erlebnisgesellschaft. Kultursoziologie der Gegenwart (~Event society. Contemporary cultural sociology), Frankfurt am Main, New York, 2000, p. 292ff and 322ff.

3 Gernot Böhme, Atmosphäre. Essays zur neuen Ästhetik (~Atmosphere. Essays on the new aesthetic), Frankfurt am Main, 1995, p. 58

4 Boris Groys, Über das Neue. Versuch einer Kulturökonomie. (~The new. A study of cultural economics.) Munich, Vienna 1992

5 Gerhard Schulze, Die Erlebnisgesellschaft. Kultursoziologie der Gegenwart (~Event society. Contemporary cultural sociology), Frankfurt am Main, New York, 2000, p. 293

6 Michel Foucault, Andere Orte (~Other places), in: Aisthesis. Wahrnehmung heute oder Perspektiven einer anderen Ästhetik (~Aisthesis. Perception today or perspectives on another aesthetic), Leipzig 1998, p. 46

Arne Winkelmann
Kunst daheim und zuhause

Eine Annäherung an das Werk von Franz Hoefner und Harry Sachs

Wohnst Du noch …?

Der Slogan ‹Wohnst Du noch oder lebst Du schon?›, mit dem der Möbelhersteller IKEA seit 2002 wirbt, dient als sophistischer Stolperstein dazu, sich im Kopf der potentiellen Konsumenten einzugraben und könnte als lustiges Wortspiel abgetan werden. Doch lässt sich mit diesem abgenutzten Werbebonmot ein Zugang zu den Arbeiten von Franz Hoefner und Harry Sachs finden, der um Themen wie Wohnen, Heim, Behaust-Sein, Haus, Raum und Einrichtung kreist. Seit nunmehr über zehn Jahren beschäftigt sich das Künstlerduo – teilweise auch in Zusammenarbeit mit Michael Boehler und Markus Lohmann – mit dem Themenkomplex der alltäglichen menschlichen Behausung beziehungsweise scheinbar gewöhnlichen Orten und Räumen.

Im IKEA-Slogan wird der Wert des Wohnens unter den des Lebens gestellt, was zunächst die Frage nach der Axiologie aufwirft, die eine solche Priorisierung erklären würde. Heißt Wohnen demnach Nicht-Leben oder ist es auf einer niedrigeren Daseinsstufe anzusiedeln? Franz Hoefner und Harry Sachs würden die Frage vielleicht damit beantworten, dass sich das Wohnen als eine unbewusste und passive Gestaltung des Alltags vom aktiven und affirmativen Erleben der Umgebung unterscheidet, denn mit ihren Arbeiten thematisieren sie genau diese Paradoxie, dass man mit seinem Haus, seinem Büro, seiner Wohnungseinrichtungen tagtäglich umgeben ist und ihr doch kaum Beachtung schenkt, geschweige denn sie adäquat für sich gestaltet. Das, was den Nutzer eines Bürogebäudes, einer Einkaufspassage, eines Hotels oder seines eigenen Zuhauses alleine durch seine Omnipräsenz und Unausweichlichkeit eigentlich brennend interessieren müsste, nämlich die qualitätvolle Gestaltung seiner baulich-räumlichen Umwelt, ist ihm in den meisten Fällen gleichgültig oder in seinem Bewusstsein gar nicht existent. Die Anästhesie gegenüber der unmittelbaren Umgebung stellt für die beiden das schier unerschöpfliche Reservoir ihrer Inspiration dar.

In der Installation *Privat* in der Galerie Engler & Piper haben die Künstler das Wohnen als anspruchsloses Vegetieren, als primitives Hausen dargestellt: Der Betrachter passiert zunächst weiße, leere Galerieräume, um in einer hinteren Ecke zu einer Wohnungstür mit Klingelschild und Laterne zu gelangen, wo angeblich die beiden Galeristen wohnen. Durch diese Tür steigt er in einen Keller hinab in eine unbeschreiblich verwahrlost anmutende Wohnung. Das Labyrinth der niedrigen Räume ist vollgestopft mit alten Möbeln, Brettern, Latten, ausgedienten Elektrogeräten, Teppichresten, Autoreifen, Postern,

Stoffresten … kurz allem, was sich in ein paar Jahren in einem Lagerraum so ansammeln kann. Hoefner und Sachs haben diesen Wohlstandsmüll von Einrichtungsgegenständen, Baumaterialien und Abfällen zu einem Wohn-, einem Schlafzimmer, einer Küche, einem Bad, einer Sauna und sogar einem ‹Vorgarten› umgestaltet. Sie haben umgestellt, umgeräumt, übereinandergestapelt, geschachtelt, gestopft, zersägt, verschraubt, genagelt, gespaxt, verkantet, gebastelt, gefrickelt, gestückelt, haben arrangiert, aufgehängt, dekoriert, drapiert, verziert, sortiert und inszeniert. Hässliche, durchgesessene Couchgarnituren mit bunten Stoffen oder braunem Breitcord bezogen bieten ‹gemütliche› Kuschelecken und Liegestätten für den distinguierten Musikgenuss, wie die Unmenge der Lautsprecherboxen vermuten lassen, die Wände sind mit einer Plakatsammlung ausgekleidet, die offensichtlich aus den Achtzigern stammt, und in einer Ecke züngeln die künstlichen Flammen eines Kamins, vor dem sich eine Schwung Holzscheite ergießt. In einem anderen Gelass wurde aus Styroporplatten einer Geräteverpackung und zwei Gasheizgeräten (Gamaten) eine Sauna imitiert, bei der sich der amüsierte Besucher fragt, ob sie tatsächlich funktionieren könnte. In wieder einer anderen Ecke signalisieren zwei Nachttischlampen, dass die zwei derben Holzpritschen daneben Stockbetten darstellen sollen und der Betrachter sich nun im Schlafzimmer befindet.

In ihrer Dichte und Fülle erinnert dieses Environment an die Wunderkammern des 17. Jahrhunderts, in denen Barockfürsten ihre willkürliche Sammlung von Kuriositäten ausstellten, die ob ihrer Machart und Einzigartigkeit staunen machen sollten. Denn auch diese Einrichtung lässt den Betrachter staunen, wundern und kopfschüttelnd lachen. Doch bei allem Schmunzeln über dieses illustre Objet trouvé Interieur beschleicht den Besucher auch manchmal der Ekel und er assoziiert sehr unappetitliche Zeitphänomene: Dieses geordnete Durcheinander erinnert an die ‹Penner-Ecken›, die Obdachlose sich unter Brücken als Ersatz-Zuhause einrichten, an die überfüllten und vollgestopften Wohnungen von Messies, an die Hinterlassenschaften von Mietpiraten, die vor dem Zorn des Vermieters zur nächsten Bleibe geflüchtet sind, an spartanische Unterkünfte von illegal eingeschleusten Arbeitskräften, die sich über diese Zumutungen nicht beschweren können … So könnte es aussehen, wenn man als gesellschaftlich Ausgestoßener oder Benachteiligter eher vegetiert, am Existenzminimum dahinlebt und damit ‹noch wohnt› und nicht lebt beziehungsweise erlebt. So lugt hinter der Ironie und Scherzhaftigkeit, mit denen Hoefner und Sachs diese ‹unterirdische› Behausung geschaffen haben, doch immer ein kritischer Zeitbezug hervor. Kann man noch von Wohnen sprechen oder ist das eine andere Existenzform?

Ähnlich wirkte die Installation *Douaneville* in Hamburg: Auf der Überdachung einer Zollstation an der Grenze zum Hamburger Hafen wurden Wohnwägen, Zeltpavillons und Campingmöbel aufgestellt. Ausgerichtete Satelliten-Schüsseln, flatternde Wäschestücke und leuchtende Lampen suggerierten, dass sich dort eine Wagenburg von Obdachlosen gebildet hätte. Auch

hier sah es so aus, als ob sich eine gesellschaftliche Randgruppe ihre Existenznische geschaffen habe. Wohnen wird dabei auf die Schutzfunktion vor Wind und Wetter reduziert, Wohnen im permanenten Moment des Improvisierten, Vorläufigen und Imperfekten. Dieses Exponieren des Privaten wurde zu einem öffentlichen Ärgernis in Hamburg. Ist das Wohnen wirklich Privatsache?

Auch mit den Installationen *Interieur*, *Neuhaus Wohnerlebniswelt* und *Utrechter Hütte* umkreisen Hoefner und Sachs die kultursoziologische Dimension des Wohnens. Die Wohnungseinrichtung mit all ihren Möbel, Bildern, Accessoires, Gerätschaften und anderem ist nicht nur Ausdruck der individuellen Persönlichkeit ihrer Bewohner, sondern erlaubt auch die Zuordnung zu deren Milieuzugehörigkeit. Der Soziologie Pierre Bourdieu hat nicht als erster darauf aufmerksam gemacht, dass sich das soziale Sein des Bewohners in seinem Haus respektive seiner Wohnung und Einrichtung abbildet und objektiviert.[1] Das Eigenheim ist die symbolische Manifestation der Milieuzugehörigkeit.

Mit ihren Installationen geben Hoefner und Sachs intime, fast bloßstellende Einblicke in Milieus, die dem Kunstconnaisseur oftmals sehr fern sind, wie dem sogenannten ‹Harmonie-› oder dem ‹Unterhaltungsmilieu›.[2] Bei der Installation *Neuhaus Wohnerlebniswelt* kriecht der Besucher durch einen labyrinthischen Tunnel, der aus den zurückgelassenen Schrankwänden, Türen, Lampen, Teppichen und Tapeten eines zum Abriss freigegebenen Plattenbaus in Halle-Neustadt gebaut wurde. Wie Alice im Wunderland oder Gulliver im Lande Liliput krabbelt der Betrachter durch die ‹Architektur› industrieller Massenmöbel und bekommt so nahe – fast unerbittlich – wie sonst nie vor Augen geführt, wie billig, unecht, labil und auf Verschleiß konzipiert diese Einrichtungsgegenstände waren beziehungsweise sind. Durch die Wahrnehmungsverschiebung und Enge entfalten die Dekors und Muster der Werkstoffe, die Scheinmaterialität von Holz, Ziegelsteinen oder Putz eine ganz eigene, befremdliche Wirkung. Hoefner und Sachs zusammen mit Markus Lohmann und Natascha Rossi legen das Wesen dieser Möbel als Imitate, Simulacra und Fakes offen, wenn auch auf eine sehr poetische und unterhaltsame Weise. Die Spanplatte als ‹Rohstoff› dieser Möbel verdeutlicht das Auseinandertreten von innerem Design, also einem möglichst ökonomischen Herstellung und Oberflächendesign sprich, der Imitation eines wertigen Materials, die Diskrepanz von Materialität und Oberfläche, von Sein und Schein[3], womit schon wieder die Dichotomie vom Noch-Wohnen oder Schon-Leben ableitbar wäre. Fast sarkastisch zieht die Frage herauf, ob es sich hier noch um Wohlstandsmüll oder Armutsmüll handelt, den die Künstler verarbeitet haben.

Boris Groys hat in seiner Betrachtung ‹Über das Neue› dem ‹kulturellen Archiv›, also den Sammlungen, Archiven, Museen usw. den ‹profanen Raum› gegenübergestellt, der Alltägliches und Belangloses beinhaltet.[4] Dieser profane Raum stellt jedoch das Reservoir dar, von dem aus die kulturellen Archive durch bestimmte Auswahl, Umstellung und Verschiebungen erweitert werden. So könnte man auch die Installation *Neuhaus Wohnerlebniswelt* verstehen, bei der banale, triviale, fast anästhetische Objekte und Materialien als Gegenstände der Betrachtung und Wahrnehmung inszeniert werden.

Die Künstler machen sich jedoch nicht über die Bewohner dieser Plattenbauwohnungen und deren Geschmack lustig. Sie desavouieren deren ästhetische Urteilsfähigkeit oder Stilempfinden nicht. In der Arbeit *Utrechter Huette* wird sogar in psychologischer Einfühlung das Gemütlichkeitsschema des Harmoniemilieus durch die dekonstruktivistische Transformation einer Schrankwand in ein kleines Häuschen vollzogen. Aus einer rustikalen Schrankwand mit Holzfurnier, kassettierten Türchen, Butzenscheiben und Zierleisten wurde ein archetypisches Holzhaus gezimmert, das den Wunsch nach heimeliger Gemütlichkeit und häuslicher Überschaubarkeit visualisiert. Dieser Transformationsprozess entspricht in fast kongenialer Weise der Beschreibung des Einrichtungsstils des Harmoniemilieus bei Schulze: ‹Die Aneignung des Innenraums vollzieht sich hier durch Besetzung von Lücken, durch Schaffen von Höhlen (die wiederum besetzt werden wie die Arkaden der Schrankwand oder wie der Raum unter dem Fernsehtischchen), durch Verdunklung, Unterbrechung glatter Flächen, Musterung und durch Erzeugung einer unverkennbaren Wolke von Stallgeruch, die aus einem heterogenen Materiallager der Gemütlichkeit gespeist wird.›[5] Die kleine, gemütliche Hütte versinnbildlicht das Stilempfinden konservativer Bevölkerungssegmente und deren Suche nach dem Ideal, dem Traumhaus.

Denn solche und andere Sehnsüchte und Wunschvorstellungen des Wohnens sind es, die die Möbelindustrie, den Einrichtungshäusern und vor allem den Baumärkten seit Jahrzehnten zu stetigen fortschreitenden und von allen baukonjunkturellen Einbrüchen unbeeindruckten Aufstieg verholfen haben. Die kommerzielle Ausbeutung dieser Visionen von Traumhäusern, von Luftschlössern und Wolkenkuckucksheimen stellt einen weiteren Aspekt dar, der das Werk von Franz Hoefner und Harry Sachs maßgeblich prägt.

‹… oder lebst Du schon?›

Was also soll nach dem Wohnen kommen, wenn nicht die Einlösung aller gestalterischen Einrichtungsträume. Das was Einrichtungshäuser wie IKEA und Baumärkte mit ihren Werbeversprechen suggerieren, ist die ästhetische Selbstverwirklichung des Kunden. Der Kreativität seien keine Grenzen gesetzt, alles sei möglich und nur der individuelle Geschmack des Kunden entscheide, verheißen die Anbieter solcher Wohnträume. Doch sind dies nur leere Floskeln und Wortkulissen, die vorgaukeln, dass die getroffene Auswahl aus dem (wenn auch vielfältigen) Warensortiment etwas mit kreativer Selbstverwirklichung zu tun hätte. Denn eigentlich hat die individuelle Auswahl aus einem beschränkten Angebot nichts mit Individualität zu tun. IKEA stellt den Inbegriff der Standardisierung von Wohnkultur dar, der in globalem Maßstab zu einer Vereinheitlichung der Inneneinrichtung geführt

hat. Diese Standardisierung und Normierung von Industrieprodukten führt zu einer Egalisierung der Alltagsästhetik wie sie im früheren Ostblock aus ganz anderen Gründen angestrebt wurde. Im Glauben an seine ästhetische Unabhängigkeit und die Individualität seines Geschmacks kauft der Kunde oftmals nichts anderes als mehrheitsfähige Massenware.

Hoefner und Sachs widmen sich diesem kommerzialisierten und ökonomisierten Handel mit Sehnsüchten und Wunschvorstellungen des Wohnens in ihrer Aktionsreihe *Neueröffnungen*, die unter anderem aus der Ausstellung *Kuchen Immobilien*, der Installation eines *Fremdenverkehrsamtes* und der Videoinstallation *Club Ibis* besteht: Wie im Untertitel schon deutlich wird, thematisiert die ‹Musterhaus-Ausstellung› *Kuchen Immobilien*, den Traum vom eigenen Heim. (Das Wort Kuchen leitet sich aus den entfernten ü-Tüpfelchen des Schriftzuges ab, mit dem hier früher weiße Ware angeboten wurde.) Mit der Phraseologie der Immobilien- und Bausparbranche simulieren Hoefner und Sachsen ein Angebot von Wohnambientes, die bestimmte Erlebnis- oder Stimmungsgehalte versprechen. Das Angebot ‹vom Haus in den eigenen vier Wänden›, das seit Jahrzehnten schlicht das Ideal der Behausung im Kopf der meisten Bundesbürger darstellt, richtet sich dabei an eine Klientel, das finanziell nicht in der Lage ist, ein Haus zu bauen, und für das dieser Wunsch trotz dieser Tatsache nun doch Wirklichkeit werden soll. Aus Foto- und Mustertapeten haben die beiden Künstler Interieurs geschaffen, die diese euphemistisch glückverheißenden Ankündigungen entlarven und ad absurdum führen. Aus der Tapete mit dem efeuberankten Ziegelsteinmuster wurde beispielsweise das Modell *Burg*, aus der Tapete mit den Holzbrettern das Modell *Fort*, aus der Kombination beider Tapetensorten der Typ *Fachwerk* oder die Fototapete von der New Yorker Skyline zum Typ *Hochhaus*. In ihrem Maßstab und ihrer handwerklichen Mediokrität konterkarieren diese Interieurs das, was in den Köpfen der Kundschaft sich bei den genannten Schlagworten an Vorstellungen und Illusionen aufgebaut haben mag. Auch hier muss der Ausstellungsbesucher lachen, wenn er durch die krude, aus Spanplatten ausgesägten und mit Tapete beklebten Kulissen wandelt – doch stellen solche Enttäuschungsmomente über nicht eingelöste Versprechen die bittere Kehrseite dieser Vermarktungsstrategien in der Realität dar. Was vielleicht noch bitterer sein mag, ist, dass in der Wirklichkeit dieser Nepp nicht einmal bemerkt wird, weil viele Kunden ihre Vorstellungen im Moment der ernüchternden Offenbarung gehorsam nach unten korrigieren.·

Träume gehen deshalb in Erfüllung, weil die Fantasie von der der Marketing-Sprache korrumpiert wird. Auf die Frage also ‹… lebst Du schon?› kann nach der Anschaffung entsprechend vermarkteter Einrichtungsgegenstände, Möbel, Lifestyle-Produkte, Accessoires auch keine andere Antwort mehr möglich sein als ein affirmatives ‹Ja!›. Traumerfüllung ist nicht mehr die Sache von Zauberfeen, sondern der Industrie: Sie ist standardisiert, billig und wirtschaftlich. Hoefner und Sachs spielen mit dieser Attraktion, die gewisse Reizworte

auslöst, und der ökonomiebedingten Schäbigkeit, mit der dieser Attraktivität entsprochen wird – so auch bei der Einrichtung eines fiktiven *Fremdenverkehrsamtes* in den Räumen des ehemaligen bulgarischen Fremdenverkehrsbüros.

Bei dieser Installation thematisierten sie die künstlichen ‹Erlebnis›-welten der Tourismusindustrie, die als Kompensationsheterotopien[6] (wenn auch nur für kurze Zeit) ‹leben› beziehungsweise ‹erleben› ermöglichen sollen, wenn schon die graue Alltagswelt dies versagt. Hier schöpfen Hoefner und Sachs aus dem Vokabular und den unzähligen Reizworten der Tourismusbranche, mittels derer neben den exotischen oder heimischen ‹Paradiesen› vor allem das Unterhaltungs- und Freizeitangebot der Reiseanbieter angepriesen werden. Das Missverhältnis dieser blumigen Vermarktungskampagnen und den vorgefundenen Halbwahrheiten vor Ort grassiert in einem bestimmten Marktsegment derart, dass seit Jahren abendfüllende Fernsehdokumentationen versuchen Aufklärung zu verschaffen.

Mit beschichteten Spanplatten von aus Konkursmassen übernommenen Büromöbeln haben Hoefner und Sachs ein Muster-Hotelzimmer möbliert, Sportstätten, einen Wellness-Bereich und eine Strandanlage eingerichtet, die das Prinzip von So-billig-wie-möglich auf ironische Weise bloßstellen. Das Muster-Zimmer ist so eingerichtet, dass kein Zweifel über die Priorität besteht, die der Corporate Identity und der Praktikabilität der Reinigung gegenüber dem Komfort des Gastes eingeräumt wird. Der vermeintliche Gast wird noch stärker reglementiert und eingeengt als zuhause, er wohnt noch standardisierter als daheim. Das versprochene, ach so spektakuläre Erlebnis des Urlaubers vollzieht sich nach Gebrauchsanleitungen und Anweisungen von Animateuren.

Uniformität und Gleichförmigkeit, Standardisierung und Normierung stehen auch bei der Videoinstallation *Club Ibis* im Fokus. Die Entität einer Hotelkette, weltweit den gleichen Komfort anbieten zu können, ist eine fest definierte Aufenthaltsqualität, die von Innenarchitekten, Designern und Architekten auf das Peinlichste überall auf dem Globus gleich reproduziert wird. Die Hotelketten-Zimmer konterkarieren eigentlich das, was eine Reise, einen Urlaub eigentlich ausmachen sollte, das Neue und Ungewohnte, Exotische und Fremde. Stattdessen bieten sie die Gewissheit von Uniformität und Normalität. Hoefner und Sachs geben mit ihrem Video, das sie in einer Art Selbstversuch, bei dem sie sich über mehrere Tage in einem Hotelzimmer des Hotel Ibis in Rennes eingesperrt haben, als eine Art Kammerspiel gedreht haben, eine Gebrauchsanleitung, wie sich diese Eintönigkeit durchbrechen lässt. In einfallsreichen Szenen und Handlungsanleitungen trotzen sie den wenigen standardisierten Einrichtungsgegenständen Erlebnisse ab, wie einen Abend am Lagerfeuer, eine rasante Skiabfahrt oder den Ausritt auf einem Pferd. Das Video führt vor, ‹wie sich das Hotelzimmer mit Hilfe des Fernsehers in eine aktive Erlebniswelt verwandeln lässt›, beschreiben Hoefner und

Sachs ihre Arbeit. Das Leben, das nach dem Wohnen kommen soll, findet im Fernseher statt. Wohnst Du noch oder glotzt Du schon?

‹…… .. …. …. ….. .. …..?›

Der Slogan an sich, der Claim, das Logo oder der Jingle sind gleichfalls alltagsästhetische Phänomene, denen Hoefner und Sachs mit ihren eigenen Piktogrammen und Werbeprogrammen kritische Kontrapositionen geben. Zu fast jeder ihrer Arbeiten entwickeln sie ein Logo, wie die Palme und die Tanne beim *Fremdenverkehrsamt*, dem wabenartigen Stadtwappen bei *Honey Neustadt* oder das Haus und die Burg bei *Kuchen Immobilien*, das den Grundgedanken der Installation auf den Punkt bringt oder den Selbstzweck dieser ökonomisch motivierten Emblematik aufs Korn nimmt. Das *Kuchen*-Logo besteht aus dem stilisierten Umriss von einem archetypischen Haus in der Silhouette eines Burgturms – eine Visualisierung des Häuslichkeitsparadigmas ‹My home is my castle›. Weitere klischeehafte Werbesprüche legen die Plattitüden der Marketingstrategen offen: ‹Sie bleiben wo Sie sind. Ihr Haus kommt zu Ihnen› oder ‹Für jeden ein Stück vom großen Kuchen›

Mit der Arbeit *erikaLand* haben Hoefner und Sachs in ihrer ironisch-scherzhaften Weise die Allgegenwart von Emblemen, Symbolen und Icons persifliert. Die Gebäude der Werkleitz Gesellschaft Halle / Saale, ein Ensemble ehemals leerstehender Bauten, wurde im Rahmen des *Amerika Festivals* zu einer Assemblage US-amerikanischer Symbole umgebaut. Auch diese Arbeit ist ein überdimensionales Objet trouvé, bei denen Hoefner und Sachs zusammen mit Michael Boehler Fundstücke vor Ort entkontextualisieren, umarrangieren und damit vollständig umdeuten. So wird aus der Fassade eines Industriebaus und mit Wärmedämmplatten ein riesiges Sternenbanner (Emblem), aus der klassizistischen Fassade eines leerstehenden Veranstaltungssaals wird durch das Hinzufügen einer weiteren Flagge, und einem weißen Partyzelt das Weiße Haus (Icon) und aus Kellerverschlägen haben die Künstler ein Fort als Symbol für den Wilden Westen sprich die amerikanische Pionierzeit gebaut. Die mit einem Tarnnetz umspannte Hecke stellt dabei das neueste Symbol für den amerikanischen (Kultur-)Imperialismus dar, die Ära des ‹Kriegspräsidenten› George W. Bush. Die Omnipräsenz von Zeichen und Piktogrammen führt zu Reizüberflutung und inhaltlichen Verkürzung oder Entleerung auch anderer Kommunikationsformen.

In der Installation *Forum Arcaden* im Kunstverein Gera werden die Logos bekannter Konsumgüterunternehmen als gerahmte Aquarelle spöttisch in den Rang von Kunstwerken erhoben. Hoefner und Sachs haben sie als Koordination für eine fiktive zukünftige Mall inszeniert, als Fixpunkte für ein Shoppingzentrum, das die Innenstadt wie in so vielen ostdeutschen Kommunen wiederbeleben soll. Durch die Art der schwärmerischen Wiedergabe und huldigenden Präsentation werden diese Logos zu Heilszeichen hochstilisiert, einem Heil das in der Verfügbarkeit von Konsumprodukten liegt. Wie kritik-

los, selbstverständlich und inflationär der Gebrauch und die Wahrnehmung von Logos geworden ist, ist eigentlich bedauerlich wenn nicht sogar traurig, wenn nicht Hoefner und Sachs sich ab und zu in ironischer Weise damit auseinandersetzten. Also: Wohnst Du noch oder lebst Du schon?

1 Pierre Bourdieu u. a., Der Einzige und sein Eigenheim. Hamburg 1998, S. 26.
2 Siehe Gerhard Schulze, Die Erlebnisgesellschaft. Kultursoziologie der Gegenwart, Frankfurt am Main, New York, 2000, S. 292ff u. 322ff.
3 Gernot Böhme, Atmosphäre. Essays zur neuen Ästhetik, Frankfurt am Main, 1995, S. 58
4 Boris Groys, Über das Neue. Versuch einer Kulturökonomie. München, Wien 1992
5 Gerhard Schulze, Die Erlebnisgesellschaft. Kultursoziologie der Gegenwart, Frankfurt am Main, New York, 2000, S. 293
6 Michel Foucault, Andere Orte, in: Aisthesis. Wahrnehmung heute oder Perspektiven einer anderen Ästhetik, Leipzig 1998, S. 46

Biography

Franz Hoefner
*1970 in Starnberg, lives and works in Berlin
1993–1994 Studies of Film and Television Studies at the University of Bochum
1994–2000 Studies of Fine Art at the Bauhaus-University Weimar, MFA

Harry Sachs
*1974 in Stuttgart, lives and works in Berlin
1995–1997 Studies of Fine Art at the Bauhaus-University Weimar
1997–2002 Studies of Fine Art at the Academy of Fine Arts Hamburg, MFA
Since 2006 Co-founder and co-director of Skulpturenpark Berlin_Zentrum
(www.skulpturenpark.org)

Projects and solo exhibitions (selection)

2008
BaumWall, in the context of *space thinks,* Berlin (curators: Schumacher & Jonas)
Park Sculpture in Sculpture Park, Skulpturenpark Berlin_Zentrum, Berlin
Forum Arcaden, Kunstverein Gera (curator: Silke Opitz)
2007
Rückbau, Galerie Invaliden1, Berlin
Kunststiftung Baden-Württemberg, Stuttgart
Sanierungsmaßnahmen, Galerie Wendt+Friedmann, Berlin
Das Beschäft, with Michael Boehler and Markus Lohmann, Kunstverein
Harburger Bahnhof, Hamburg (curators: Tim Voss, Veit Rogge, Susanne Schröder)
2006
Honey Neustadt, project in public space, Berlin
Eigenheimzugabe, Galerie Wendt+Friedmann, Berlin
Mézesújváros, Stúdió Galerie, Budapest (Hungary)
Odyssee Freiburg, Werkraum Theater Freiburg (curator: Arved Schultze)
Home Run, La vitrine, Faux Mouvement – Centre d'Art contemporain, Metz (France)
2005
Active Men – Le Retour, Faux Mouvement – Centre d'Art contemporain, Metz (France)
Home Run, Homie Galerie, Berlin
2004
Interieur, Faux Mouvement – Centre d'Art contemporain, Metz (France)
Haus C0, Planet 22, Art Zürich (Switzerland)
Privat, Galerie Engler+Piper, Berlin

2003
Neuhaus-Wohnerlebniswelt, with Markus Lohmann and Natascha Rossi,
Kultur/Block, Halle-Neustadt (curator: Daniel Herrmann)
Utrechter Huette, Galerie Engler+Piper, Berlin
2002
Mehrzweckhalle, with Michael Boehler and Markus Lohmann, project in
public space, HafenCity Hamburg
Frühjahrsmesse für Existenzgründer, HfBK Hamburg
2001
Club ibis, in the context of *Aux Voyagers,* DfJW (curator: Bettina Klein),
Rennes (France)
2000
Fremdenverkehrsamt, project in public space, Kochstrasse, Berlin
Fontane Buchservice, project in public space, Reinickendorfer Strasse, Berlin
Kuchen Immobilien, project in public space, Torstrasse, Berlin
1999
Aktivposten, Neu Deli, with Michael Boehler, Franziska Lamprecht,
Markus Lohmann, Hajoe Moderegger and Kathrin Wolf, Weimar
(curators: Leonie Weber and Natascha Rossi)
1998
Dixiland, with Franziska Lamprecht and Hajoe Moderegger, media lab
Galerie EIGEN+ART, Leipzig
Dixiland, with Franziska Lamprecht and Hajoe Moderegger, Galerie für
Zeitgenössische Kunst, Leipzig (curator: Klaus Werner)

Group exhibitions (selection)

2008
Sky Limit Walled City, with Matthias Einhoff, Philip Horst, Markus Lohmann
and Daniel Seiple, Goethe Institute Lahore (Pakistan)
Werkleitz Festival, with Michael Boehler, Werkleitzgesellschaft, Halle
(curator: Daniel Herrmann)
5th berlin biennial, with Matthias Einhoff, Philip Horst, Markus Lohmann
and Daniel Seiple, Skulpturenpark Berlin_Zentrum *(*curators: Adam Szymczyk
and Elena Filipovic)
Fernbeziehung Stuttgart-Berlin, Gustav-Siegle Haus, Stuttgart
Torstrasse 166, Haus der Vorstellung, Berlin (curator: Jaana Prüss)
Wunderlust Berlin, Paul Kopeikin Galerie, Los Angeles (curator: Laurie Dechiara)
Sommerloch, Galerie Nikolaus Bischoff, Lahr (curators: Nils Arndt und
Steffen Lenk)
Light Garden, NOASS, Riga (Latvia)

2007
Lada Project, Art Forum Berlin (curator: Hajnal Németh)
KaDeOs, Kaufhaus des Ostens, Kunsthaus Erfurt (curator: Silke Opitz)
Prime Time, Galerie Wendt+Friedmann, Berlin
Made in, Made by – Berlin, Budapest, Lada Project, Berlin
Kunstlabor, E-Werk Freiburg
2006
Eigenheim, everything but the kitchen sink, Kunstverein Göttingen
(curators: Laurie Dechiara and Bernd Milla)
Tales from the Travel Journal Vol. I, Contemporary Art Centre
(curator: Catherine Hemelryk), Vilnius (Lithuania)
Normalnull, Spreekanal, Berlin (curators: Sybille Hofter and Sven Eggers)
Fluidic, UNA Galeria (curators: Simona Soare and Marta Jecu), Bucharest
(Romania)
2005
Rosa9, Kunstverein Freiburg (curator: Silke Bitzer)
X-Wohnungen, Hebbeltheater Berlin (curators: Matthias Rick and Arved Schultze)
Transmission, Neues Museum, Weimar (curator: Liz Bachhuber)
Neues Leben – Neues Wohnen, Galerie Kunsthaus Erfurt (curator: Silke Opitz)
Selfmade, Galerie Weisser Elefant, Berlin (curator: Spunk Seipel)
Divine, Galerie Andreas Wendt, Berlin
La Bauhaus si muove!, Centro d'arte e Cultura San Paolo Esposizioni
(curators: Andrea Dietrich and Julia Draganovic), Modena (Italy)
Ich war Künstler, ACC-Galerie, Weimar
2004
Deptford X Festival, London (Great Britain)
Berliner Kunstsalon, Berlin
Zoll-Douane, with Michael Boehler and Markus Lohmann, Hamburg
(curator: Filomeno Fusco)
Baustaub, Galerie Maerz (curator: Norbert Hinterberger), Linz (Austria)
2003
4.OG, Alsterhaus Hamburg (curators: Filomeno Fusco and Elena Winkel)
Flotsam und Jetsam, Kunstraum Bethanien, Berlin (curators: Liz Bachhuber
and Katharina Hohmann)
Radar Connecting Europe, Extra50 Programme, 50th Venice biennial
2002
Erfolge nichtnewtonscher Turbulenzen, Kunstraum B/2, Leipzig
(curator: David Mannstein)
Wo die Kunst zu Hause ist, exhibition project in various private apartments, Berlin
2001
Ich bin mein Auto, Staatliche Kunsthalle Baden-Baden (curator: Matthias Winzen)
Gonflé, Faux Mouvement – Centre d'Art contemporain, Metz (France)
(curator: Maryse Jeanguyot)

re//mir, Borey Art Gallery, St. Petersburg (Russia)
re//mir II, Galerie art agents, Hamburg
1999
Kunststudenten stellen aus, Bundeskunsthalle Bonn
La Calamar, with Annekathrin Schreiber, tram depot, Weimar
1998
Tranz(it)Formation, with Michael Boehler, Tranzit House and National Art
Museum (curator: Timotei Nadasan), Cluj (Romania)

Film festivals and TV screenings (selection)

2009
TV screening ARTE: ‹Die Nacht / La Nuit›;
Ambulart, Guadalajara (Mexico), Quito, Guayaquil (Ecuador) and Hamburg
2008
TV screening ARTE: ‹Die Nacht / La Nuit›
2007
18th festival internacional de curtas-metragens de São Paulo;
WRO 07 biennale miejsca, National Museum, Wroclaw
2006
CINEPOLIS, Hamburg
2004
TV screening ARTE: ‹durch die Nacht mit …›; Transmediale, Berlin;
lazymarie, Utrecht; emaf, Osnabrück; COURTisane Festival, Ghent; Soester
Kurzfilmtage; Courts Toujours, Lyon; International Short Film Festival
Hamburg; Internationales Bochumer Videofestival; Media Art Festival Fries-
land; Emergeandsee, Budapest, London, Berlin; Impakt Festival, Utrecht,
Netherlands; Krakow Film festival
2003
Stuttgarter Filmwinter; Program Video Folkwang XI, Museum Folkwang Essen;
Viper, Basel; Visionaria, Siena; BackUp, Weimar; Exground, Wiesbaden;
Kasseler Video- und Dokumentarfilmfestival; Bandits-Mages, Bourges
2002
Berlinale, Panorama; Transmediale, Berlin; Image Forum Festival, Tokyo;
Viennale, Vienna; Sarajevo Filmfestival; Sao Paulo Short Film Festival;
Hamburg Kurzfilmfestival; Melbourne Filmfestival; Bristol Short Film Festival;
Viper, Basel; Kurzfilmtage Winterthur; Aarhuus Festival of Festivals; Toronto World-
wide Short Film Festival; Reykjavik Short Film Festival; Montreal ‹Prends ça court›
2001
Infernale, Berlin; Filmfest Weiterstadt; Viper, Basel

1999
TV screening ARTE: ‹Switch 3›; Transmediale, Berlin; Kurzfilmtage Winterthur
1998
Infernale, Berlin
1997
European Media Art Festival, Osnabrück; Bandits-Mages, Bourges;
Ostranenie-Festival, Dessau

Teaching and lectures

2009
Kunstverein Leipzig
Werkleitz Gesellschaft, Halle
2008
Annemarie Schimmel House, Lahore (Pakistan)
2007
‹13 Satellites›, workshop with Matthias Einhoff, Beaconhouse University of
Lahore (Pakistan)
2006
Goethe Institute, Budapest (Hungary)
2005
‹Arche Neuland›, workshop with Markus Lohmann, International Summer
School Halle-Neustadt
2004
‹Hausbau in der Kunst – die Kunst des Hausbaus›, workshop, Bauhaus-
University Weimar
‹Auto, Haus, Urlaub›, Kunstverein Freiburg
2003
‹Survival Camp – Strategien des künstlerischen Überlebens›, workshop with
Annekathrin Schreiber, Bauhaus University Weimar
2000
‹Kunst im ökonomischen Rahmen›, seminar, Dorint Hotel Weimar

Grants, awards and residencies

2008
Grant from Stiftung Kunstfonds, Bonn
Residency in Lahore (Pakistan), VASL International Artists' Collective
Residency in Budapest (Hungary), Budapest Galéria

2007
Support for a catalogue from the Cultural Office of the Berlin Senate
2006
Project support from the Berlin Senate's Department of Science, Research
and Culture
Grant from Kunststiftung Baden-Württemberg
2005
Les Pepinières – artist-in-residence grant, Budapest (Hungary)
2003
RADAR connecting Europe – artist-in-residence grant, Venice (Italy) in
cooperation with La Biennale di Venezia
2002
Project support from Hamburgische Kulturstiftung; Hamburg Cultural
Office, Freundeskreis der HfBK
Filmförderung Hamburg
Postgraduate grant from the state of Thuringia
2001
Infernale Berlin, Audience Award
2000
Franco-German Youth Office (DFJW), artist-in-residence grant, Rennes (France)
1999
Award for fine arts from the Ministry for Education and Research, ‹Kunststu-
denten stellen aus› Federal German competition, Bundeskunsthalle Bonn

Bibliography

Catalogues

‹Skulpturenpark Berlin_Zentrum›, edited by KUNSTrePUBILK, Berlin 2009
‹Space thinks›, edited by Birgit Anna Schumacher and Uwe Jonas, Berlin 2009
‹Spacecraft 2›, edited by Robert Klanten and Lukas Feireiss, Berlin 2009
‹Beyond Architecture›, edited by Robert Klanten and Lukas Feireiss, Berlin 2009
‹When thinks cast no shadow. 5th berlin biennial for contemporary art›,
edited by Adam Szymczyk and Elena Filipovic, Berlin 2008
‹Amerika. Werkleitzfestival 2008›, edited by Werkleitz Gesellschaft, Halle 2008
‹Normalnull: Ausstellung Sichtungsraum›, edited by Sibylle Hofter, Berlin 2008
‹La Bauhaus si muove!›, edited by Andrea Dietrich, Julia Draganovic, Claudia
Löffelholz, Centro d'arte e Cultura San Paolo Esposizioni, Modena (Italy) 2008
‹Tales from the Travel Journal Vol.1›, edited by Catherine Hemelryk,
Contemporary Art Centre, Vilnius 2006
‹Constantly in Motion. Trends in Experimental Film and Video in Germany
1994–2004›, edited by Hermann Nöring, Carola Ferber, Detlef Gericke-
Schönhagen, Goethe Institut Germany, 2005

‹Transmission. Laurence Rathsack & Liz Bachhuber & Alumni›, edited by Klassik Stiftung Weimar, Weimar 2005
‹Checkpoint Charley. 4th berlin biennial for contempory art›, edited by Maurizio Cattelan, Massimiliano Gioni, Ali Subotnik, Berlin 2005
‹RADAR connecting Europe›, edited by Marsilio Editori, Venice (Italy) 2004
‹Zoll-Douane. Art along the borders›, edited by Filomeno Fusco and Ulrich Gerster, Nürnberg 2004
‹Neuhaus-Wohnerlebniswelt›, edited by Kultur/Block, Halle-Neustadt 2003
‹4.OG›, edited by Filomeno Fusco, Hamburg 2003
‹Dreams and Conflicts. La Biennale di Venezia›, edited by Francesco Bonami and Maria Luisa Frisa, Venice 2003
‹Artgenda 2002. 4th Biennial for Art in the Baltic›, Hamburg 2002
‹52. Internationale Filmfestspiele Berlin›, Berlin 2002
‹Ich bin mein Auto: die maschinalen Ebenbilder des Menschen›, edited by Johannes Bilstein and Matthias Winzen, Cologne 2001
‹Aux Voyageurs›, edited by DFJW, Karlsruhe 2001
‹>>re//mir<<. Artist Communication Hamburg-St. Petersburg 2001›, Hamburg 2001
‹Kunststudenten stellen aus. 14. Bundeswettbewerb›, edited by Ministry for Education and Research, Bonn 1999
‹Neu Deli. Ausstellungen›, edited by Bauhaus University Weimar, Weimar 1999
‹Looping›, edited by Erfurter Kunstverein, Städtische Galerie Villingen-Schwenningen, Sonderjyllands Kunstmuseum Tønder, Weimar 1999
‹Tranz(it)formation›, edited by Timotei Nadasan, Sandor Antik, Cluj (Romania) 1998
‹Projekt Kunsthonig›, edited by Bauhaus University Weimar, Deutsches Bienenmuseum, Weimar 1997

Press articles (selection)

‹Forum Arcaden auf dem Marktplatz›, Ostthüringer Zeitung, 17/09/2008
‹Reihe: Ordnung sagt Arbeit›, Hajo Schiff, Kunstforum international, volume 185, 2007
‹Wir geben Ihnen ein Zuhause›, Anita Kerzmann, Das Magazin – Theater Freiburg, 2nd volume, 2007
‹Eine Galerie im Rückbau›, Jana Kühn, Berlin Art Info, April 2007
‹Eigenheim, everything but the kitchen sink›, Thomas Wulffen, Kunstforum International, volume 181, 2006
‹Helden des Monats›, ART, 10/2006
‹Erste Honig-Ernte im Plattenbau›, BZ, 02/10/2006
‹Hohenhonighausen liegt in Kreuzberg›, Wohnen in Berlin/Brandenburg, Sept./Oct. 2006
‹Honig aus dem Plattenbau›, Deutsches Bienen-Journal, Sept. 2006
‹Die Platte brummt›, Annette Kögel, Der Tagesspiegel, 03/08/2006
‹(Kunst-) Honig vom Berliner Mauerstreifen›, Caroline Bock, online article, appeared in DPA, Die ZEIT, Süddeutsche Zeitung, Die Welt, Hamburger Abendblatt, Rhein-Zeitung, Sächsische Zeitung 25/07/2006
‹Wahre Wohnwaben›, Andin Tegen, Berliner Morgenpost, 23/06/2006
‹Le corps utile›, Marianne Brausch, d›Letzebuerger Land, 01/03/06
‹Einblick (133)›, Interview, TAZ, 22/02/2006
‹Eigenheimzugabe›, TAZ, 01/02/2006
‹Kieken, Wundern, Staunen›, Spunk Seipel, Umelec International, Jan. 2006
‹Vernetzter Stadtraum›, centerfold, Regioartline Kunstmagazin No.9, 2005
‹Selfmade›, Christoph Tempel, Bauwelt, 28/01/05
‹Das Wohnzimmer zittert›, Kolja Mensing, TAZ Berlin, 20/01/05
‹Ist das Hamburgs neuer Bambule-Platz?›, Hauke Brost, BILD Hamburg, 24/09/04
‹Flotsam & Jetsam›, Hermann Pfütze, Kunstforum International, volume 164, 2003
‹Berlin 2002 – Major Mishaps, Minor Surprises›, Neil Young, CinemaScope, Feb. 2002
‹Kunst auf Rädern›, Frame, volume 7, May/June 2001
‹Ich bin mein Auto. Die maschinalen Ebenbilder des Menschen›, Hans-Dieter Fronz, Kunstforum volume 157, 2001
‹Im Zimmer von Tante Waltraud›, Marin Majica, Berliner Zeitung, 21/09/2002
‹Mehrzweckhalle am Dalmannkai›, Hamburger Morgenpost, 09/08/02
‹Les nuits de la pleine lune›, Claire Doutriaux and Paul Ouazan, ARTE Magazine, volume 13, April 1999

Authors

Spunk Seipel
*1971 in Hof / Saale, grew up in Nuremberg; studied economics and art history in Berlin and Vienna; founder of the project gallery Expo 3000 (1999–2002) in Berlin, with weekly exhibitions, readings and concerts; works as a freelance curator in Berlin, Munich, Landshut, Vienna, London, Johannesburg and other cities; writes about art for various international media such as Kondensat, Kunstmagazin Berlin, Junge Kunst, Taz, Umelec, Art in Africa and for various art catalogues.

Arne Winkelmann
*1969 in Ludwigshafen, Rhineland-Palatinate; architectural historian and publicist in Frankfurt am Main; studied architecture in Weimar and Krakow; 2004 doctorate on the architectural conservation of ‹Socialist Modernism› from the Bauhaus University Weimar; 2006 doctorate on ‹Culture Factories› from the Humboldt University Berlin; 2000–2006 editor at the BauNetz online service for architects, Berlin; 2006–2007 researcher at the German Architecture Museum, Frankfurt am Main; 2007–2008 lecturer at Mannheim University of Applied Sciences.

Susanne Schröder
*1975 in Mönchengladbach; carpenter; studied art history, philosophy and French literature in Hamburg; freelance work for artists and institutions, including Galerie Sfeir-Semler (Hamburg), Kunstverein Harburger Bahnhof (Hamburg), Kunsthalle Weishaupt (Ulm); has been working since 2007 in Berlin for Karin Sander and for KUNSTrePUBLIK e.V.; currently working on a catalogue for Skulpturenpark Berlin_Zentrum.

Autoren

Spunk Seipel
*1971 in Hof / Saale, in Nürnberg aufgewachsen; Studierte Wirtschaft und
Kunstgeschichte in Berlin und Wien; Gründer der Projektgalerie Expo 3000
(1999-2002) in Berlin, mit wöchentlichen Ausstellungen, Lesungen und
Konzerten; Arbeitet als freier Kurator u.a. in Berlin, München, Landshut,
Wien, London und Johannesburg; Schreibt über Kunst in verschiedenen
internationalen Medien wie Kondensat, Kunstmagazin Berlin, Junge Kunst,
Taz, Umelec, Art in Africa und verschiedenen Kunstkatalogen.

Arne Winkelmann
*1969 in Ludwigshafen / Rheinland-Pfalz; Architekturhistoriker und
-publizist in Frankfurt / Main; Studium der Architektur in Weimar und Krakau;
2004 Promotion an der Bauhaus-Universität Weimar am Lehrstuhl für
Denkmalpflege zur Architektur der ‹sozialistischen Moderne›; 2006 Promotion
an der Humboldt-Universität zu Berlin am Kulturwissenschaftlichen Semi-
nar zum Thema ‹Kulturfabriken›; Von 2000 bis 2006 Redakteur bei BauNetz
Online-Dienst für Architekten, Berlin; 2006 bis 2007 wissenschaftlicher
Mitarbeiter im Deutschen Architekturmuseum, Frankfurt/Main; 2007 bis
2008 Lehraufträge an der Hochschule Mannheim.

Susanne Schröder
*1975 in Mönchengladbach; Tischlerin; Studium der Kunstgeschichte,
Philosophie und Französischsprachigen Literaturwissenschaften in Hamburg;
Freischaffende Arbeit für Künstler und Institutionen, u.a. Galerie Sfeir-
Semler (Hamburg), Kunstverein Harburger Bahnhof (Hamburg), Kunsthalle
Weishaupt (Ulm); Ist seit 2007 in Berlin für Karin Sander und für
KUNSTrePUBLIK e.V. tätig; Arbeitet zur Zeit an einem Katalog über den
Skulpturenpark Berlin_Zentrum.

Thanks to | Dank an

Sándor Antik, Nils Arndt, Liz Bachhuber, Boris Bauer, Silke Bitzer,
Michael Boehler, Tim Boesel, Albert Bomerski, Artur Bomerski,
Leo Brinkmann, Maria Brockhaus, Vesna Bukovcak, Georg Bugiel,
Andrew Carmichael, Lorenzo Cinotti, Laurie Dechiara, Nicole Degenhart,
Ramona Dengler, Andrea Dietrich, Marc Doradzillo, Julia Draganovic,
Jörg Drefs, Solvej Dufour Andersen, Reingard Ebner, Karin Ehrle,
Sven Eggers, Matthias Einhoff, Paul Ekaitz, Andreas Engler, Lukas Feireiss,
Valentina Ferrarese, Agathe Fleury, Maike Fraas, Jochen Fritz, Filomeno Fusco,
Jens Galler, Heike Gallmeier, Gunter Gauck, Emanuel Geisser, Vinzenz Geppert,
Marc Gröszer, Thomas Gera, Ehsan Haq, Catherine Hemelryk, Stefan Hens,
Daniel Herrmann, Norbert Hinterberger, the four Franz Höfners, Monika
and Gunter Höfner, Florian Höngdobler, Sybille Hofter, Elisabeth Honerla,
Philip Horst, Holger Hutt, Ingo Sillus, Sven Ittermann, Iris Janke, Maryse
and Patrick Jeanguyot, Ludovic Jecker, Marta Jecu, Uwe Jonas, Rita Kalman,
Dionisis Kavallieratos, Bettina Klein, Steffi Klekamp, Alexander Klenz,
Mirko Klitscher, Florian Köhler, Hendrik Konzok, Steven Kovats,
Alexander Krussig, Gwendolyn Kulick, Bettina Lamprecht, Franziska Lamprecht,
Gergely Laszlo, Steffen Lenk, Lion Karl Rocko, Markus Lohmann,
Péter Lovas, Caro Mantke, Markus Meyrahn, Stefan Moersch, Frank Motz,
Hajoe Moderegger, Huma Mulji, Timotei Nadasan, Stephanie Nagel,
Hajnal Németh, Petra Olschowski, Silke Opitz, Gritt Pfefferkorn,
Phillipp Humpert, Edmund Piper, Richard Plonka, Peter Prinz, Mirko Rausch,
Matthias Rick, Veit Rogge, Natascha Rossi, Gisela and Werner Sachs, the
four Harry Sachs, Karin and Richard Sachs, Richard Sachs sen., Ulla Sachs,
Laura Scarpa, Sascha Schäffke, Sören Schiebler, Moritz Schleime, Axel Schmidt,
Thomas Schmidt, Tim Schober, Annekathrin Schreiber, Susanne Schröder,
Arved Schultze, Birgit Anna Schumacher, Martin Schwegmann,
Patrick Sheehan, Simona Soare, Spunk Seipel, Dan Seiple, Peter Stoffel,
Transit Berlin soccer team, Malte Urbschat, Tim Voss, Marco Wagner,
Leonie Weber, Andreas Wendt, Herbert Wentscher, Klaus Werner, Elena Winkel,
Arne Winkelmann, Kathrin Wolf, Markus Wüste, Merxe and Richard from
X-Tattoo projects, York Bruno Lux, Yves Loppinet, Naurin Ahmad Zaki,
Dzintars Zilgalve, Zanda Zilgalve

Imprint | Impressum

Published by | Herausgeber
hoefner / sachs
piccolo mondo, 2009
franz.hoefner@gmx.de / sachs@gmx.org

Distributed by | Vertrieb
gestalten
Die Gestalten Verlag GmbH & Co. KG
Mariannenstrasse 9–10
10999 Berlin
Germany
Tel. +49 30 726132000
Fax +49 30 726132222
Email: sales@gestalten.com
www.gestalten.com

ISBN 978-3-89955-248-5

Bibliographic information published by the Deutsche Nationalbibliothek.
The Deutsche Nationalbibliothek lists this publication in the Deutsche Nationalbibliografie; detailed bibliographic data is available on the internet at http://dnb.d-nb.de
Bibliografische Information der Deutschen Nationalbibliothek.
Die Deutsche Nationalbibliothek verzeichnet diese Publikation in der Deutschen Nationalbibliografie; detaillierte bibliografische Daten sind im Internet über http://dnb.d-nb.de abrufbar.

Concept | Konzeption
Maike Fraas, Franz Hoefner, Harry Sachs

Layout | Gestaltung
Maike Fraas

Text | Text
Franz Hoefner, Harry Sachs, Susanne Schröder

Editing | Lektorat
Susanne Schröder

Proofreading | Korrektorat
Arne Winkelmann, Daniel Seiple, Patrick Sheehan

Translation | Übersetzung
Patrick Sheehan, Patricia Mehnert

Printed by | Druck
Druckerei Conrad

Made in Germany

Supported by funds of Kulturverwaltung des Berliner Senat and Stiftung Kunstfonds, Bonn.
Mit Unterstützung der Kulturverwaltung des Berliner Senat sowie der Stiftung Kunstfonds, Bonn.

STIFTUNGKUNSTFONDS